CW01023465

STUDIES IN ARCHITECTUI

EDITED BY ANTHONY BLUNT AND RUDOLF WITTKOWER

VOLUME VII

ST LOUIS AND THE COURT STYLE IN GOTHIC ARCHITECTURE

ROBERT BRANNER

ST LOUIS AND THE COURT STYLE IN GOTHIC ARCHITECTURE

ROBERT BRANNER

DEPARTMENT OF ART HISTORY AND ARCHAEOLOGY

COLUMBIA UNIVERSITY, NEW YORK

A. ZWEMMER LTD

LONDON

For Shirley
and for Sumner and Grod

COPYRIGHT © 1965 A. ZWEMMER LTD
PUBLISHED BY A. ZWEMMER LTD, 26 LITCHFIELD STREET, LONDON WC2

FIRST EDITION 1965
REPRINTED IN PAPERBACK 1985
0 302 02753 X

MADE AND PRINTED IN GREAT BRITAIN AT
THE CAMELOT PRESS SOUTHAMPTON

Contents

List of Plates

List of Text Illustrations

ACKNOWLEDGMENTS

Permission to reproduce the following photographs is gratefully acknowledged to A.C.L., Brussels, for Pl. 18; the Warden and Fellows of All Souls College, Oxford, for Pl. 131; Archiv Mas for Pl. 135; Archives Nationales for Fig. 3 and Pl. 78; Archives Photographiques for Pls. 2, 4, 11, 16, 20, 24, 25, 33, 35, 45, 49, 51, 52, 53, 54, 55, 58, 59, 66, 69, 75, 76, 84, 86, 110, 111, 112, 119, 120 and 124; Bibliothèque de la Ville de Rouen for Pl. 115; Bibliothèque Nationale, Paris, for Pls. 3, 50, 71, 77, 138 and 139; Courtauld Institute of Art, London University, for Pl. 132; Foto Marburg for Pls. 128 and 129; Giraudon for Pl. 63; M. Henri Gouïn for Fig. 4 and for his gracious permission to make Pls. 26, 27, 28, 29 and 30; M. Pierre Héliot for Pl. 21; *Kunstdenkmäler der Rheinprovinz* for Figs. 12, 13 and 14; Musée Carnavalet, Paris, for Pls. 80 and 108; Rheinisches Bildarchiv for Pl. 134; the Controller of Her Britannic Majesty's Stationery Office for Pls. 127 and 133, both from the *Royal Commission on Historical Monuments Inventory of London*, vol. 1; M. Francis Salet for Figs. 6 and 7; Miss Georgia Sommers for Pl. 74. The remaining plates are the author's copyright.

ERRATA

p. 2, last line: for *dé'litable* read *délitable*

p. 8, note 25, line 7: for *1287* read *1289*

 line 8: for *1219* read *1229*

p. 19, line 14: for *not* read *now*

p. 61, note 19: for *St Pathos* read *St Pathus*

p. 68, line 21: for *mask* read *mark*

p. 73, line 9: for *arleady* read *already*

p. 139, line 7: for *picked* read *pecked*

p. 144, note 7, line 2: for *Eude's* read *Eudes'*

Preface

IN recent years there has been a tendency in the study of Gothic architecture to attribute a single building to a single architect whenever possible. This is a natural enough reaction to the established archaeological method, which fragments a Gothic monument into many parts and assigns each one to a different man, often – or so it seems – with no more justification than a change of profile. But the newer approach has dangers of its own, for in the desire to see the building as an aesthetic whole, it must explain changes of design as changes of mind on the architect's part. It thus tends to minimize and to obscure differences between various portions of the building which are sometimes crucial for the history of style. Moreover it reinforces the suggestion of a "psychology" of the architect in the thirteenth century, a time when we are in fact totally uninformed about such matters by other sources, and it thereby leaves the strong imprint of our own century on studies traditionally considered to have the detachment and authority of scientific works. The older method that came into vogue around the turn of the century also has drawbacks, the most obvious being that one often fails to see the forest for the trees and produces a catalogue of parts rather than a concept of style. The fact of the matter is that the results of both approaches are valuable and therefore both methods must be used. The task should be not the justification of method but the investigation of truth.

This book is passionately partisan. I have no doubt that it will stimulate objections, some of them heated, because it attempts to alter many things long considered fixed and because it attacks some idols. However, that is not my aim but an unfortunate if necessary by-product of critical study. In the endeavour to discern the generating elements of a particularly beautiful phase of Gothic design, the buildings had to be diligently compared, and in the process many minor anomalies came to light that had not appeared to those who studied the monuments singly. The adjustments are in fact few, and in any place or period other than the court of

Saint Louis of France they would undoubtedly pass almost unnoticed. Some buildings have had to be redated by as little as two or three years, and only in the case of the cathedral of Clermont Ferrand has a radically new suggestion been made.

As for the idols, the task of the iconoclast is always thankless, even when his motives are worthy. I did not set out to "destroy" the reputation of Pierre de Montreuil, and I have not done so: he plays a more than inconspicuous role in the present study. But it has not been possible to attribute to him the numerous buildings which past ages have clustered about his name. That accretion in fact deserved the most minute examination, since it bade fair to outstrip the two other cases where the existence of a name has served to obscure rather than to clarify stylistic situations: Godefroy de Claire and Maître Honoré. Lest it be loosely said that I have erred through an excess of caution, however, I must beg the reader to suspend his judgment until he has finished the argument, bearing in mind that it is always more difficult to prove a man did not make something than it is to suggest he did.

One study – L. Schürenberg, *Die kirchliche Baukunst in Frankreich zwischen* 1270 *und* 1380, Berlin, 1934 – bears so closely on the buildings discussed here that it has not been possible to refer to it in note in the usual manner. But it should be kept in mind constantly for illustrations and bibliography, even though I consider it unreliable on the subject of dates.

My thanks are gratefully given to the many persons who have assisted me. In particular I should like to express my gratitude to M. Jacques Dupont, Inspecteur Général de la Commission des Monuments Historiques, who understands the problems of research; to M. Francis Salet, Directeur du Musée de Cluny, who is an interested but impartial observer; to M. A. Roussy, Directeur du Service de la Bibliothèque du Sénat in Paris; to M. Surirey de Saint Remy, Directeur de la Bibliothèque Historique de la Ville de Paris; to Dr Herbert Rode, Dombauverwalter of the Metropolitan Chapter of Cologne; to M. Henri Goüin, proprietor of the manor of Royaumont, who graciously allowed me to study the remains

of Saint Louis' abbey in detail; to M. Jean Gimpel, whose scepticism is always welcome; to M. R. de Courcel, Président de la Société archéologique de Corbeil; and to Mlle Jeanne Vinsot, Directeur du Service Photographique of the French historic monuments commission, who enabled me to provide the reader with prints of some of the most precious and splendid photographs in her charge. Professor Jean Bony, of the University of California at Berkeley, gave me several valuable pointers, and Professor Rudolf Wittkower, of Columbia University, was kind enough to read the manuscript and to make important corrections. I am also profoundly indebted to Mr John Waddell, Chief of Reference Services in the Columbia University Libraries, whose very reliability gave me courage. The research for this book was made possible by a grant from the John Simon Guggenheim Memorial Foundation. Some of the material was presented in another form in the Charles T. Mathews Lectures at the Metropolitan Museum of Art in New York in 1963 and 1964.

New York, 23 March, 1964 ROBERT BRANNER

CHAPTER I

Paris, the King and the Arts

ABOUT 1269 Richard von Dietensheim, the prior of Wimpfen im Thal, decided to rebuild his monastery church and for this purpose he hired a skilled architect who had just come from the city of Paris.[1] The mason reconstructed the building *opere Francigeno* – in the French manner – and such was its beauty and fame that people came from far and wide to admire it. This well-known event gives us several important insights into the state of architecture in Europe in the second half of the thirteenth century. The "French manner" meant what we now call the Gothic style – a natural enough term since Gothic originated in northern France and remained largely in the hands of French-speaking people during the century between 1140 and 1240. Moreover the prior of Wimpfen apparently felt that if the Gothic style was good, its Parisian version was even better. During the reign of Saint Louis (1226–1270) architecture in Paris had developed into the highly sophisticated art that I have called the Court Style. Paris was the capital of France and in some ways also the capital of Europe, the largest city in the world and one unrivalled in prestige. In the later thirteenth century Parisian things also had about them an ineffable aura of the king, who was considered by some to be the perfect combination of the just ruler, the holy man and the chivalrous knight. The style of his buildings was in vogue and Prior Richard was merely one among many patrons throughout Europe who thought it would provide a particularly splendid setting for a sanctuary.

The Court Style of Louis IX and his immediate successors first developed the forms that attracted the attention of antiquarians nearly two

1. For the text, see G. Schäfer, *Kunstdenkmäler im Grossherzogtum Hessen*, pt. 1, vol. 3, Darmstadt, 1898, pp. 201–264.

centuries ago and that are still among the most universally recognized hall-marks of the Gothic style. The picturesque exterior of the monument, with its gables and finials, the prodigious windows with their intricate patterns of tracery, the intimate but still imposing scale and the fine detailing of the interior were all characteristics of Parisian architecture in the later thirteenth century. While the style came into focus only after the king's return from the Fourth Crusade in 1254, its origins lay in the preceding decades, primarily in a group of buildings in and around Paris – Royaumont, St Denis and of course the Ste Chapelle. Such was the renown of the chapel and such the prestige of the French court, that Paris rapidly became the architectural centre of Europe, for a time dominating and giving direction to the general expansion of the Gothic style throughout France and abroad.

Paris had not always been the leader in artistic matters in the Middle Ages. In the eleventh century very few large or important buildings had been put up in the Ile de France, and monumental figural sculpture was almost non-existent.[2] The area really entered the mainstream of European artistic thought with the creation of the Gothic style in the early twelfth century, and by the mid-thirteenth Paris had progressed to the point where her artists established the mode that others followed. The explanation of this ascendancy lies in the contemporary prestige of French culture, the eminence of the king of France among the rulers of Europe and the unique position occupied by the city.

The prestige of French culture in thirteenth-century Europe is well known. French was the language of much of the *haut-monde* and it came more and more often to replace Latin in treaties and trade agreements. The Icelandic *Princes' Mirror* of about 1247 urged students to learn French as well as Latin because they were the most widely used languages, and Brunetto Latini himself wrote in French, giving as reasons that he lived in France and that French was the most accessible and "plus dé'litable" of

2. Cf. G. L. Micheli, *Le décor géometrique dans la sculpture de l'Aisne et de l'Oise au XIᵉ siècle*, Paris, 1939.

tongues.[3] French literature was extensively read, translated and imitated, and it was natural for French art also to be looked on as beautiful and desirable.

The eminence of the king of France was perhaps most succinctly stated by Matthew Paris, who was not himself a Francophile but who nevertheless called Louis IX the "king of earthly kings, both because of his heavenly anointment and because of his power and military prominence".[4] Matthew might have added another distinction, the famous *touche aux écrouelles*, which the king of France alone once claimed to possess; but as the king of England had also adopted this habit in the twelfth century, it must no longer have seemed significant to the historian of St Alban's.[5] Not so the other points, particularly the unction. No other European king could point to such an unusual symbol of divine selection; Matthew said it was the consecration of the French king with celestial chrism that made him appear to be most worthy ("dignissimus"), and the ceremony gave strong support to the popular belief that the king of France was first among his peers.[6]

The power and military prominence of Louis IX were equally evident to all. As the result of a century of effort by his forebears, the Capetian monarch exercised direct or indirect control over all present-day France west of the Rhône, Saône and Meuse Rivers, except Aquitania.[7] By mid-century France was also at general peace and had reached a peak of prosperity, so that during his first crusade Louis was able to spend more than £250,000 a year on the expedition and another £50,000 on his household.[8]

3. For the *Konungs Skuggsjá*, see G. Sarton, *Introduction to the History of Science*, vol. 2, Baltimore, 1931, p. 531; B. Latini, *Li livres dou trésor*, ed. F. J. Carmody, Berkeley, 1948, p. 18.

4. M. Paris, *Chronica majora*, ed. Luard (Chronicles and Memorials), vol. 5, p. 480. Cf. M. Gavrilovitch, *Étude sur le traité de Paris de 1259* (Bibliothèque, Ecole pratique des hautes études, 125), 1899, p. 43.

5. P. E. Schramm, *History of the Coronation*, Oxford, 1937, pp. 125–126; cf. R. Vaughan, *Matthew Paris* (Cambridge Studies in Mediaeval Life and Thought, n.s., 6), Cambridge, 1958; and M. Bloch, *Les rois thaumaturges* (Publications, Faculté des lettres de l'université de Strasbourg, 19), Strasbourg, 1924.

6. M. Paris, *op. cit.*, p. 606.

7. R. Fawtier, *The Capetian Kings of France*, London, 1960, p. 32. Fawtier has been used throughout this chapter.

8. H. Wallon, *Saint Louis et son temps*, Paris, 1875, vol. 1, pp. 408–410.

It was not only things French that were highly prized in the later thirteenth century, however, as Richard von Dietensheim made clear. It was especially those from Paris, the capital and heart of the kingdom. The idea of a fixed capital was unusual in medieval Europe, for according to the feudal concept of monarchy the government was lodged in the person of the ruler, and he was itinerant. In France, however, the Capetians had made Paris their main residence in the twelfth century – a move anticipated by epic literature[9] – and the city rapidly assumed the status of a permanent administrative centre.[10] Philip Augustus encircled it with a new wall, and after losing his archives and treasure-wagons to the English in the famous ambush at Fréteval in 1194, he gave these instruments of monarchy greater security by keeping them in Paris. The chancery, parliament and the Chambre des Comptes eventually followed suit, each facilitating the operation of the other branches of government as well as giving the king firmer control over them all. A class of civil servants grew up to staff the agencies, increasing the population of Paris and serving to entrench its position as capital of the realm.

The presence of the king drew the nobility and clergy to the city, and they contributed in no mean way to its brilliance. The great lords and churchmen found it advantageous to have town-houses in Paris, so as to be close to the centre of activities during long portions of the year. In the twelfth century such noblemen as the counts of Champagne and Etampes, the archbishop of Reims and the abbots of St Denis and St Maur already had houses there, and in the course of the thirteenth century it became obligatory for every important person to have a *pied-à-terre* in the capital.[11] In most cases these were elaborate houses, "large, ample and painted, with spacious rooms", in the words of Latini.[12] One such house, that of

9. L. Olschki, *Der ideale Mittelpunkt Frankreichs im Mittelalter,* Heidelberg, 1913, p. 40.

10. An interesting anachronism in this respect is contained in the epitaph of King Clovis, once in the abbey of Ste Geneviève in Paris, who "Parisiis sedem regni constituit"; the inscription was probably made during the reign of Louis VIII (1223–1226) (G. Corrozet [N. Bonfons], *Les Antiquitez de Paris,* Paris, 1586, vol. 2, ff. 7V°–8R°).

11. M. Félibien, *Histoire de la ville de Paris,* Paris, 1725, vol. 1, pp. 256, 266, 273 and 311. Cf. R. Dion, "La leçon d'une chanson de geste: Les Narbonnais", *Paris et l'Ile-de-France,* I, 1949, pp. 23–45, esp. p. 41.

12. B. Latini, *op. cit.,* p. 126.

Jean de Nesles, was bought by no less a person than Queen Blanche de Castille.[13]

Paris also had one of the most famous universities in Europe. Teachers of theology such as Thomas Aquinas and Bonaventura, Albertus Magnus and Guillaume de St Amour, attracted large numbers of students from every corner of the Continent, so that a Gossuin de Metz in the mid-thirteenth century could call Paris the "fountain of science" and a Robert de Blois could honestly state that if a clerk had not been to study at Paris, he was ashamed of himself.[14]

King, nobles, prelates, civil servants, students – all required services and goods, and this stimulated trade and industry in the city. Parisian merchants were already quite numerous and wealthy in the early thirteenth century. It was in fact they who paid for the city wall that Philip Augustus began about 1190 and that served as a perimeter for Paris for nearly a hundred years. Within the walls the city continued to expand, reflecting the constant rise in both population and economy. Between 1190 and 1240, for example, more than thirty churches, most of them parishes, were founded or enlarged in the capital. The artisans also profited from this prosperity, for their services and products were in increasing demand. When Louis IX reorganized the provostship of the city in the 1260s there were a hundred specialized crafts and not the meanest were those concerned with the arts.

Thirteenth-century Paris contained numerous ateliers producing illuminated manuscripts, ivories, embroidery, tapestries, jewellery and liturgical utensils, even cameos and gems engraved *all' antico*.[15] Parisian goldsmiths like Master Bonnard, who made the large reliquary for Ste Geneviève in the late 1230s, came into their own,[16] and the ivory carvers

13. J. Lebeuf, *Histoire de la ville et de tout le diocèse de Paris,* rectifications by F. Bournon, Paris, 1890, p. 37.

14. Gossuin de Metz, *L'image du monde,* ed. O. H. Prior, Lausanne, 1913; for Robert de Blois, see Ch. V. Langlois, *La vie en France au moyen âge,* Paris, 1924, p. 177.

15. P. Verlet, "Orfèvrerie mosane et orfèvrerie parisienne au XIIIe siècle", *L'art mosan,* Paris, 1952, pp. 213–215.

16. See G. Bapst, "La châsse de Ste Geneviève", *Revue archéologique,* ser. 3, VIII, 1886, pp. 174–191.

shortly followed suit. The materials they used were sumptuous and the works they created were largely for the king and the members of his court, a patronage that constantly drew new masters to the city and spurred on the development of ateliers already there. Patrons were therefore no longer obliged to order objects from distant centres or to import workers, as Abbot Suger did for his great cross a century earlier. This meant, inevitably, the emergence of Parisian styles in each medium.

Architecture and sculpture in Paris naturally profited from the rise of the city as an artistic capital, although both arts had a long local history and specifically Parisian styles can be distinguished from 1200 on in sculpture and from the 1160s in architecture.[17] Both were centred in the workshop of Notre Dame, which supplied sculptors for Amiens, Chartres and Magdeburg in the 1220s, for example, and architects for Meaux and Troyes, among other places.[18] In the middle and later years of the century Parisian masters were numerous and in demand. It was surely not a coincidence that among the architects whose names have come down to us, a good many of those working far afield came from the hamlets and small towns lying around the capital: Robert de Luzarches, the builder of Amiens; Renaud de Montgeron, who worked for Alphonse de Poitiers, and Pierre d'Angicourt, who worked for his brother, Charles d'Anjou; or Etienne de Bonneuil, who went to build the cathedral of Uppsala.[19] Together with their compatriots who remained in Paris, these were the men who helped to form and to carry abroad the Court Style of Gothic architecture.

★ ★ ★

The king sponsored three kinds of architecture in addition to civil

17. W. Sauerländer, "Die kunstgeschichtliche Stellung der Westportale von Notre-Dame in Paris", *Marburger Jahrbuch für Kunstwissenschaft*, XVII, 1959, pp. 1–56.

18. A. Goldschmidt, "Französische Einflüsse in der Frühgotische Skulptur Sachsens", *Jahrbuch der königlich Preussischen Kunstsammlungen*, XX, 1899, pp. 285–300.

19. For Renaud de Montgeron, see H. Stein, *Les architectes des cathédrales gothiques*, Paris, 1929, p. 31; this otherwise unidentified mason may be the same as the Renoudus de Mongisone, *lathomus*, mentioned in the *Layettes du trésor des chartes*, vol. 5, p. 325 a. For Pierre d'Angicourt, see C. Enlart, *Manuel d'archéologie française*, 2nd ed., Paris, 1919, vol. 1, p. 77, note 2. For Etienne de Bonneuil, see L. Delisle in *Bulletin, Société de l'histoire de Paris*, V, 1878, pp. 172–173.

works: military, domestic and religious. The military works gravitated around the first crusade and included the staging-area at Aigues-Mortes and the fortifications at Jaffa, but they do not seem to have been many or of particular stylistic importance. The domestic works, such as the new royal château at Tours, are known to us almost exclusively through texts.[20] By far the most numerous and most important, however, were the religious works, as is indicated by contemporary authors. Joinville, writing of King Louis after the crusade, said, ". . . just like the writer who has finished his book and who illuminates it with gold and azure, so the king illuminated his kingdom with the beautiful abbeys he made, and with the great number of hospitals and convents of Dominicans, Franciscans and other religious orders . . ."[21] The image suggests that Joinville was thinking as much of the actual buildings as of the institutions.

We are informed about the genesis and development of a royal project in a rather general manner by Egidio Colonna, Archbishop of Bourges (1294–1316).[22] The archbishop wrote that when the king wanted to put up a building, he first indicated this to his friends, councillors or officers, who presumably discussed the project with him and helped to formulate it more precisely. These men then communicated it to other people: to the architect, who designed the work; to those who helped the project and to those who "removed hindrances", that is to say, agents who undertook to acquire the property and insure legal title to it, and to acquire rents and income for the institution in the event that this was necessary. And finally, according to Colonna, the building was put into work with labourers, who erected the walls and the roof, cut the stones and hewed the beams, and carried out more menial tasks. The construction of the Cistercian abbey of Maubuisson, which Blanche de Castille founded in 1236 and for which large portions of the accounts

20. Recueil des historiens des Gaules, vol. 20, pp. 117, 201 (1229).

21. Joinville, Histoire de Saint Louis, ch. 758 (numbering after the various editions by N. de Wailly).

22. Paraphrased from B. Vallentin, "Der Engelstadt", in K. Breysig et al., Grundrisse und Bausteine zur Staats- und Geschichtslehre, zusammengetragen zu Ehren G. Schmollers, Berlin, 1908, p. 109.

have survived, confirms the latter parts of this procedure in some detail.[23]

The king of course had no monopoly on church building. Bishops, deans and abbots continued to erect cathedrals and monasteries, as they always had. But occasionally the king undertook the work for them. The abbey of Royaumont and the priory of Nogent are cases of royal initiative, and the *chantier* of Tours Cathedral seems to have been very closely associated with royal workshops if not in fact headed by an architect chosen by the Crown.[24] Some prelates naturally sought to employ masters who had worked for the king to design their own projects – Cologne Cathedral was undoubtedly created in this manner – while some patrons, such as Henry III, sent their architects to Paris to examine the most recent and best known of Louis' buildings. The king in turn was not averse to hiring architects from abbeys and cathedrals, at least during the early part of his reign.

The various royal programmes were probably not always carried out by the same persons. Although it would be incorrect to establish too sharp a distinction between architect and engineer, the *ingeniator* did exist and was probably entrusted with purely military works, as were Jocelin de Cornot and his family on the first Crusade.[25] The architect, on the other hand, worked on both domestic and religious projects and there seems to have been no distinction between the two, perhaps because a monastery, like a palace, had rooms and halls and posed the same sort of problems for the designer.

The loss in 1737 of all but the merest fragments of the royal French

23. H. de l'Epinois, "Comptes relatifs à la fondation de l'abbaye de Maubuisson", *Bibliothèque, Ecole des chartes*, XIX, 1857–1858, pp. 550–567.

24. This relationship was originally suggested to me by M. Louis Grodecki.

25. Joinville, chs. 41 and 61. Cf. "magister Johannes Mestifoignes, ingeniator", among the *servientes* of Philip III in 1274–1275 (B. Prost, "Liste des artistes, mentionnés dans les états de la maison du roi . . .", *Archives historiques, artistiques et littéraires*, I, 1899–1900, pp. 425–437). It has been said that Eudes de Montreuil also accompanied Louis to the Near East, but this rests on the sole authority of the Franciscan, A. Thévet, *Les vrais pourtraits et vies des hommes illustres . . .*, Paris 1584, ff. 503–504, in a passage vaunting the qualities of the king's mason who was buried in the Franciscan convent in Paris. Thévet credited Eudes (d. 1287) with buildings such as the Mathurin chapel (1219), and particularly with the fortifications of Jaffa. It is strange, however, that he makes no mention of Eudes in his description of Jaffa (*Cosmographie universelle*, Paris, 1575).

archives prevents us from knowing the names of King Louis' architects. He probably employed individual master masons for particular works, as did the king of England at the same time, and there is every reason to suppose that some men stood high in royal favour and were given several works in succession. The counts of Champagne seem to have hired a Master André in this way in the late twelfth and early thirteenth centuries.[26] If he worked for the king, such a man's title would undoubtedly have been *cementarius regis* or *lathomus regis* for the duration of the work or of his employ.[27] The line between this kind of employment and a regular position is extremely difficult to draw unless one is informed about such signs of tenure as a yearly salary, a robe, a horse, the right to eat the lord's food and so on. Once again the Champenois provide an early example, for about 1223 Thibaud IV appointed a certain Thomas de Vitry to what was clearly an office of master carpenter to the count.[28] It is likely that the king had a similar office for architecture shortly after the middle of the century. Henry III created one in 1256, and it is attested in France in 1285.[29] Perhaps Guillaume de St Pathus, whom Louis IX appointed head of the mason's craft in Paris, probably not long after 1254, was the first Master of the King's Works.[30] Nearly all important institutions with buildings to maintain had an office of this sort by the middle of the thirteenth century. The cathedral of Paris, for example, had an architect master of the works in 1265; he had probably taken an oath to execute his duties faithfully and in accordance with the rules of his craft,

26. H. Stein, "Le maître d'oeuvre André, architecte des comtes de Champagne (1171-1222)", *Nouvelle revue de Champagne et de Brie*, IX, 1931, pp. 181-185.

27. Cf. Ralph the Mason II in J. Harvey, *English Mediaeval Architects*, London, 1954, p. 213.

28. V. Mortet-P. Deschamps, *Recueil de textes*, Paris, 1929, p. 232.

29. J. Harvey, "The mediaeval Office of the Works", *Journal, British Archaeological Association*, ser. 3, VI, 1941, pp. 20-87. Master Eudes de Montreuil is called *Magister cementarius operum domini regis* in September 1285 (J. Depoin, *Cartulaire de l'Hôtel-Dieu de Pontoise*, Pontoise, 1886, no. cii, and *idem*, "Deux maîtres de l'oeuvre de l'église Notre-Dame de Pontoise aux XIIIe et XIVe ss."), *Mémoires, Société historique et archéologique de l'arrondissement de Pontoise et du Vexin*, X, 1886, pp. 63-64.

30. Etienne Boileau, *Le livre des métiers*, ed. R. de Lespinasse and F. Bonnardot (Histoire générale de Paris), Paris, 1879, pp. 88-89; see also R. de Lespinasse, *Les métiers et corporations de la ville de Paris* (*ibid.*), vol. 2, Paris, 1897, pp. 597-601, who says that the masons and carpenters alone were under the jurisdiction of the king's masters in the thirteenth century and that the latter became the Masters of the King's Works in later years.

as is indicated by a document of ten years later.[31] The bishop and chapter of Meaux Cathedral appointed a regular architect in 1253 and the city of Paris itself is said to have had a *maître des oeuvres* in 1257.[32] It should be noted that these titles generally do not appear in documents made for purely internal use, such as account books or tax lists, but were used in official documents that might be invoked in a court of law. Hence some offices may be hidden from us through the chance preservation of only one kind of text.

The Master of the King's Works probably had very limited duties in the thirteenth century. The office was an administrative convenience intended to insure that architects and members of the craft working for the king adhered to the rules and carried out the work properly, and to provide the treasury with certification of the work done. In later years the king had a sworn mason and carpenter, who worked together and who were both Masters of the King's Works, in each bailiwick and provost-ship throughout the country.[33] Inspectors and experts were still called in from the ranks for particular jobs, however. Pierre de Montreuil, the mason, and Bernard, the carpenter, for instance, were named by the king in 1260 to inspect a house that was in dispute between the abbey of St Germain des Prés and some townsmen.[34] But this was not "working for the king" in the usual sense of the word and did not, by itself, make Pierre a royal architect or Bernard a royal carpenter.[35]

Whether or not King Louis actually had a Master of the Works during

31. Pierre de Montreuil in 1265; see H. Stein, "Pierre de Montereau et la cathédrale de Paris", *Mémoires, Société des antiquaires de France,* ser. 8, I, 1912, pp. 14–28. For the *lathomus et carpentarius ecclesie Parisiensis jurati,* see B. Guérard, *Cartulaire de l'église Notre-Dame de Paris* (Collection de documents inédits), vol. 2, Paris, 1850, pp. 478–479.

32. Mortet, *Recueil,* pp. 283–284; G. Corrozet, *Antiquitez* (1586), vol. 1, f. 65.

33. See N. Canat de Chizy, "Etude sur le service des travaux publics . . .", *Bulletin monumental,* LXIII, 1898, pp. 245–272; 341–357; 439–473; and G. Dupont-Ferrier, *Les officiers royaux des baillages et sénéchaussées* (Bibliothèque, Ecole pratique des hautes-études, 145), Paris, 1902.

34. R. Branner, "A Note on Pierre de Montreuil and St.-Denis", *Art Bulletin,* XLV, 1963, pp. 355–357.

35. By the same token an architect working on a "royal abbey" was not working for the king but for the abbot. A "royal abbey" in France meant one where the king had the nomination or the approval of the election of the abbot. See Fawtier, *Capetian Kings,* pp. 99–100 and second folding map.

the latter part of his reign is a point of relatively minor importance, for such an officer might not automatically have been charged with designing every building the king wished to erect. The master of the works of a cathedral of course designed the monument and directed its execution, and during fallow periods when there was no major project in hand, he acted as inspector in the line of maintenance. But the king always had several projects under way at the same time – Louis had military works going at Aigues Mortes in 1241 when he was also building a new priory at Nogent les Vierges and the Ste Chapelle in his palace in Paris[36] – and he undoubtedly employed a number of different architects on them. Through the diversity of designs, however, there can be detected a certain uniformity of approach that seems to reflect a Crown policy toward building.

Royal architectural policy, to the extent that it can be re-established, was not inflexible and several important shifts will be noted in it during the reign of Louis IX. But this policy must also have been influenced by the taste of the time, so that while certain stylistic developments appear to have originated in royal shops, others took their start outside them, in such *chantiers* as the one at Notre Dame. The Court Style was not the exclusive creation of the king or his architects but was broadly based and deeply rooted in French tradition. We must therefore begin with a discussion of its sources.

36. A. Fliche, *Aigues-Mortes et Saint-Gilles,* Paris, 1950, p. 7.

The Sources of the Court Style

THE architecture designed in the mid-thirteenth century for Saint Louis and the members of his court was one of elegance and taste. Like other monuments of the Rayonnant style, the buildings in Paris and the vicinity were virtuoso performances. Light and thin in the extreme, they mark the absolute victory of void over solid. Structurally each one is a spare skeleton from which the unnecessary parts have been removed. Visually each is a jewel, its surface exquisitely faceted to give an impression of ever-changing effects. And each is a speculation upon the nature of plane geometry, using the straight line, the circle, the arc and the square. The Court Style did not innovate in the composition of ground plans or of volumes. In fact it hardly innovated at all, but rather developed to an unusually high degree certain tendencies already latent in the architecture of the early thirteenth century. The most apparent are the co-ordination of surface effects and the dissolution of masses. The surface patterns seem to originate in the window tracery and to flow freely across triforium and dado, pier, portal and gable, uniting the surfaces of the edifice in an all-embracing skein of shafts and arches. But for all their fineness of detail, the buildings are not devoid of monumentality. They have a measured elegance, a stateliness without excessive weight that were peculiarly Parisian qualities surviving from the twelfth century. Like the Rayonnant style in general, however, the Court Style was created within the framework of High Gothic architecture with which the thirteenth century opened in northern France.

With the High Gothic cathedrals of Chartres, Soissons and Reims, designed between 1194 and 1210, the structural problems that fascinated the twelfth century were essentially solved. Piers and flying buttresses

alone now sustained the vaults, and walls lost their supporting function to become simple closures stretched around the skeleton. The latter were pierced wherever possible – by large windows in the clerestory and by narrow, longitudinal passages in the triforium. The system was eminently flexible. The proportions and parts of the building could be modified to a startling degree without endangering stability, whether along the lines of glazing the dark triforium or of repressing the passage and the story altogether. The flying buttress was enough to steady the vaults and it rapidly became a universal sign of the Gothic style.

But High Gothic was much more than a solution to structural problems. It was a complex and subtle affirmation of a way of thought, a seeking for stability, not only in structure, but also in the balance of mass and void, in the distribution of light and of the colonnettes and ribs by means of which the Gothic architect organized the surfaces and volumes of his building.[1] The label alone is modern; the concept is rooted in man's past, and for some architects, including those at the start of the thirteenth century, it may even have implied a perfect co-ordination of all the fundamental aspects of architecture. The balance and harmony of Chartres and Reims, for instance, are imperturbable (Pls. 2, 4). The stories are drawn on the flat surface of the elevation and are in the proportion A:B:A, the tall clerestory corresponding in size to the main arcade. The immense openings of the windows, when filled with the dark colours of glass, also correspond in visual weight to the larger but heavily bordered arcades.[2] The nave wall is composed of a succession of identical units, linked by thin mouldings and by the much more powerful triforium that slides behind the responds. And every story is articulated by ribs and shafts that obey the dictates of some unnatural gravity, growing bulkier as they near the ground. The proportions of Chartres and Soissons – and undoubtedly also those first intended at Reims before the vaults were raised – strike a balance between width and height, between the openness of the void and

1. See H. Focillon, *Art of the West*, vol. 2, London, 1963, pp. 33 ff., and his *The Life of Forms in Art,* 2nd ed., New York, 1948, pp. 11–12.
2. Cf. H. Jantzen, *Uber den gotischen Kirchenraum*, Berlin, 1951.

the solidity of the masonry surrounding it. Here is no modish sketch or brilliant *tour de force*, but a meditation, profound, reasoned and eternal.

High Gothic buildings were not stamped from a dye, however. Soissons Cathedral (begun before 1200), for example, is lighter and thinner than Chartres and does not reveal the same obsession with weight in the handling of effects.[3] It is also less diverse, taking for models forms that were variants at Chartres, such as the pier with only one shaft or the single vault covering both an ambulatory bay and a chapel, and expanding them into a whole system. These features are symptomatic of the elliptical nature of Soissons that, together with the thin overall structure, looked forward to Amiens and beyond. The general austerity of the monument also formed the basis for Longpont, the first High Gothic church of the Cistercians (begun about 1210) (Pl. 3). Longpont represented a slight retrogression from the achievements of High Gothic, for the piers were simple columns and the clerestory was short, in the twelfth-century manner. But the speech of Soissons, in a more severe idiom, could be heard clearly at the abbey, in elevation, windows and effects. The plan itself was like a textbook version of a contemporary cathedral plan, standardized and rid of all irregularities. Of course these qualities were to be expected in a Cistercian monument and the importance of Longpont lay just there, in the frank adoption by that order of a cathedral programme and in the creation of a purified strain of High Gothic, inaugurating a tradition that was to parallel and sometimes to oppose the highly ornamented Court Style.

The greatest success of a very thin structure and extreme tallness was reserved for Robert de Luzarches at Amiens (begun in 1220) (Pl. 1). This master heightened the piers until the main arcade equalled the combined triforium and clerestory in size, in the ratio A:A, and he raised the overall height of the vaults to nearly 140 feet. Real dimensions, however, were unimportant in comparison with their consequences, the effect of pulling the volumes of the basilica up to vertiginous proportions. But if Amiens

3. For a comparison of the two, see C. F. Barnes, Jr., "The Cathedral of Chartres and the Architect of Soissons", *Journal, Society of Architectural Historians*, XXII, 1963, pp. 63–74.

is the essence of the immoderate, it appears almost canonic beside the first project of Beauvais (begun in 1225).[4] Using staggered volumes that rise to three different heights above five aisles, something like those of Bourges, the anonymous Beauvais Master created a gigantic void, a prodigious speculation upon the nature of the universe and man's place in it. Beauvais, however, was the last imaginative French experiment with the configurations of space until the end of the thirteenth century. Later decades were preoccupied with decoration, not dimension, and they took other aspects of Reims and Amiens as their sources of inspiration.

The 1220s: Tracery

The decorated architecture of the Court Style grew from an intense interest in the co-ordination of surface effects. In the 1220s this took several forms, chief among which were the elaboration of tracery patterns, the refinement of the High Gothic bay design and the dissolution of the impression of bulk created by the exterior of the monument.

The Reims of Jean d'Orbais, the master who laid out the plan and built the aisles and radiating chapels of the cathedral between 1210 and 1220, was above all an affirmation of Chartres. But in one respect it went far beyond Chartres, and that was in the creation of window tracery. In the twelfth century the area of Reims and Soissons had experimented with the subdivision of the window wall into doublets and triplets, occasionally surmounting these by an oculus. That was the source for the great windows of Chartres, where a veritable rose rides above two broad lancets. Despite their new proportions, however, these windows were still simple openings in a masonry wall. What Jean d'Orbais did was transform the pattern technically, retaining the shapes but reducing them to "bars" of stone and glazing the interstices. His tracery was not technically perfect, for he used bars only in the lower half of the oculus and in the arches (Fig. 1A).[5] It remained for Robert de Luzarches at Amiens and the anony-

4. R. Branner, "Le maître de la cathédrale de Beauvais", *Art de France* II, 1962, pp. 77–92.

5. For an analysis, see R. Branner, "Paris and the Origins of Rayonnant Gothic Architecture down to 1240," *Art Bulletin*, XLIV, 1962, pp. 39–51. Certain portions of this article, particularly those concerning the date and the sources of St Denis, must be treated with caution. An identical window form is found in the north side-aisle of Troyes Cathedral (not long after 1208).

mous first master of Troyes Cathedral to extend them to the central post (Fig. 1B and Pl. 6), and for the architect who enlarged the clerestory windows of Paris Cathedral about 1225 to translate the upper parts of the design into the new technique (Fig. 1C).

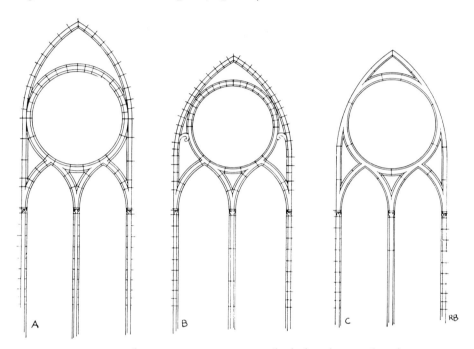

Fig. 1. Window tracery. A. Reims Cathedral, radiating chapel.
B. Amiens Cathedral, nave aisle.
C. Paris Cathedral, clerestory.

Bar tracery had an obvious advantage over the plate-like windows of the twelfth century, since it left the architect free to experiment with new patterns and techniques in almost any way he wished, without risking serious structural consequences to the fabric of the building. The divorce of window from general structure is proven by the many cases where tracery was never inserted into the openings of vaulted and otherwise completed edifices.[6] But in another way window and structure were now

6. Cf. the views of St Nicaise at Reims or of Lagny in the *Monasticon Gallicanum*, pls. 67 and 92. For other considerations on tracery, see W. Gross, *Die abendländische Architektur um 1300*, Stuttgart, 1947, pp. 106, 109.

to be more intimately related than ever before. At Reims, bar tracery is in fact something of a paradox, for it dissipates the solidity of the wall in a monument where density is paramount. Its first great successes were at Amiens and Paris, where mass was not a primary concern. And as the mass of the Gothic building was reduced, linear effects like those of window tracery were repeated and accentuated on other surfaces. As the core of the compound pier seemed to evaporate, for example, there were left behind the colonnettes and pilasters that once constituted only its sheath but that now formed the entire support. And the window mullions literally reached down to invade the triforium. All this – the main lines of the development within which the Court Style was formed – was implicit in Jean d'Orbais' windows in the chapels and aisles of Reims Cathedral.

Bar tracery, however, was by no means the sole or even the major originator of the rich array of new forms created in the 1220s, although it undoubtedly helped the development along. Many of the patterns that were to proliferate in this technique in subsequent decades, particularly those with two or three lancets, also had early counterparts in plate tracery. One was the triplet surmounted by a large oculus, which must have originated in the area of Reims and Soissons even if no early example there has survived. The oldest extant example is probably the plate tracery in the chevet of Bourges Cathedral, a monument heavily imbued with Soissonnais characteristics,[7] and it corresponds to the later bar tracery in the cathedral of Châlons sur Marne (Pl. 15: the tracery in the bay illustrated is coursed because it is blind; elsewhere it is in the early bar technique of Reims). Another pattern can be seen at Villers St Paul, on the Oise River near Paris. There the windows of the chevet that was built about 1225 are triplets with an exaggerated central lancet, also deriving from north-eastern France, but in the apse and transept terminals the upper part of the window lunettes also contain three small oculi (Fig. 2).[8] The

7. R. Branner, *La cathédrale de Bourges*, Paris-Bourges, 1962, fig. 78.

8. See E. Lefèvre-Pontalis, "Monographie de l'église de Villers-St.-Paul", *Mémoires, Société académique d'archéologie de l'Oise*, XIII, 1886, pp. 172–197; A. Mäkelt, *Mittelalterliche Landkirchen aus dem Entstehungsgebiete der Gotik* (Beiträge zur Bauwissenschaft, 7), Berlin, 1906, pp. 58–64.

same pattern was repeated in the apse of Port Royal (dedicated in 1230),[9] lying to the west of Paris, which is preserved for us in a later example at Lys (Pl. 16), and to the east of the capital at Essomes (about 1230), in the

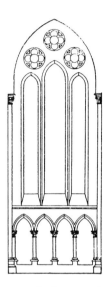

Fig. 2. Villers St Paul, chevet window (Mäkelt).

technique of Jean d'Orbais. Essomes contains still another triplet-and-oculus pattern, in which the three roundels all touch one another – a contemporary example also can be seen at St Maur des Fossés near Paris (Pl. 17) – and the counterpart in plate technique is to be found in the eastern bays of the nave of Lyon Cathedral, a frankly northern monument in the garb of Burgundian Gothic forms. The last kind of triplet, with a large trilobe at the top, is also found in both techniques, for example in the triforium of Amiens Cathedral and in the sanctuary of Cambronne lès Clermont (dedicated in 1239) (Pl. 14).

The doublet, too, was executed in plate as well as bar tracery. One pattern has two trefoil arches beneath a quadrilobe and is found in the portals as well as triforia of the Paris region, for instance at Brie Comte Robert,

9. See esp. the interior view of 1762 in Paris, Bibl. Nat., Est., Va 376, vol. 2.

and also at St Nicaise in Reims (Pls. 9, 22).[10] Two trefoil arches with a
trilobe at the top can be found in the gallery of the façade of Notre Dame
in Paris (Pls. 23, 24). St Nicaise and Notre Dame are especially illuminat-
ing, for each contained both plate and bar work side by side, indicating
the virtual interchangeability of the techniques at that time. There
was only one pattern that was too complex to have a counterpart in plate
tracery, the window with four lancets and three oculi, of which the oldest
examples are undoubtedly those in the nave of Amiens.

The appearance of these new forms and new versions of old forms in
the 1220s reveals a profound and widespread change in the attitude to-
ward linearity and surface. Unadorned masonry, such as could be seen
in the twelfth-century nave of Notre Dame, was no longer permitted,
nor were the heavy plastic effects of Laon. Even the balance of High
Gothic was out of style. Surfaces might still be flat, but they were not
treated as pierced or engraved screens. In places as far apart as St Quentin
and Chartres (St Père), triforium spandrels began to sport quadrilobes,
while in Burgundy they burst forth in bushy, three-dimensional crockets.
Normandy also participated in the movement toward greater richness
with balustrades, full-fledged cornices and elaborate, geometric motifs in
spandrels and tympana. Beyond any doubt, however, this tendency
found its most expressive medium in the window tracery of Picardy,
Champagne and the Ile de France. There, walls did not have to support
shapes applied to their surface but were forced to coagulate into patterns
of solid and void. The shell of the building was transformed into an
embossed, textured envelope, nowhere presenting crude or unornamented

10. For St Nicaise, see H. Deneux, ''L'ancienne église St -Nicaise de Reims'', *Bulletin monumental*,
LXXXV, 1926, pp. 117–142, with bibliography; for Brie, J. Vallery-Radot, ''L'église de Brie-
Comte-Robert (Seine-et-Marne)'', *ibid.*, CLXXVI, 1912, pp. 144–164. Both plate and bar tracery
seem to have been used there, as can be seen in a careful inspection of the De Son engraving (Pl. 22)
and in the anonymous eighteenth-century painting in the Musée de la Ville de Reims showing a
detail of the façade. A similar design is found on the buttresses of the façade at Amiens (Pl. 7) and in
the dado of Notre Dame la Ronde at Metz (*c.* 1220). The technique of recessed panels (or of mould-
ing the edges of the openings) may first have been used in the south transept rose of Chartres; it
also occurs in the upper arcading on the verso of the façade at Amiens.

surfaces to view.[11] Far more than during the High Gothic period, the design of the building became a kind of calligraphy, a series of strokes and swirls possessing a beauty of its own. It was natural, under such circumstances, for the elaboration of effects to assume other forms, and of these probably the most important was the literal extension of tracery patterns beyond the window cell.

The Bay

In 1220 Master Jean Le Loup had just been put in charge of Reims Cathedral, and the first business of the day was to erect the upper stories of the chevet and transept.[12] The very first bays to be put up – those in the hemicycle – contain a feature new to High Gothic design, the linking of the triforium and clerestory by means of colonnettes (Pl. 4). Insignificant as this detail may seem at first – it was to be rejected almost immediately in the choir of Reims and in all subsequent campaigns on the cathedral – it nonetheless formed a parallel to the invention of window tracery, both in its emphasis on increased linearity and in its implications for the elevation. Linkage implied a new and more intimate relationship between the upper stories of the building, one that foretokened the disappearance of the triforium both as a dark zone below the windows and ultimately as an independent story altogether. With window tracery, it led to a new line of elevations that was to culminate in the standard Rayonnant designs of the late thirteenth century.

Linkage did not originate with Jean Le Loup at Reims Cathedral. It first appeared in France at Arras, about 1170, where each lancet of the clerestory surmounted an arch framing two smaller arches (Pl. 21). It was then taken up without the framing arch at St Remi at Reims, about

11. Many of the decorative details mentioned in this chapter are also found in England, often slightly earlier than in France, but they were used in a profoundly different way: the vocabularies were similar but the syntax differed. In France, the details have a structural air about them, as if they played roles in the stability of the work; whereas in England they have an air of appliqué, worked into (and out of) the thickness of the monument without affecting its stability. See also G. Webb, "The decorative Character of Westminster Abbey", *Journal, Warburg and Courtauld Institutes,* XII, 1949, pp. 16–20.

12. For the chronology of Reims Cathedral used here, see R. Branner, "The labyrinth of Reims Cathedral", *Journal, Society of Architectural Historians,* XXI, 1962, pp. 18–25.

1175, and copied at Notre Dame en Vaux at Châlons sur Marne a decade later. From 1185 to 1220 no examples of linkage are known from north-eastern France, but in 1220 it came in for intensive reconsideration, at Amiens as well as at Reims. Jean Le Loup's version had only one arch below each lancet, a simpler pattern that was repeated about 1245 at Agnetz near Paris (Pl. 12) and that was ultimately to become the basis of the Rayonnant elevation. But the hemicycle of the cathedral of Reims had another, unforeseeable, consequence. It seems to have stimulated a revival of interest in twelfth-century forms of linkage, particularly the one at St Remi. Shortly after 1220 this pattern proliferated around Reims in the new three-storied elevation, for instance at Orbais, Essomes and Vaudoy en Brie, not far from Paris (Pls. 10, 11).[13] A variant with the window and the arches placed in a recessed panel, which had been used in the western bays of St Remi, was revived at St Jacques at Reims (Pl. 13) and obviously had some influence on the nave of Agnetz.

In all these examples the effect of linkage on the elevation did not go beyond a somewhat more intimate association of triforium and clerestory. At Amiens, however, the case was different, for there Robert de Luzarches related linkage to a new version of the High Gothic bay (Pl. 1). At Chartres the single bay had for the first time been made the basic unit of design and it was framed from top to bottom by prominent shafts in several orders. At Amiens the bay is outlined by a single colonnette that has its base on the pavement and its capital beneath the vault. The whole unit is repeated at exactly half size in the "lancet" occupying half the width of the upper two stories – even the oculus is at the proper scale – and the shape is repeated again, at still smaller size, in the individual lancets of the clerestory. Thus the linkage of the upper stories appears to be a natural consequence of the progressive subdivision of the bay. One might think that the upper stories of Reims were conceived in the same way but merely on a simpler pattern, were it not for the fact that there, in

13. The 1:2:1 rhythm of the triforium at St Jacques at Reims also appears in Ripon choir, about 1180, and in the south choir bay at Essomes, as well as later at León Cathedral. The "recessed panel", deriving from the west bay of the nave of St Remi at Reims, recurs at Agnetz and León, and it is paralleled at St David's.

the broad transept bays and those adjacent to the crossing, the central post of the window has two colonnettes placed side by side, rather than just one (Pl. 5). This detail is repeated in the triplet at Châlons (Pl. 15) and indicates that in Champagne at this time, each lancet was still thought of as a separate unit rather than as part of the whole tracery pattern. Integration was preceded by mere association, as it were. At Amiens, on the other hand, the independence of each story is maintained, for the two major arches of the triforium are subdivided into three small ones while those of the clerestory house only two each. Thus while Robert de Luzarches created a more skilfully woven pattern than Jean Le Loup, he was less willing to accept the implications of linkage, which suggested an exact and complete correspondence between the stories. Both partis were to exist side by side in the mature Court Style.

There is another important difference between Amiens and Reims. In the latter, the elevation is flat. But in the former, while seeming flat, the elevation is actually formed by a number of receding planes that are subtly underlined by the wall responds, which grow more complex as they mount. This probably derived from the west front of Notre Dame in Paris.[14] At Amiens the window tracery itself has two planes that can easily be measured by the eye on the lower jamb, the recessed one corresponding to the smaller forms of the tracery. The lancet arches rest on the mouldings at the edges of the bay, rather than on colonnettes, and this was to stimulate a series of designs with simple chamfered mouldings that in turn foretokened the sharp forms of the end of the century.[15]

The merger of triforium and clerestory coincided with another aim of the 1220s, the illumination of the entire building and the removal of the dark zone between the main arcade and the windows. The idea of glazing the triforium probably originated in the region of Paris. Lancets were placed in the triforium at Beauvais (1225) and at Chelles (1226), which was copied at Vaudoy (Pl. 11). Another essay in the same vein, the plac-

14. J. Bony, *Cathédrales gothiques en France du nord*, Paris, 1951, p. xi.
15. E.g. in the aisle windows at Troyes Cathedral, St Sulpice de Favières, St Martin aux Bois, and Freiburg Cathedral.

ing of small openings of various forms near the top of the triforium wall, can be found in the nave of St Leu d'Esserent.

Massing

The glazed triforium dislocated the exterior masses of the monument. The lean-to roof behind the triforium, joining the clerestory to the aisle wall and giving the outside of the building an impression of continuity and solidity, had to be altered in order to allow light to reach the triforium glass. The sloping ribbon of the roof was now humped up into a long peak or even into a number of pyramids, and the smooth flow of surfaces was broken, accentuating the picturesque quality that had already been brought to the exterior by the invention of the flying buttress.

However, the disintegration of the massing could be achieved whether or not the triforium was glazed. In the radiating chapels of Cambrai Cathedral and the nave chapels of Notre Dame, small pedimental gables rose above the cornice in each bay and altered its strong longitudinal effect.[16] But it was an older form of gable, the deep one astride the window, that adorned the summit of Cambrai where it alternated with the pinnacle (Pl. 20).[17] Cambrai was begun about 1220, closely following the model of Reims, and the upper stories were probably planned about 1230. The clerestory windows were of the Villers type in the straight bays and twin lancets beneath a larger oculus in the hemicycle. The arrangement seems to have been copied exactly in the chapels at nearby Tournai Cathedral, which was begun in 1243 (Pl. 18).[18]

Gables were in particular favour in the area of Laon and Reims in the later twelfth century and it is not surprising to find them among the following of Reims Cathedral. Hugh Libergier's façade at St Nicaise at Reims, begun in 1231, is a case in point (Pl. 22). There, pediments

16. For Cambrai, see H. R. Hahnloser, *Villard de Honnecourt*, Vienna, 1935, p. 68; for Paris, see Branner, "Origins of Rayonnant" (1962), fig. 16.

17. For the origin of this type, see E. Lefèvre-Pontalis, "L'origine des gables", *Bulletin monumental*, LXXI, 1907, pp. 92–112.

18. R. Branner, "Villard de Honnecourt, Reims and the Origin of Gothic Architectural Drawing", *Gazette des Beaux-Arts*, ser. 6, LXI, 1963, pp. 129–146. For Tournai, see P. Héliot, "Le choeur de la cathédrale de Tournai", *Académie royale de Belgique, Bulletin, Classe des Beaux-Arts*, XLV, 1963, pp. 31–54.

crowned each bay and buttress at belfry level, and across the base ran a
series of seven deep gables. These were organized in a rhythm all their
own, rising and spreading slightly to reach a climax in the centre. As at
Cambrai, pinnacles rose from the ends to increase the accidented effect.
The façade of St Nicaise in fact eschewed all horizontals, even in the
central bay, where the great rose (unfortunately replaced in the Flam-
boyant period) rode upon two large, traceried windows. Hugh Libergier's
façade was based upon Laon, and we cannot know to what degree either
of the façades planned at Reims Cathedral in 1210 and 1225, but never
executed, may have influenced his design. The thinness and the flatness of
the ground story, as well as its linearity, were new qualities that originated
in the 1220s.

Amiens and Paris

A large portion of northern and eastern France, from Paris to the Escaut
River and to Reims, participated in the developments of the 1220s that
have just been outlined. Architects must have travelled often and widely
in this vast area and the "personalities" of the different localities seem
momentarily to have lost their sharpness of definition. When a window
design appeared at Port Royal and Cambrai and a gable type at Cambrai
and Paris, all within a year or two of one another, pinpointing the time
and place of origin of the individual form may seem to lose much of its
meaning for the historian. But regional traditions did not vanish entirely
in the great triangle and the two major foyers of the twelfth century – one
in Paris and the other in the area of Reims, Laon and Soissons – continued
to make themselves felt. Thus the triplet window was at this time still
clearly north-eastern, although the examples in the vicinity of Paris are
among the earliest of the new versions of the form that are known. In the
same way the chapel of St Leu built in Paris in 1235 was just as Rémois
in design as if it stood next to its model, the archiepiscopal chapel in
Reims.[19]

The relationship between Paris and Amiens probably ought to be

19. For St Leu–St Gilles, see M. Dumolin and G. Outardel, *Les églises de France. Paris et la Seine,*
Paris, 1936, pp. 73–77, with bibliography.

viewed in much the same way. Amiens may contain elements from northern sites such as Arras, that go unrecognized because their sources have been destroyed,[20] but the Picard church also contained many Parisian features. It is of course unthinkable without Chartres and Reims behind it, for the plan, the structure, the elevation, the piers and many other details were clearly designed within the framework of High Gothic and the very conception of the monument can only be measured against its great predecessors. Still the Parisian qualities are also strong, although they are not of the kind capable of unquestioned archaeological proof. Robert de Luzarches' structure has a refinement about it – Henri Focillon might have called it an elegance – that recalls the nave of Notre Dame in Paris: the literal reduction of mass to a minimum and the reliance on a few technical devices, such as the flying buttress, to maintain equilibrium. At Amiens and Paris, the handling of elements and forms also gives one the strong impression of a mannered approach that is absent from Chartres and Reims, and also from Soissons.

Certain other factors support the suggestion that Robert de Luzarches had a Parisian side. His birthplace lay in the Parisis,[21] and in the normal course of events he might as easily have gone to the capital for his apprenticeship as to any other city. When he went to work at Amiens, shortly before 1220, he took with him sculptors from the west façade of Notre Dame, and his nave reveals a knowledge of certain details in the western bays of the nave of Paris, which were just being completed at that time.[22] It is well within the bounds of possibility that he was hired in the capital through the offices of someone like Jean Algrin, dean of the chapter of Amiens and a former professor at the university of Paris, as was suggested by Durand,[23] or even Bartholomew of Roye, Grand

20. Arras had aisles of great real height and the nave is said to have had a dado of trefoil arches. See P. Héliot, "Les anciennes cathédrales d'Arras", *Bulletin, Commission royale des monuments et des sites*, IV, 1953, pp. 1–105, esp. p. 73.

21. A. Longnon, "L'Ile-de-France", *Mémoires, Société de l'histoire de Paris,* 1, 1879, pp. 1–43.

22. See also Branner, "Origins of Rayonnant" (1962), note 17.

23. G. Durand, *Monographie de l'église Notre-Dame cathédrale d'Amiens*, Amiens-Paris, vol. 1, 1901, pp. 16–17; see also A. de Truchis de Varennes in *Dictionnaire de biographie française*, 1, 1933, c. 1499–1501.

Chamberlain at the courts of Philip Augustus, Louis VIII and Louis IX. Bartholomew was interested in the arts and had a long experience with architecture during the twenty or so years he spent trying to found the abbey of Joyenval just west of the capital.[24] He was also familiar with Amiens, which lies only twenty-five miles from Roye, and after his death in 1237 he was recorded in the cathedral necrology as having "ornamented the cathedral with many precious things".[25] If the canons wished to find a master mason from Paris, either Dean Jean or Bartholomew would have been an ideal agent.

The postlude to this hypothesis is more factual, for there are clear and unmistakable relationships between Amiens and Paris. One has already been mentioned, the technical development of window tracery. Although the shape of the new clerestory openings at Paris is closer to those in the chapels of Reims, the technical step taken by Robert de Luzarches in augmenting the amount of bar tracery in the window was prerequisite to the final achievement at Notre Dame. Likewise the four-lancet window from the nave of Amiens was taken over and elaborated in the chapels added to the nave of Paris in the 1230s (Pls. 31, 32). But by far the most important connections are to be found on the façades and towers of the two cathedrals.

At first glance the west front of Amiens appears to be much more heavily decorated than the one in Paris (Pls. 33, 34). As the west façade of Notre Dame rose from the ground, however, the ornamentation grew richer and richer – a typical illustration of the progressive aesthetic shift from 1200 to 1230 – until in the upper gallery it reached nearly the same degree as at Amiens. There are parallels between the two buildings even in the lower stories, for the fortuitous gable framing the north portal at Notre Dame, that was cut into the façade during an early change of

24. A. Dutilleux, "L'abbaye de Joyenval", *Mémoires, Société historique et archéologique de l'arrondissement de Pontoise et du Vexin*, XIII, 1890, pp. 41–114; L. Delisle, "Eloge de Barthélémi de Roye . . .", *Littérature latine et historique du moyen âge* (Instructions adressées par le comité des travaux historiques et scientifiques aux correspondants du ministère de l'instruction publique et des beaux-arts, 30), Paris, 1890, pp. 65–67; see also R. Gandilhon, in *Dict. biogr. française*, V, 1951, c. 681.

25. Durand, *Amiens*, p. 18.

plan,[26] looks not unlike the free-standing gables on the Picard cathedral, and blind trefoils appear in the spandrels of both rose windows. But the open galleries are the most revealing for their genetic similarities: there are trefoil arches grouped by twos beneath a lobed motif and framed by an arch lined with cusps, the spandrels filled with trilobes (Pl. 23).[27] The handling of the forms is obviously different on the two buildings, and the forms themselves are not all identical. But the sense of decoration in these particular parts is very similar and there can be little doubt that the designs themselves are related.

In view of these similarities the question naturally arises as to which was the originator and which the borrower, for in a case of such closeness the suggestion of parallel creation must be ruled out. The dates of the two monuments, far from helping to provide a clear answer, only increase the dilemma. The first stone of Amiens was laid in 1220, and at that time the plans had unquestionably been drawn up and a good part of the foundations implanted. But changes, especially of a decorative character, were still possible and some were obviously made as the façade went up (Pl. 34). The rose story was probably under construction about 1230. The façade of Notre Dame in Paris, on the other hand, was begun about 1200 and by 1220 the rose story was just approaching the designing stage: most students of Paris agree that the rose was executed about 1225. The upper gallery probably followed at once.[28] Since Paris grew more and more decorated only with time, it would appear that Amiens was the source for the various forms I have just noted, particularly the gallery. But some of

26. W. Sauerländer, "Die kunstgeschichtliche Stellung der Westportale von Notre-Dame in Paris", *Marburger Jahrbuch für Kunstwissenschaft*, XVII, 1959, pp. 1–56.

27. Arches with cusped soffits also appear in the tribune of the hemicycle at St Etienne at Caen, probably not before 1220, and together with other decorative details they can be compared generically to the galleries at Amiens and Paris. But the forms at Caen are handled in the less "organic" manner mentioned in note 11 above. Cf. the north transept rose of Chartres Cathedral, also from the 1220s. Some connection with Paris is also suggested by the similarity of the aediculae on the chevet buttresses of Chartres to those on the north nave buttresses of Notre Dame, and by the small floral ornaments that are to be seen on the south transept rose of Chartres and the Paris façade gallery.

28. The dates generally given for the towers are much later (see M. Aubert, *Notre-Dame de Paris*, 2nd ed., Paris, 1929, p. 35), but they are *ante quem* and do not fix the parts absolutely in time.

the forms in Paris, namely those in the rose bay, look older and probably
were older on an absolute scale. In brief, it seems impossible to extricate
these two buildings from one another. Perhaps Robert de Luzarches was
a friend of the Master of the Façade of Notre Dame and a regular visitor
to the capital. The two men may then have exchanged ideas as did
Pierre de Corbie and Villard de Honnecourt *inter se disputandum*, according
to Villard's anonymous follower.[29] This would go far toward explaining
the intimate rapport that continued to exist between Amiens and Paris in
the half-century following 1215.

The Return of Regionalism
The fluidity of the 1220s lasted into the next decade – it was never again
to disappear entirely in France – but at that time a new regionalism had
already begun to make itself felt. Reims Cathedral of course continued to
be one of the great architectural forces, both directly and indirectly. It had
an enormous *chantier* that inherited the regional traditions of preceding
generations and passed them on to the large number of new masters and
new shops that it formed and colonized in the 1230s – at gigantic Cambrai,
at tiny Essomes, to Hugh Libergier and to the Master of St Denis. But
Reims itself began the retreat from innovation as early as 1225 and over
the next decade the north-east in general gradually followed suit. The final
statements of modernity there were the upper stories of Cambrai and
Hugh Libergier's St Nicaise (1231). Since St Nicaise came to dominate
Champagne, one must look far afield for innovation in the 1240s, for
example to Strasbourg.[30] Although the area had earlier "created" the
technique of bar tracery and had been among the first to elaborate series
upon series of new window designs based on it, eastern France now
turned to St Nicaise as a model. For the next thirty years the common
pattern in the area – it would probably not be an overstatement to say the
exclusive one – was the quadrilobe above two trefoil arches, unframed
and unencircled, that Libergier had made the leit-motif of his abbey

29. Hahnloser, *Villard*, pp. 29–30.
30. See my forthcoming "Remarques sur la nef de la cathédrale de Strasbourg", in press with the
Bulletin monumental.

(Pls. 102, 103). The variety of the 1220s and '30s vanished and provincialism held sway.

A form of regionalism became equally strong in Paris at the same time, but it was more like a magnetic field in which new elements and ideas were constantly being attracted and aligned in useful positions. Many early Champenois forms were adopted there, and virtually the entire impact of Amiens was absorbed over the decades in Paris. Parisian architecture was also catholic and employed a wide variety of buildings as models. And it did not lapse into provincialism after the work of Hugh Libergier's Parisian counterpart, the St Denis Master.

Royaumont and the St Denis Master

THE major works of the 1230s in northern France were created by two distinguished architects, Hugh Libergier and the anonymous St Denis Master. The first of these designed the abbey church of St Nicaise at Reims in 1231 and directed the construction until his death in 1263. The second seems to have worked on three buildings, the cathedral of Troyes (about 1229 ff.), the abbey of St Denis (about 1233 ff.) and the chapel of St Germain en Laye (about 1238). Standing as they did at the same point in time and with much the same backgrounds, the two men naturally shared many habits and ideas. Both were imbued with the spirit of Reims but were aware of Amiens. Both employed the very latest techniques, and both designed buildings in the decorated, linear mode that had been coming into fashion in the 1220s. But each man reacted differently to his environment and gave expression to his own personality. Libergier's work was characterized by extreme finesse, by mannered disalignments in the façade and elevation of his church (Pl. 22, fig.3), and by the deliberate contrast of round-headed and sharply tapered arches. The St Denis Master was more forthright, at least by comparison, preferring larger, more open forms and avoiding overly subtle contrasts and oppositions. Moreover he came to work in the heart of the Ile de France at a moment when two very different points of view existed there literally side by side. One, represented by the *chantier* of Notre Dame, was close to his own approach and there is every likelihood that he himself actually worked on the cathedral for a time. But the other was resistant to the innovations of High Gothic, employing them only in a very restrained form, and it was this approach that had the stamp of royal approval in 1230. It is a mark of the St Denis Master's success that,

within a few years, his own style was to be taken up by the Crown. That shift of patronage amounted to a liberalization of royal taste, a step that was necessary to the later formation of the Court Style.

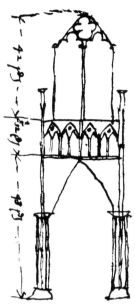

Fig. 3. Reims, St Nicaise, elevation (Paris, *Arch. Nat.*, N III Marne 4/6).

Royaumont and Tours

The first royal building of any consequence to be erected during the reign of Louis IX was the abbey church of Royaumont.[1] Louis VIII had specified in his will of 1225 that all his jewels and their gold settings, including crowns and rings, were to be sold and the money used to

1. See H. Gouïn, *L'abbaye de Royaumont*, Paris, 1958, with bibliography. Louis agreed to officiate at the foundation ceremony of the Victorine priory of Ste Catherine de la Couture in 1229, but it was not for that reason a royal work. Ste Catherine had been founded in fulfilment of the vow of a group of sergeants before the battle of Bouvines; the king's similar vow was fulfilled by the Victorine abbey near Senlis (see note 3). See A. L'Esprit, "Le prieuré Ste Catherine du Val des Ecoliers", *La cité. Bulletin trimestriel, Société historique et archéologique du IVe arrondissement de Paris,* XIII, 1914, pp. 241–272; 357–384). Cistercian St Antoine was also said to have been due to the liberalities of the young king, but this is unconfirmed; the source may have been the king's amortization of abbey properties in 1227. The church was dedicated in 1233 (M. Félibien, *Histoire de la ville de Paris*, Paris, 1725, vol. 1, p. 267; Le Nain de Tillemont, *Vie de Saint Louis* [Société de l'histoire de France], ed. J. de Gaulle, Paris, 1847, vol. 1, p. 477; H. Bonnardot, *L'abbaye royale de Saint-Antoine-des-Champs* . . ., Paris, 1882).

construct an abbey of the order of Saint Victor, dedicated to the Virgin.[2]
In his will of 1222, Philip Augustus had also left money and rents for the
founding and upkeep of a Victorine abbey, to be located at Charenton le
Pont at the southern edge of Paris. Saint Louis' grandfather may have
been partial to the Augustinian canons of St Victor in Paris, for in the
same year he founded an abbey near Senlis to commemorate the battle of
Bouvines and confided it to that order.[3] There is no record that the abbey
at Charenton ever took form, however, and it is possible that Louis VIII
was troubled at having failed to carry out his father's wishes and tried to
pass the obligation on to his own executors. Be that as it may, Louis'
abbey was also not destined to see the light of day, for in its place there
was founded a monastery of Cistercians.

The shift from Victorines to Cistercians was very likely due to the
regent, Blanche de Castille.[4] She had a particular affection for the brothers
of St Bernard, with whom she had been associated in prayers since 1222,
and she later founded two Cistercian convents on her own initiative,
Maubuisson and Lys.[5] She may also have tried, by the creation of Royau-

2. For this will and others, see G. Wolf, *Florilegium testamentorum*, Heidelberg, 1956.

3. A. Vattier, "L'abbaye de la Victoire", *Comptes-rendus et mémoires, Comité archéologique de Senlis*,
ser. 3, II, 1887, pp. 3–32 ("Notice historique"); 33–60; IV–V, 1889–1890, pp. 83–128; VI, 1891,
pp. 112–128; VII, 1892, pp. 71–95; VIII, 1893, pp. 3–32; IX, 1894, pp. 129–159; X, 1895, pp. 96–
116. A. Cavillon, "Les derniers jours de l'abbaye de la Victoire", *ibid.*, ser. 5, I, 1908, pp. 74–93. For
the Louis XI church, see Paris, Bibl. Nat., Est., Va 434 and Va 145.

4. Blanche's gift of £300 to Victorine Ste Catherine in 1229 was perhaps meant as a way of satis-
fying the executors of her husband's will for shifting Royaumont to the Cistercians, for one of the
executors was the abbot of St Victor himself. The tradition that Victorine Ivernaux was founded at
this time by the Crown in fulfilment of Louis VIII's will may have been based upon a similar dona-
tion, for Lebeuf showed this priory was already in existence in 1218 (J. Lebeuf, *Histoire de la ville et
de tout le diocèse de Paris*, vol. 14, Paris, 1754, pp. 280–287; see also Dom Gervais de Gembloux's
history [Paris, Arch. Nat., L 917], ed. J. de Crèvecoeur in *Bulletin, Société d'histoire et d'archéologie de
Brie-Comte-Robert*, IV, 1912–1913, pp. 102–104, 125–129 . . .; and ed. E. Galtier in *Vieux-Saint-
Maur*, VI, 1929, pp. 34–40; a partial plan of 1747 is in Paris, Arch. Nat., N III [Seine-et-Marne]
192).

5. E. Berger, *Histoire de Blanche de Castille* (Bibliothèque, Ecoles françaises d'Athènes et de Rome,
70), Paris, 1895, p. 30. For Maubuisson, see O. Vergé du Taillis, *Chroniques de l'abbaye royale de
Maubuisson, 1236–1798*, Paris, 1947 (the 1830 view following p. 32 is unreliable); for Maubuisson
and Lys, M. Aubert and A. de Maillé, *L'architecture cistercienne en France*, 2nd ed., Paris, 1947, *passim*,
and M.-A. Dimier, *Recueil de plans d'églises cisterciennes*, Grignan-Paris, 1949, with bibliography. In
1236, Blanche also founded Biaches near Péronne (M.-A. Dimier, *Saint Louis et Cîteaux*, Paris,
1954, p. 83).

mont, to imitate her father, Alfonso VIII. He had founded the convent of Las Huelgas outside Burgos and was buried there in 1214, and he seems to have wanted to establish the house as a necropolis for the kings of Castille.[6] A similar idea may even have been formulated for Royaumont – the traditional burial ground of the French kings was St Denis but there was nothing obligatory about it, and in 1180 Louis VII had been laid to rest in the Cistercian monastery of Barbieux.[7] Whether or not such a grandiose scheme had been conceived for Royaumont, the new abbey was certainly thought of as a family necropolis, for every one of Saint Louis' children who died before he did was buried there.[8] Special overtones apparently also attached to the name, for the site had been known as Cuimont and was altered in the charter of foundation to Royaumont, "the royal hill".[9] Louis IX was a boy of fourteen when the abbey was founded in 1228 and he helped in the construction himself, performing symbolic acts of labour along with the monks. Throughout the rest of his life Royaumont was to occupy a special place in his heart; it was there that his family was educated, that he used to retire to meditate and that he gathered together a group of intellectual monks and friars during the later years of his reign. It was probably as much for its prestige as for its formal architectural character that Royaumont played a continuing role in the evolution of thirteenth-century style.

Monks were installed in Royaumont in 1228 or 1229, indicating that the conventual buildings were erected immediately, and the large abbey church was dedicated in 1236. Historians have generally claimed that Royaumont was a copy of Longpont, which Louis and Blanche had seen when they attended the dedication there in 1227. But the similarities were largely restricted to plan (Fig. 4). Royaumont took over the diagrammatic cathedral plan of Longpont almost literally, including the ambulatory and the seven radiating chapels, the aisled transept and the long nave.

6. A. Manrique, *Cisterciensium seu verius ecclesiasticorum annalium...*, Lyon, vol. 3, 1659, p. 340.

7. See Aubert-Maillé, vol. 1, p. 332. One of the king's tombs was perhaps made at Blanche's order.

8. Even Jean Tristan, who died at Tunis shortly before the king did, was to be buried at Royaumont (Dimier, *Saint-Louis*, p. 80).

9. *Gallia christiana*, vol. 9, *Instrumenta*, c. 265.

However, the elevations of the two abbeys were quite different from one another (Pls. 3, 30; fig. 5). Longpont was a restrained version of High Gothic, with a triforium modelled upon Soissons and even the different patterns of the clerestory windows taken from the neighbouring cathedral. Royaumont retained the plain columns and short clerestory of Longpont, but for the unending band of arcades in the central story it substituted a more modern unit-design that was widely employed in the 1220s.[10] Moreover, Royaumont eschewed the monumental surface effects of Longpont for much thinner ones. These features place it close

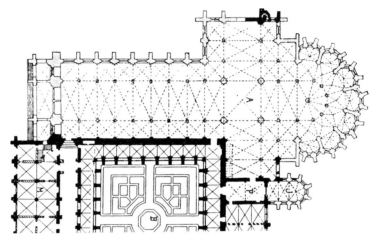

Fig. 4. Royaumont, plan (Chauliat).

to a small group of Parisian works of the decade following 1225: the parish church of St Severin, on the left bank of the capital; Brie Comte Robert (Pl. 9), and the transept of St Quiriace at Provins, the last erected in 1238.[11]

The group as a whole marks the conditional acceptance of High Gothic design by Paris. In the early thirteenth century, the capital showed remarkable resistance to this architecture, for only the west façade of Notre Dame was designed on the principles that characterize Chartres, and its

10. R. Branner, "Paris and the Origins of Rayonnant Gothic Architecture down to 1240", *Art Bulletin*, XLIV, 1962, pp. 39–51, esp. note 21.
11. *Ibid.* for the bibliography.

influence was naturally limited by the fact that it was a façade and not a nave. Versions of the High Gothic elevation, based mainly on the Long-pont scheme, of course filtered into the region at such places as Taverny, and elements and details such as the *piliers cantonnés* of St Leu d'Esserent also made their appearance.[12] But the Chartrain elevation was generally rejected in favour of one with a tall triforium and a short clerestory that characterized older and provincial design at this time, for example in

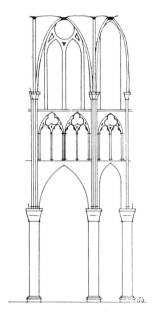

Fig. 5. Royaumont, elevation of choir and hemicycle.

Normandy and Burgundy.[13] Traces of this resistance are still to be seen in the Royaumont group, where the triforium is relatively tall and the clerestory has not yet moved clearly beyond the vault zone, while the columnar piers indicate the rejection of recent experiments in unifying the design of the bay and a return to the twelfth-century system. Similar

12. A. Fossard, *Le prieuré de Saint-Leu d'Esserent*, Paris, 1934; E. Lefèvre-Pontalis, "Eglise de Taverny", *Congrès archéologique*, LXXXII, 1919, pp. 50–68.

13. See J. Bony, "The Resistance to Chartres in early thirteenth-century Architecture", *Journal, British Archaeological Association*, ser. 3, XXI–XXII, 1957–1958, pp. 35–52.

features characterize the nave of Gonesse (Pl. 8), which in many ways seems to reflect the scheme planned for St Denis in 1231.[14]

Royaumont was distinguished from the other members of the group primarily by its Cistercian quality. Walls were left unadorned wherever possible, windows failed to occupy the full area available to them and the capital sculpture was simple.[15] Tympana with elegantly etched but blind trefoil arches surmounted the doors, and the terminal wall of the transept contained a relatively small rose window above three plain lancets. Otherwise, the abbey church was a typical example of contemporary Parisian work – the mouldings, the responds, even the bar tracery in the clerestory windows were practically interchangeable with the same parts in many other buildings in the vicinity (Pls. 26, 27, 28). Only the triforium tracery was more elaborate.[16] One is obliged to conclude, I think, that Royaumont was built by a local architect particularly versed in the design of large parish churches and priories.

It is surprising that such a man should be chosen to build a monument clearly intended as a symbol of the new régime. That was not due to chauvinism, to the desire to elevate Parisian masters above their fellows, but rather to Blanche's policy of using ordinary rather than extraordinary methods whenever possible and to the same highly developed sense of modesty and restraint that made her feel kinship with the Cistercians. It would have been perfectly possible, no doubt, to engage the current master of Notre Dame or one of his foremen, or even to recall Robert de

14. Branner, "Origins of Rayonnant" (1962), pp. 45–46. The relation of the strong piers at Gonesse to St Denis is unmistakable, and the triforium pattern is not unlike that of the Royaumont group, with a single unit per bay. It is uncertain whether Gonesse was to have squarish four-part vaults like twelfth-century Voulton or Notre Dame at Corbeil, or a compressed six-part vault like Nesles la Vallée. It is possible that limited linkage of the Amiens variety was planned in the upper stories.

15. The ground-story windows in the chevet and eastern side of the transept were single lancets; the clerestory windows over the same parts, as well as in both stories of the west side of the transept and in the nave were twin lancets beneath an oculus.

16. The twin-lancet-and-trilobe was executed in bar tracery, as is proven by the many fragments in M. Goüin's garden. There is a possibility that in one bay, at least – the north one on the east wall of the north transept, adjacent to the extant spiral staircase (Pl. 29) – the triforium had a triplet grouped beneath a trilobe, that is, the pattern of the triforium of Amiens executed in bar tracery. The remains on the ground suggest this was an atypical solution, however, perhaps used in a bay of unusual width. It was not repeated in the later works reflecting Royaumont.

Luzarches, who could qualify as a "local" man and whose work at Amiens must already have been eliciting comment. Just such a solution was to be found by King Louis some thirteen years later. In 1228, however, the *avant-garde* was shunned in favour of a more moderate course.

The Crown's policy of restraint can be seen also in the second church in which Blanche and Louis took an active interest in the early 1230s, the cathedral of Tours. Louis VIII had been a canon of St Maurice and promised to assist in the reconstruction, and his son was received by the archbishop in 1227, indicating that strong contacts with the royal family were maintained after the elder Louis' death.[17] The work was precipitated by an "accident" that destroyed the sanctuary about 1233, and in the 1240s the king showed his continued interest by granting the chapter rights to extract stone and to cut wood on his lands near Chinon. According to tradition, which is not always wrong, the reconstruction was decided upon by Blanche de Castille herself. Tours may therefore be considered an example of royal style.

Just as Longpont and Royaumont took "cathedral" elements and purified them in what is generally called the Cistercian manner, so Tours took the "Cistercian" kind of purification as a guide during the early period of construction (Pl. 35, fig. 6). Here the model was Chartres instead of Soissons, and a number of features mark the ground story as a conscious imitation of the High Gothic monument: the *piliers cantonnés*, the axe-faced keystones, the distribution of windows with simple lancets in the radiating chapels and twin lancets beneath an oculus – in plate tracery – in the straight ones. There are in addition some regional details, such as the extra ribs in the ambulatory and chapel vaults, which characterize the Loire Valley, and the passage running through the chapel buttresses which appeared at Le Mans as well as Chartres (Pl. 58). But there is evidence of an intervention from the north-east. The use of *piliers cantonnés*

17. F. Salet, *La cathédrale de Tours*, Paris, 1949, pp. 7–10; A. Mussat, *Le style gothique de l'ouest de la France*, Paris, 1963, pp. 164–169. As far as I can see, there is no reason not to assume that work was undertaken immediately after 1233, when a quest was made for funds. The dean of Tours was also a canon of Notre Dame in Paris in 1234, a fact that strengthens the relationship stressed here (V. Mortet-P. Deschamps, *Recueil de textes*, Paris, 1929, pp.250–251).

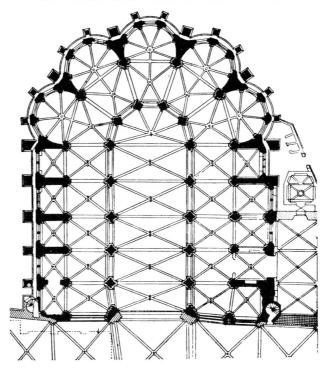

Fig. 6. Tours, Cathedral, chevet (Salet).

right around the hemicycle and of stilted main arcades above them cor-
responds to the parti of Amiens, which may have preceded Tours by no
more than a year or so, and the chapel buttresses, with slim colonnettes in
the angles, repeat the verticals in the rose story of the Amiens façade
where a low passage is also present. Paris, too, seems to have made itself
felt at Tours. Each colonnette of the pier, including the one on the nave
side, has a capital half as high as the main capital, a design deriving from
the nave of St Leu d'Esserent on the Oise River (about 1215–1220).[18] And
although the upper stories of the cathedral were executed in a second
campaign in a later version of Parisian style, they repeat the disposition of

18. The same form appeared at Marmoutiers (Mussat, pl. XV a), but probably not in the earliest
bays (built from 1218 to before 1236), where there was a High Gothic triforium. The capital design
also appeared in the choir of Auxerre Cathedral (c. 1220–c. 1235); R. Branner, *Burgundian Gothic
Architecture* (Studies in Architecture, 3), London, 1960, pl. 1.

Royaumont and were undoubtedly planned that way from the start (Pl. 36).

The canonic character of Tours required uniformity in all parts of the building, an aim that was particularly strong during the early phase of the work. That is undoubtedly why the piers are the same on all sides and why the hemicycle resembles the choir at that level. The responds also have the same number of shafts in every bay, even though this resulted in an irregular correspondence between support and vault. None of these features was unique at Tours, but nowhere else did they appear in such quantity. Tours was conceived as a purification of Chartres, a standardization of the principles first enunciated in the High Gothic cathedral. Throughout the first campaign one has the impression that the monument was "thought" rather than "felt", that mass and void were incidental to silhouette and line which were considered amply sufficient to convey the coherence of the design. In this sense Tours closely resembled the two Cistercian abbeys near Paris.

If the purism of Royaumont can be laid directly to the Cistercians, the purism of Tours cannot. The common denominators of the two monuments were royal, Parisian qualities, representing the same sense of restraint that could be felt in the way Blanche de Castille governed the kingdom. She may even herself have had a certain awareness of style, that made it possible for her to select an architect and a design that would give formal expression in stone to her desire for discretion. At this very time, however, certain members of the court were adopting the richer, more decorated style of the St Denis Master.

The St Denis Master

The St Denis Master's début upon the architectural stage of north France was not an unusual one. Hired to complete the cathedral of Troyes, he created a design that in its beauty and ornateness must have fulfilled all the requirements of the bishop and chapter there. Much more striking was the way in which he was shortly taken up. He could not have been at Troyes for more than three or four years when he was called to St Denis

by Abbot Eudes Clément, and only three or four years after that he was
working for the king. This marks a complete turn-about in the royal
policy toward architecture, from Cistercian purism to Rémois splendour,
as it were, and it is not inconceivable that the shift was arranged by the
Benedictines of St Denis.[19] They had none of the Cistercians' reservations
about ornamented works and their own traditions were in fact much
closer to those of Cluny than of Clairvaux. The St Denis Master's style
was also much more in keeping with what contemporaries must have
expected from the Crown. Royaumont and Tours illustrated Blanche's
rule to dress well enough to maintain the respect of people but not so
ostentatiously as to excite their envy.[20] Before he was through, the St
Denis Master had gone a good bit beyond that mark.

The St Denis Master probably began his career in Burgundy. At both
St Denis and St Germain en Laye he employed a wall passage running on
top of the dado, which is sometimes called the Champenois or Rémois
passage from its appearance in twelfth-century Reims (Pls. 40, 42). It was
also used in Reims Cathedral, where a distinctive moulding with crockets
or leaves runs across the pier from the respond capital to the window wall.
This detail did not characterize the Burgundian passage, however, and as
it is also absent from St Germain and St Denis, a Burgundian source such
as Auxerre Cathedral (Pl. 39) or St Martin at Clamecy seems indicated.
Another Burgundian detail is the manner of raising the passage up above
the vault, detaching the latter from the wall which then forms a rectangle
at the top rather than an arch. This is particularly clear at St Germain and
is also found in the transept terminals at St Denis, and it is a characteristic
of the same two Burgundian monuments, both of which were under
construction about 1220.

The St Denis Master, however, was primarily a student of Jean Le

19. The later royal Cistercian foundations were women's convents and were extremely plain.
Maubuisson, for example, had single lancets with simple chamfered edges, at least in the apse and
transept (a part of one window is extant). Lys had a three-storied nave, but it was on columns with a
triforium of simple openings; decorative windows were apparently used only in the apse and
transepts. The form of Biaches is unknown.

20. Berger, *Blanche de Castille*, p. 256.

Loup at Reims Cathedral. At St Denis and at Troyes he used the same number of units in both triforium and clerestory rather than doubling the lower arches as at St Remi (Pls. 37, 43): the small twin arcades within each arch of the triforium are probably a throwback to Arras (Pl. 21) and emphasize the architect's independence of spirit at a time when the cry was for St Remi. And the hemicycle bays of St Denis resemble those of Reims Cathedral fairly closely, in marked contrast to the St Remi revivals. The window tracery at St Denis also has the calm, stable quality of Reims, and it is more than a coincidence that at St Denis as well as at Troyes, this architect employed Jean Le Loup's twin colonnettes in the central mullion. In brief, the St Denis Master's work must also be included among those secondary milieux emanating from Reims Cathedral which were mentioned in the last chapter. His style is distinguished by its neo-classicism, by his ability to infuse the new forms and techniques that had recently become available to the Gothic architect with something of the poise and monumentality of High Gothic. Jean Le Loup may well have been responsible for making him aware of his talents in this direction.

The earliest design that can be attributed to the St Denis Master, the windows in the aisle at Troyes (Pl. 38), are related to the clerestory at Reims by the shape and certain details of their tracery. But the next work, in the upper stories of Troyes, also reveals connections with Paris (Pl. 37). The pattern of the triforium arcade is nearly identical with the gallery above the central and southern bays of Notre Dame (Pl. 24). At Troyes the story is treated more soberly, as one would expect from a student of Jean Le Loup, and spandrel trilobes are rendered unnecessary there by the presence of mullions. At both Troyes and Paris, however, the galleries are constructed in bar tracery, with tall, monolithic supports and precisely the same *découpage* of the stones in the arches. Another Parisian element at Troyes is the glazed triforium, which, as we have seen, appeared in the vicinity of Paris about 1225. It therefore seems likely that the St Denis Master himself worked on the west front of Notre Dame before going to Troyes at the end of 1228 or in 1229.

Corroboration of this Parisian sojourn is to be found in a most unexpected

place, the cathedral of Amiens. In the transept terminals and choir aisles there appear two designs that were new to the *chantier* of Robert de Luzarches and his immediate successor. One was the trefoil arch and trilobe enclosed by a narrow, stilted arch, a pattern that can also be seen on part of the gallery of Notre Dame (Pls. 19, 25).[21] The other was the four-lancet window with three oculi of nearly exactly the same size, in the clerestory of Troyes. At Amiens this window is executed in the technique of the nave clerestory, with two planes of mouldings and other details characteristic of the developed tracery of Robert de Luzarches (Pl. 67 left). But neither this design nor the blind arcading on the transept wall at Amiens can have been established much before 1232–1233, when the elevation at Troyes must already have been laid out and the gallery at Notre Dame completed. The old exchanges between Paris and Amiens were still going on and a new line of communication was established with Troyes.

The St Denis Master's Burgundian sojourn seems to have provided him with the ability to handle thin structure with the virtuosity for which that province is known, and it also perhaps gave him the taste for relatively low, broad spaces. A short time later, probably from Jean Le Loup, he received an intellectual formation and the ingredients for an elevation. And Paris provided him with a better knowledge of bar tracery and with a particular pattern. One senses that his future was assured from the moment he began work at Troyes.

Troyes Cathedral

The ties between Troyes and Paris in the early thirteenth century were many. Troyes was the chief seat of the count of Champagne, one of the Crown's major vassals, as well as the site of two of the famous Champagne fairs, at which Parisian merchants were regularly to be found. The bishops of both cities were fellow suffragans of the archbishop of Sens, the king's archbishop, and Bishop Hervé, who began the Gothic cathedral

21. The pattern was to become popular in Parisian tracery of the 1250s and was to pass in modified form to London at the end of the century (J. M. Hastings, *St Stephen's Chapel*, Cambridge, 1955, pl. 24).

in 1208, had formerly been a professor at the university of Paris.[22] Bishop Robert (1223–1233) was often at the king's side during the early part of the reign, accompanying his monarch on *tournées* throughout the country. Robert had been dean of the cathedral chapter for several years before his election to the bishopric, and in this capacity he had very likely been in general command of the construction and become familiar with the whole process of building. He must also have known the first Gothic architect of Troyes who, there is every reason to think, had worked at Notre Dame in Paris just before coming to Troyes.[23] It was therefore natural, after this man had been released from his duties, to turn to Paris for a successor, and it was undoubtedly there, among the masons working on the façade of Notre Dame, that the St Denis Master was found.

In November 1228, the papal legate to the archdioceses of Lyon and Sens granted an indulgence of forty days to all those who contributed to the new fabric of Troyes Cathedral and authorized the chapter to send out agents in quest of further funds for the work. Earlier in the year a hurricane had struck the building, which was still under construction, and inflicted considerable damage on it. Repairs of some sort may have been attempted at once but it must soon have become apparent that more extensive revision was needed. An examination of the building reveals that the older project was abandoned in favour of a new one, and the change undoubtedly marks the arrival of the St Denis Master on the scene.[24] One is reminded of William of Sens and the way in which he persuaded the monks of Canterbury to rebuild rather than to repair their cathedral after it had been damaged by fire in 1174.

22. A. Prévost, *Le diocèse de Troyes*, vol. 1, Domois, 1923, pp. 104–107.

23. R. Branner, "Les débuts de la cathédrale de Troyes", *Bulletin monumental*, CXVIII, 1960, pp. 111–122. The remarks on the date of the upper parts of the choir, on p. 114, must be revised in the light of the present study, for there is no reason to assume work was deferred for fifteen years beyond 1228. The texts concerning the quests are in H. d'Arbois de Jubainville, "Documents relatifs à la construction de la cathédrale de Troyes", *Bibliothèque, Ecole des Chartes*, XXIII, 1862, pp. 214–247 and 393–423.

24. The nineteenth-century restorations of the cathedral were severe, but old photographs show that the present windows incorporate old pieces and that their form is therefore original. The statues on the hemicycle piers are a modern invention, however, as are the *culées* of the flying buttresses. The latter are so massive and complex that they might have been designed by a French counterpart to Butterfield.

The new work at Troyes was sharply restricted by what had already been erected in the campaign of 1208. The entire ground story was finished and the chapels were in use, and it is likely that the piers had already been prolonged into the clerestory when the hurricane struck. Faced with a completed main arcade, including the wall-responds in the spandrels, the St Denis Master could alter only the upper part of the bays. He seems to have established the base of the triforium as his point of departure, raising the projected vaults so as to provide more window area and a more vertical bay. In the south aisle, which was probably also damaged by the storm, he removed the old five-part vaults and the extra responds along the wall in order to form normal aisle compartments. Everywhere he touched Troyes, the building grew larger, lighter and more ample.

The outstanding achievement of Troyes lies in the design of the triforium and clerestory, which are bound together to a greater degree than ever before (Pl. 37). By giving each story the same number of elements, the St Denis Master was able to prolong all the window mullions down to the bottom of the triforium. In one way this was a step beyond Amiens, for it enabled the architect to include in his elevation still another repetition of the general pattern of the window – a fourth, one more than Amiens – in the triforium arcade. But his approach to the problem was Rémois. As pointed out in the last chapter, the twin colonnettes on the central mullion indicate that the pattern was still thought of as being composed of parts set side by side, rather than as a subdivided whole. Nor is there any recession, as there is at Amiens. The axis of the bay is accented by the slightly broader mullion alone, and all sets of forms except the one in the triforium are placed in the same strict plane. One moulding, straight and curved, split into two and recombined, serves to define the various lancets and oculi.

The upper stories at Troyes are brought into even closer harmony with one another by the use of a glazed triforium, and the St Denis Master's design for this part has several distinct advantages over the older Parisian types. The glazed openings at Troyes are larger and admit more light to the interior, and they also correspond roughly with those of the triforium

arcade in size and shape, so that to someone standing on the pavement the two patterns are seen off-centre with respect to one another. This makes the depth of the passage difficult to measure visually and it enhances the screen-like quality of the walls.

Within the curtailed context of Troyes, the St Denis Master thus managed to alter profoundly the entire aspect of the Gothic church. His preoccupation with logical considerations at this period of his career appears in three ways. Perhaps the clearest is the repetition of forms at different sizes. Another is the one-to-one relationship of rib to respond, the three shafts of the hemicycle respond supporting one ogive and two wall-ribs, and the five shafts of the other responds bearing a transverse arch, two ogives and two wall-ribs. Although the piers and responds were designed by his predecessor, the St Denis Master accepted them and wove them into the fabric of his work. Lastly, his elevation is one of the supreme examples of Ile de France and, indeed, of French thinking of the Gothic period, for the tracery is deceptively simple while serving both a decorative and a structural purpose. It is not applied to the surface of a wall but with the glass constitutes the very wall itself, a luminous tissue stiffened by fragile struts that echo in small the larger Gothic skeleton of the edifice.

St Denis

The St Denis Master apparently did not confine himself to Troyes, where the rate of construction seems to have been rather slow,[25] but undertook concurrent jobs for the king about 1238 and for the abbot of St Denis perhaps as early as 1233. This brought him back to the immediate neighbourhood of Paris and gave him an opportunity to develop his ideas in one of the wealthiest abbeys of the realm as well as in one of the king's châteaux.

The work at St Denis was undertaken by Abbot Eudes Clément (1230-

25. The terminals and end bays of the transept, which reflect St Nicaise at Reims, were probably erected in response to the quest for funds made in 1240. This would be the *terminus ante quem* for the end of the campaign I have here ascribed to the St Denis Master.

1245), after consultation with the king.[26] Tradition had it that the nave walls of the old Carolingian church had been consecrated by Christ himself, and although Abbot Suger had planned to tear them down in the twelfth century, he never actually did so. The task therefore fell to Eudes, upon whom the weight of the tradition was so great that he had to obtain the consent and approbation of Louis and Blanche. Whether or not the Crown also supplied funds for the Gothic work, Saint Denis was more than ever considered the "patron" of France and the Apostle of Gaul, and the abbey continued to hold the *regalia* with which the king was crowned. The simple desire to express the abbey's relationship to the Crown may explain the presence of royal coats of arms among the ornaments of the Gothic work.[27]

The chronology of St Denis is much better known than that of Troyes. Work began in 1231.[28] In January 1234, when the king's uncle was

26. S. McK. Crosby, *L'abbaye royale de Saint-Denis*, Paris, 1953, pp. 58–59.

27. For the decorations, see J. Dupont, "Travaux de mise en valeur à l'église abbatiale de Saint-Denis", *Les monuments historiques de la France*, 1955, pp. 106–115, and J. Formigé, *L'abbaye royale de Saint-Denis*, Paris, 1960, pp. 120–148. St Denis was almost certainly not a royal workshop. The presence of royal "arms" on the work does not prove the contrary, for the "prestige du roy et de la maison de France ont sans doute multiplié ces armes royales, mais il n'est pas nécessaire de supposer chaque fois une donation royale . . ." (L. Grodecki, *Vitraux des églises de France*, Paris, 1947, with reference to the stained-glass at Clermont-Ferrand); cf. L. Pichon, "La décoration héraldique dans les carrelages du moyen âge, le châtel de Castille", *Bulletin monumental*, LXXXV, 1926, pp. 159–178. As for the funds, they are a supposition of Félibien based upon the presence of the "arms" of Castille and France in the choir and the crossing and on some of the steps leading to the altars in the chevet (*Histoire de Paris*, vol. 1, p. 227). Even if the Crown had given money, however, this would not prove it also exercised control over the project or approved the design; the king and/or queen contributed to Ste Catherine (see note 4 above), to Chartres Cathedral, to St Germain des Prés, to Vézelay, to Soissons Cathedral and to the Dominicans at Rouen (before 1257), among many other places, and in no sense can all these works be termed royal for that reason alone. For the meaning of "royal abbey", see ch. 1, note 35.

28. E. Berger, "Annales de Saint-Denis", *Bibliothèque, Ecole des Chartes*, XL, 1879, pp. 261–295, esp. p. 290. The observations on the hemicycle made by E. Medding-Alp ("Zur Baugeschichte der Abteikirche von St-Denis", *Zeitschrift für Kunstgeschichte*, V, 1936, pp. 246–250) are pertinent ones, but she misdated the parts by thirty years: the comparison of the capitals with those in Notre Dame en Vaux at Châlons sur Marne is telling, but the latter was severely restored after a flood in 1234 and the capitals in question undoubtedly date from that time (L. Hubert, *Notre-Dame-en-Vaux de Châlons-sur-Marne*, Epernay, 1941, p. 15); none of the thirteenth-century parts in the chevet of St Denis would seem to have been made before 1231. Abbot Eudes said the reconstruction was useful as well as necessary, because the church threatened to fall down ("in reparatione ecclesie nostre tam utili quam necessaria cum ruinam minaretur . . .", Paris, Arch. Nat., LL 1157, p. 85; paraphrased by Félibien, p. 227), and this probably explains the very first work (1231), which consisted of replacing Suger's piers in the chevet and adding props beneath them in the crypt.

buried in the church, the old crossing and liturgical choir to the west of it may still have been standing,[29] but by February 1237 the new north transept was complete and with the chevet was probably already vaulted. In the 1240s the first of Suger's radiating chapels were rededicated, and by November 1241, when Abbot Eudes instituted and reorganized a number of services, the entire chevet and transept of the thirteenth-century church had very likely been terminated and the lower portions of the nave set out.[30]

The first work at St Denis, the piers in the hemicycle and choir, had been executed by another master from Notre Dame, a man closely associated with the nave chapels of the cathedral.[31] But only a year or two later the St Denis Master seems to have taken charge. To him are probably due the new and larger plan of the transept and the form of the side aisles, as well as the upper stories of the chevet, both wings of the transept, the lower parts of the nave and three complete bays on the north side (Pl. 43).

The rapid execution of the larger part of St Denis in the 1230s means that it contains more of the St Denis Master's work than does Troyes. The

29. In February 1233 (n.s.), the old nave was probably still erect, for it was very likely there that the great crowd assembled for the celebration of the Feast of the Dedication of the Church, when the Nail from the Passion was lost during exhibition (Félibien, p. 228).

30. The chronology outlined in note 24 of my 1962 article (see note 10 above) must be revised. The crux of the matter lies in the interpretation of the 1231 entry in the *Annales* (Berger, *loc. cit.*, p. 290): "Hoc anno cepit Odo abbas renovare capitium (=chevet) ecclesie B. Dionysii Aryopagiti in Frantia, et perfecit illud usque ad finem chori (the monks' choir, occupying the three eastern bays of the Gothic nave; see Pl. 61), hoc excepto quo(d) turris ubi sunt cinbala a parte revestiarii (the sacristy, lying off the south arm of the transept) non erat perfecta, nec voltatus erat chorus, sed a parte sancti Ipoliti (on the west side of the north transept) totum erat perfectum, et etiam voltatum erat a parti vestiarii." Since work subsequent to 1231 is described, the entry could not have been written in that year. The text undoubtedly forms a résumé of all the construction undertaken by Abbot Eudes (1230–1245). For the suspension of work in 1241, see Appendix C. It is significant that the text says the monks' choir was not vaulted during Eudes' term, as is confirmed by the examination of the monument itself, and this lends support to the accuracy of the text as a whole. The 1236 entry, marking the transfer of relics to the new oratory of St Hippolytus, refers to an event that actually took place on 2 February 1237 (n.s.). Félibien's statement (p. 235), that Abbot Eudes spent the better part of £30,000 on the work, is exaggerated, for the text says he spent that sum largely on prosecuting certain cases concerning the abbey in the courts (Paris, Arch. Nat., LL 1157, p. 85).

31. Branner, "Origins of Rayonnant" (1962), pp. 4–6. Mr Ralph Lieberman brought to my attention the presence of a stone curiously projecting from the eastern side of the north-eastern crossing pier; this may be a remainder of the first design (1231).

abbey is in fact the fullest expression of his mode, the building in which he was able to create all the major parts of a church except a west façade, and in which the gradual evolution of his ideas can be followed in detail. The logical canon which he designed at Troyes was here adjusted, the image made sharper and more coherent. One can sense the fineness of calculation in such details as the relative proportions and spacing of the engaged colonnettes. Nothing, it seems, was left to chance, nothing was used without re-examination of its role in the overall scheme. At the same time particular patterns sometimes slipped over the frontier of strict classicism, and ellipses made their appearance. But the latitude of movement was extremely small, for his strong sense of balance held such potentially powerful currents in check.

The outstanding feature of the plan, as Crosby remarked, is the presence of twin aisles flanking the transept.[32] The crossing seems to become the centre of an enormous, nine-squared grid, set like a martyrium in the middle of the basilica. This may indicate the rejection of Royaumont as the royal necropolis and the beginning of the end of Cistercian dominance over royal taste.[33] With two aisles behind them, the main arcades open on vast spaces whose effect is not unlike that of Suger's early Gothic ambulatories. But another reason for the plan appears in the massing of the church. The outermost squares are surmounted by towers that no longer hug the main mass of the transept but are detached from it (Pl. 100).[34] It is a pity that their spires were never executed, for the effect of aeration would be much greater. Even as it is, however, the isolation of the towers carries a step further the breakup of the exterior envelope that was noted above, and it is all the more telling because it takes place in a part of the church dominated by a tradition more than seventy years old. Starting with Laon and Arras in the 1160s, the transept was treated like a

32. Crosby, 1953, pp. 61–62.

33. This point may be strengthened by Blanche's foundation, in 1236, of Maubuisson, where she was buried in 1252: the regent was, as it were, now arranging her own affairs independently of those of her son. Between the time of Royaumont and Maubuisson, Louis had come of age and had married.

34. There is a certain relationship here to the towers flanking the choir of Chartres Cathedral, but it is doubtful whether Chartres directly inspired St Denis.

west façade with its own towers. Now that tight combination was loosened and the various elements moved apart as if impelled by some centrifugal force.

The aisles of St Denis contain the Rémois passage running above an arcaded dado (Pl. 40).[35] The passage is covered by an arch that links the rather massive responds and surmounts a two-lancet window, as we have seen. The dado arcade is detached from the wall in the Burgundian manner, and the trefoil arches are very delicately moulded.

In the chevet the elevation is virtually a repetition of the one at Troyes (Pl. 43). The only changes are in the inversion of the triforium trilobes and in the size of the oculi – the upper one again dominates the design and the neo-classical aspect of the work is reinforced. But a close look will show that from the hemicycle to the transept, the base of the triforium was raised at least three, if not four times. This clearly reveals a search for more satisfactory proportions, tending toward a decrease in the height of the upper stories. Combined with the lower pavement level in the transept and nave, where there is no high crypt as there is in the chevet, this meant a return to the A:A proportions of Amiens and a better balance between the void of the main arcade and the glazed triforium and clerestory.

In the same vein a new pier form was introduced in the transept. It has only three major shafts and is slimmer than the one in the choir with five.[36] But the exact correspondence between the shafts and the vaulting ribs has been given up, since the respond for the wall-rib now stops at the base of the triforium. This in turn means that the triforium in the transept is recessed further, with reference to the main arcades, than is the one in the choir. The St Denis Master also introduced recessed orders in

35. I cannot agree with Crosby's doubt concerning the authenticity of the aisle passages (*The Abbey of St.-Denis*, New Haven, 1942, p. 4 and note 11). Portions of the passages can be seen in Félibien's plan (Pl. 61).

36. The compound pier with three shafts on the nave-side appeared in the twelfth century nave of Bury, at Mantes, and at the end of the century at St Nicolas at Amiens. In the 1230s it also was used in the chevet of Cambronne lès Clermont, but most examples after *c.* 1240 seem to derive directly from St Denis, as is indicated by the absence of pilasters behind the shafts on the nave-side.

the arcades – in one bay even encircling the arch erected by his predecessor, who preferred the thin, single order of Parisian tradition.

One of the last steps in the evolution of forms at St Denis was taken in the south transept clerestory, where the central mullion was given three shafts instead of two (Pl. 44). This meant that each set of forms now had its own plane and its own mouldings and that straight repetition had given way to hierarchic organization, for the axis of the bay is stressed by the projecting shaft. This marks the complete integration of the approaches of Robert de Luzarches and Jean Le Loup and serves as a basis for new departures that were to lead to the long series of window designs characterizing Rayonnant architecture.

The steps just outlined – the reduction of the pier and the successive recessions of the triforium and clerestory – are symptomatic of the St Denis Master's bent. At Troyes his architecture was quite flat, but toward the end of his work at St Denis it had become plastic, not in the sense of increased bulk but of a composition having depth as well as surface. Texture had in fact taken hold of his designs, and what had earlier been drawing on the surface now began to invade the structure of the building. In this way the double function of tracery, as decoration and as window structure, was brought to full maturity.

In designing the transept terminals, the St Denis Master created his most successful works (Pls. 45, 46). Undoubtedly the salient element of the composition is the rose window, which had long held a position of honour on the Gothic façade. Beneath it, from the 1160s on, was placed a series of lancet windows, drawing the light down below the rose and making it seem to be perched upon a row of more or less fragile masonry supports. At Amiens and in a number of Parisian buildings of the 1220s, a passage was placed in front of the lancets, which began to look like a form of glazed triforium (Pl. 9). The St Denis Master took this idea as his point of departure, using a gallery once more very similar to the one linking the towers at Notre Dame (Pls. 24, 57). The tracery of his north rose is also a development of the great western eye of the cathedral, although the original, thirteenth-century rose at Amiens may have been an

intermediary. But here, too, the St Denis Master went a step beyond his sources, turning the small trilobes that ornament the solid spandrels of these façades into large, ornamental forms (Pl. 45). By analogy, as if to emphasize the relationship of circle to square, he repeated these forms in the lower spandrels and glazed them, so that there is no solid masonry at all to be found between the base of the gallery and the peak of the vault. Moreover, each story of the normal elevation is echoed in the terminal, although there is nothing there to link them to one another vertically. The result is a spectacular glass wall in which the regular rhythm of the nave windows suddenly gives way to a great, incredible wheel, the perfect geometrical form. And as if he were then dissatisfied with the radial spokes of the north transept, the St Denis Master turned to the recent roses of Reims Cathedral for inspiration in the south transept (Pl. 5). It was undoubtedly Reims that suggested the centripetal form, with its arches tapering inward toward the centre. Although not so often copied as the centrifugal north window, the rich south rose of St Denis is one of the outstanding achievements of thirteenth-century design.[37]

St Germain en Laye

The new work at St Denis must have been favourably received, for even before it was terminated the architect was asked to build a chapel in the royal château of St Germain en Laye.[38] The château had been founded in the early twelfth century by King Louis VI and served principally as a lodge for hunting in the forests of St Germain and Marly. Philip Augustus built a chapel there in 1223, which Louis IX replaced by the present, larger building about 1238.[39] Like his forebears, Louis was an ardent hunter and fisher, and the inauguration of daily masses in the St Germain

37. Centripetal tracery occurs in the transepts of Reims Cathedral, after 1236, and in the tympanum of the central doorway of the west façade, probably in the 1260s. A centripetal movement is discernible in earlier roses of the area, for example at Laon, and near Paris, at Mantes. The south transept of Burgos Cathedral is a later instance of the Reims design.

38. A. Saint-Paul first reasonably attributed the chapel to the architect of St Denis (*Bulletin monumental*, LXX, 1906, p. 302, note 1).

39. See J. de Terline, "La tête de Saint Louis à Saint-Germain en Laye", *Monumen s et mémoires, Fondation E. Piot* (Académie des inscriptions et belles-lettres), XLV, 1951, pp. 123–140, for documents and bibliography.

chapel suggests that the king intended to sojourn there more frequently than before. The architecture of the new chapel therefore had a certain importance.

According to a contemporary document, Louis' chapel was "more beautiful in material and skill" than Philip Augustus', and no one today would deny that it is a very elegant building indeed, despite severe restoration (Pls. 41, 42, 60).[40] Typical of twelfth- and early thirteenth-century residential oratories, it is small in size, with only three bays and an apse. Various parts, such as the dado, are identical with St Denis, and the portals, the rose and the four-lancet windows are very close in form to those in the south transept of the abbey, with differences due to their respective scale (Pl. 41). The provenance of the design at St Denis is further confirmed by a technical detail – the unequal length of the colonnettes supporting the wall-rib, which is found in the upper stories of the chevet of the abbey. But the wall-passage at St Germain was given a distinctly Burgundian form, as I noted above. It rises above the vault to a horizontal cover, and vault as well as respond are thrown into relief by the void. The vaults at St Germain seem particularly weightless. The separation of vault and wall also liberated the window, which now has glazed trilobes in the spandrels. This pattern, the arch-in-square, can be traced to the triforia of Troyes and St Denis, and it also appears in the roses of the abbey church. But only at St Germain was it given the sharpness of form necessary for later imitation.[41]

Troyes, St Denis and St Germain en Laye give us an excellent picture of the development of a man's style over a period of a decade. It was already mature in his first building, as if while still an apprentice he nurtured a design which was merely given a bit more depth and internal harmony in the course of execution. Was the slightness of this variation normal for the thirteenth century? Or did the architect refuse to change his style

40. Ibid., pp. 133–134.
41. The pattern has a faint relationship to the design of the clerestory of Bourges Cathedral, where oculi were placed in the window spandrels to aerate the roofs. But in this case the pattern was external, whereas at St Germain it was internal as well.

because it brought him success as it was? There is no simple answer to these questions. The manner in which the St Denis Master used his sources, however, suggests that he was probably not given to abrupt changes of style at any point in his career: his selectivity and continual reference to more recent designs at the same sites mark a gradual process of evolution rather than one of sudden shifts caused by inspirational insights. Other cases from the thirteenth century, to be examined in subsequent chapters, tend to support this conception of the relative stability of personal styles in the period.

The St Denis Master seems to have vanished from the scene in 1241, leaving the monks' choir of the abbey church uncompleted.[42] Although we shall never have an absolute answer, it is worth raising the question as to whether, had he still been available, this architect who had already worked for the king would not have been given the next royal building to design, the Ste Chapelle. As it was, the palace chapel was built by another man in a different style, one that had no more intrinsic merit than the St Denis Master's but that fired the imagination of prelates and populace alike because it was given expression in a unique and sacrosanct monument.

The influence exerted by the St Denis Master was perfectly normal, despite his seeming disappearance from the scene. If it was less extensive than one might expect, that was probably due as much to the fact that St Denis and Troyes were not foyers with long traditions, as it was to the impact of the Ste Chapelle. But some men did profit from his work, and his piers, window tracery and transept terminals were to pass into the general style of subsequent decades. The patterns in the clerestory windows of St Denis and Troyes reappear in a number of village churches in the county of Clermont, north of Paris, in the 1240s and 1250s, as if one of the master's foremen headed a group of itinerant masons who worked for some time in that area (Pl. 49). The abbot's chapel at Chaalis, of about 1245–1250, belongs in this category, although the apse bays contain

42. See Appendix C.

triplets of the St Maur type (Pl. 50).[43] Another master used the Dionysian window in the aisles of St Martin aux Bois, a monument which we will examine in the next chapter. And lastly, the rectangular window of St Germain en Laye, with its pierced spandrels, appeared at St Sulpice de Favières and Meaux in the middle of the century, as we shall see (Pls. 90, 91), later at the chapel of the Augustinians at Rouen and at Regensburg Cathedral, and ultimately with blind spandrels in the aisles of Orléans Cathedral in the fourteenth century.[44]

The St Denis Master dominated Parisian architecture in the 1230s, although his were not the only monuments of that place and period. None of his works was in fact built in the city itself, but they belong to the expanding Parisian style just as much as St Martin des Champs and the other buildings put up within the walls or in the faubourgs of the capital. The style as a whole can be seen from two points of view. On the one hand, it was highly decorated. Shafts and mouldings were abundant and deeply carved ornament was rife on spandrels and portals. Despite the fact that the forms and the foliage still obeyed rigid architectonic laws, a considerable change in scale and proportion took place in the 1230s. The epic moment of High Gothic was past, and the grandiose began to give way to the personal. The forms of the elevation at Amiens almost escape us because of the height of the building, but this is no longer so at St Denis or Troyes, nor was it so at Royaumont, which rose to only eighty feet. Instead of a visionary scale that overpowers man, the architects of the 1230s created lower spaces with broader panels of wall to hold their drawing. The detailing was thus brought closer to the viewer and could be made even more elaborate. This was a prelude to the rich intimacy of the Court Style.

The second aspect of Parisian architecture in the 1230s is an external

43. E. Lefèvre-Pontalis, "L'église abbatiale de Chaalis (Oise)", *Bulletin monumental*, LXVI, 1902, pp. 449–487.

44. For Rouen, see R. de Lasteyrie, *L'architecture religieuse en France à l'époque gothique*, Paris, 1926, vol. 1, p. 312; for Regensburg, see G. Gall, "Zur Baugeschichte des Regensburger Domes", *Zeitschrift für Kunstgeschichte*, XVII, 1954, pp. 61–78; for Orléans, G. Chennesseau, *Ste.-Croix d'Orleans*, Paris, 1921.

one but it is no less important for that reason. Paris had no major churches in High Gothic style, none that could be looked upon in the same way as were Soissons or Reims, as models of design as well as standards of excellence.[45] Royaumont and St Denis therefore filled the gap. Royaumont in particular, probably because of its close personal association with the king, was a source of inspiration to architects throughout the entire century. It is possible that a similar role might have fallen to St Denis had the Ste Chapelle not intervened.

45. Cf. W. Gross, *Die abendländische Architektur um* 1300, Stuttgart, 1947, p. 36, for some illuminating comments on models and standards. Gross seems to place the shift of emphasis toward models considerably later than I do, and he is of course not particularly concerned with Paris.

The Sainte Chapelle and the Formation of the Court Style

THE construction of the Ste Chapelle in Paris (Pl. 63), in the early 1240s, marked a shift in royal taste comparable to the one that took place between the designing of Royaumont and of St Germain en Laye a few years before. Whether the change was voluntary or not, the selection of a master from Amiens had a profound effect on the future of Parisian architecture, for the chapel was to hold the Crown of Thorns and a fragment of the True Cross which Louis had purchased from the emperor of Byzantium, and it was unquestionably the most prestigious building erected by the king of France during the entire century. With it Amiens replaced Reims as the dominant architectural influence in court circles and the spirit of Robert de Luzarches thereby came to preside over the formation of the Court Style.

The programme of the Ste Chapelle was unique, for, in addition to containing illustrious relics, the chapel was invested with a particular idea. Archbishop Gautier Cornut of Sens (d. 1241) wrote that the presence of the Crown of Thorns made it seem as if Christ had especially chosen France "for the more devout veneration of the triumph of His Passion", since the Crown was the titulus and special glory of the whole country.[1] In 1244 the pope said more simply that Christ had crowned Louis with His Crown.[2] Clearly the presence of the relics in France enhanced the

1. G. Cornut, *Historia susceptionis corone spinee* in P. de Riant, *Exuviae sacrae Constantinopolitanae,* vol. 1, Geneva, 1877, p. 47. On the Ste Chapelle, most recently see L. Grodecki, *Sainte-Chapelle,* Paris (1962), and idem, *Corpus vitrearum medii aevi,* France, I, Paris, 1959, pp. 72–84.

2. S.-J. Morand, *Histoire de la Sainte-Chapelle royale de Paris,* Paris, 1790, *pièces justificatives,* pp. 2–3, where the charter is misdated 24 May 1243 for 24 May 1244; Innocent IV was elected only on 25 June 1243.

king's position as *rex christianissimus,* as *imago Dei* and *patronus ecclesie.*[3] John of Garland, between 1245 and 1252, added that the costly chapel was built in order to house the relics and to make them accessible to the rich and poor of God, and in so doing he underlined the function of the chapel as a national shrine.[4] This idea was elaborated in the building by placing frescoes of locally venerated saints in the dado. There is therefore little wonder that the chapel was construed as a reliquary of monumental size.

Many of the physical features of the chapel confirm this concept (Pl. 69). The extensive gilding of the masonry, the backgrounds of the frescoes, which resemble enamels and chased gold, the angels in the dado spandrels and the statues of the Apostles affixed to the sides of the building strongly suggest a contemporary gold and enamel reliquary turned outside-in.[5] Metaphorically the same concept is expressed in Pope Innocent IV's bull of 1244, in the phrase, ". . . we understand that you (sc. Louis) are building a chapel in the courtyard of your palace, at your own expense, the workmanship surpassing the material . . ."[6] The last words paraphrased Ovid's *Metamorphoses,* II, 5, a passage describing Vulcan's brilliantly worked metal doors for the palace of Apollo and giving the highest praise to the craft of goldsmithery by comparing it to the already out-

3. W. Berges, *Die Fürstenspiegel des hohen und späten Mittelalters* (Schriften des Reichsinstituts für ältere deutsche Geschichtskunde, Monumenta Germaniae Historica, 2), Leipzig, 1938, p. 78.

4. Jean de Garlande, *De Triumphis ecclesiae,* ed. Wright, London, 1856, p. 22.

5. Grodecki (1962, p. 61) nearly made this point when he suggested that the spandrel angels were not inspired by English examples (which were the source for such sculpted spandrels as those in the triforium of Nevers Cathedral, for instance), but by miniatures or reliquaries. Statues inside Gothic churches are not unknown, especially in western France (see L. Schreiner, *Die frühgotische Plastik Südwestfrankreichs,* Cologne, 1963), but they are rare. The Camera Santa at Oviedo has statue-columns inside it, as M. Grodecki remarks; so does the apse of Uncastillo (Saragossa; see A. de Egry, "Leo de Garius me fecit, 1179", *Art News,* LXII, 1964, pp. 34–37, 65), while the choir of Montierender had bas-reliefs (P. Arnoult, "Les statues mutilées de l'église de Montier-en-Der", *Gazette des beaux-arts,* ser. 6, XIX, 1938, pp. 1–12). On the painting, see E. E. Viollet-le-Duc, *Dictionnaire,* vol. 7, p. 93, and W. R. Lethaby, "Medieval Paintings at Westminster", *Proceedings, British Academy,* XIII, 1927, 123–151, esp. 128–132.

6. "Cum igitur, sicut ex parte tua fuit propositum coram nobis, capellam Parisius infra septa domus regiae opere superante materiam, ut ibidem praedicta corona sanctissima ac aliae pretiosae quas de ligno crucis et aliis sacris habere dignosceris, sub veneranda custodia conserventur, tuis sumptibus duxeris construendam . . .", Morand, *loc. cit.*

standing materials of the work. The phrase was frequently quoted with
this meaning in the Middle Ages, by Suger and Matthew Paris among
others,[7] but never before had it been used in reference to architecture. The
implication is indisputable: the Ste Chapelle was like a piece of gold-
smith's work, made of precious materials but worked to an even higher
degree of perfection by the artist, like a shrine which is precious not only
by its material nature but also by its craft and its calling.

The relationship between architecture and metalwork forms one of the
keynotes of the Court Style. The association of the two media was old if
not constant in all periods of western art – parts of Nero's Golden House
in Rome were covered with gold and adorned with gems and pearls and
from late Roman times on, vaults and ceilings were often gilded.[8] In
France, King Dagobert is reported to have covered the sanctuary of St
Denis with plaques of silver,[9] and the "Sainte Chapelle" of the Bucoleion
Palace in Byzantium, whence the Cross and the Crown were taken, was
described by Robert de Clari as having silver fixtures instead of iron
ones, and columns of jasper, porphyry and precious stones.[10] Merovingian
buildings often submitted to the "primacy" of metal techniques,[11] and
architectural copies of goldsmithery were made sporadically throughout
the centuries, for instance the façade of Angoulême Cathedral,[12] the tran-
sept porches at Chartres or even the triforium at Amiens and the dado
arcade at St Denis. The Ste Chapelle was another statement in the same
spirit, although more precisely based upon the forms of a reliquary than
the earlier buildings. Its imitation of metalwork, however, lay less in the
handling of the stone itself than in the creation of the effect of a shrine
through the addition of statues, gold paint and glass grounds. But it was
made at precisely the right moment to have a maximum impact upon

7. E.g. E. Panofsky, *Abbot Suger*, Princeton, 1946, p. 62; E. Lehmann-Brockhaus, *Lateinische Schriftquellen zur Kunst in England, Wales und Schottland*, Munich, 1955 ff., nos. 2714, 3867 and 6191.

8. See A. Boëthius, *The Golden House of Nero*, Ann Arbor, 1960.

9. S. McK. Crosby, *The Abbey of St Denis*, vol. 1, New Haven, 1942, p. 72.

10. Robert de Clari, *La conquête de Constantinople*, ed. Lauer, Paris, 1924, pp. 81–82.

11. L. Bréhier, *L'art en France des invasions barbares à l'époque romane*, Paris, 1930, p. 71.

12. Ch. Daras, "Les façades des églises romanes ornées d'arcatures en Charente", *Bulletin monumental*, CXIX, 1961, p. 123.

architecture and the other arts, both conceptually and stylistically. The
style was in fact ready for the development of small-scale, highly worked
designs, as is shown by the appearance at that time of miniature Gothic
architecture in chantry chapels, in manuscript illumination and in gold-
work itself; tombstones had already adopted decorated architectural
forms.[13] In monumental architecture of the 1240s, Parisian masters such as
Pierre de Montreuil and Jean de Chelles consciously carried the idea much
further, refining the effects of their masonry until it came to resemble the
wrought surface of a golden shrine. This metallic, precious quality was to
become a fundamental part of the Court Style of Gothic architecture.

The general form of the Ste Chapelle is not unusual.[14] Private chapels
of several bays and an apse were widely favoured in the twelfth and
thirteenth centuries, especially in France, and chapels of two stories, one
at ground level and the other at the *premier étage*, were nearly as popular.
A fine example has survived from the archbishop's palace at Reims, but
others were to be found in such places as the bishops' residences at
Auxerre and Beauvais, not to mention Bishop Maurice de Sully's chapel
in Paris itself.[15] To the north of the apse of the Ste Chapelle lay the
Treasury, where the relics were originally kept, a miniature replica of the
chapel with two inner stories and three rows of windows (Pl. 71).[16]

The Ste Chapelle differed from earlier chapels primarily by its large
size. In plan each story is essentially the same (Pl. 62). There is a porch, a
nave of four bays and an apse. The upper chapel forms a single, whole
space, but the lower chapel is divided by rows of columns (Pl. 75). The

13. The Ste Geneviève reliquary, finished in 1242, recalled earlier Meuse Valley work (see the
views in J. Millin, *Antiquités nationales*, vol. 5, and A. Marty, *L'histoire de Notre-Dame de Paris*, Paris,
1907, no. 18). By the late 1250s, however, frank imitations of contemporary church architecture
were being made in and around Paris, e.g. the Saint Taurin reliquary of Evreux, ready in 1255, or
the Saint Lucien reliquary formerly at Beauvais, ready in 1261 (see P. Louvet, *Histoire et antiquités
du païs de Beauvaisis*, Beauvais, vol. 1, 1631, pp. 415–416).

14. Most recently, see I. Hacker-Sück, "La Sainte-Chapelle de Paris et les chapelles palatines du
moyen âge en France", *Cahiers archéologiques*, XIII, 1962, pp. 217–257.

15. For Beauvais, see Louvet, *Histoire* (1631), p. 47; for Auxerre, J. Lebeuf, *Mémorial concernant
l'histoire civile et ecclésiastique d'Auxerre . . .*, ed. Quantin-Challe, vol. 1, Auxerre, 1848, p. 429.

16. H.-F. Delaborde, "Les bâtiments successivement occupés par le trésor des chartes", *Mémoires,
Société de l'histoire de Paris*, XXIX, 1902, pp. 159–172; *idem,* "Etude sur la constitution du trésor des
chartes . . .", *Layettes du trésor des chartes,* vol. 5, Paris, 1909, pp. xxii–xxvii.

subdivision was necessary in the latter because it was not tall and had the special function of providing a platform for the upper story. If a single vault had been used – one considered stable by mid-thirteenth-century standards – it would have had to rest on the very pavement at the edge of the chapel and its curve would have made the story into a basement or dungeon. By introducing narrow "aisles", the architect was able to employ a smaller vault, while at the same time providing a stable, low platform for the chapel above. He also gave the lower story the familiar look of a three-aisled church and was even able to introduce a suggestion of flying buttresses in the tiny arches that strengthen the haunches of the central vaults.

Nothing is so impressive in the Ste Chapelle as the enormous expanse of window in the upper chapel, extending from slightly above the pavement to the peak of the vaults (Pl. 63). The effect of openness and lightness is of course calculated, for the buttresses contain enough masonry to stabilize vaults much higher than these, but it cannot be seen from the interior of the chapel, and the iron chain that runs through the windows to tie the piers together is made to look like another one of the rods to which the stained-glass is fixed.[17] Thus the illusion of a cage of glass is heightened and the chapel attains a dignity and monumentality comparable to its exceptional programme.

One of the outstanding features of the chapel is its extremely rich decoration. Each regular bay of the dado in the upper chapel contains three arches framing a motif in blind but strongly projecting tracery. The arches are edged with crockets, the spandrels are sculpted and a distinct cornice separates the dado from the windows above. The capitals are skilfully carved to represent innumerable kinds of flora, as if the artists "wanted to assemble in this holy spot as many leaves, fruit, flowers, birds and beasts as they could, to glorify God and thank Him for all the marvels of nature".[18] In addition to the monumental sculpture, the whole of

17. E. E. Viollet-le-Duc, *Dictionnaire*, vol. 2, p. 401.
18. Cited by Grodecki (1962), p. 60, probably from D. Jalabert, *La Sainte-Chapelle*, Paris, 1947 (unavailable to me).

the work is distinctly in a decorated mode, even to the slab of stone that probably served as the front of the altar-table in the lower chapel (Pl. 74). The pattern recalls the ones in the dado, in the balustrade of the western wall and in the upper windows of the Treasury, but it is sufficiently different to confirm the idea of a conscious search for variety of design.

The Architect and the Date

There is an old tradition that the architect of the Ste Chapelle was Pierre de Montreuil. This is natural enough when we realize that in the late sixteenth and seventeenth centuries, when history in the modern sense was first being written in France, only three Parisian architects were known by name from the time of Louis IX and all were memorialized by that most prepossessing of evidence, a stone inscription.[19] Jean de Chelles' name was engraved on the south transept of Notre Dame; Eudes de Montreuil's tombstone lay in the cloister of the Franciscans before the fire of 1580 and was described by Thévet in 1584; and Pierre de Montreuil's tomb was in the chapel he had built at St Germain des Prés, which was by then the headquarters of the leading historians of France in the Benedictine Congrégation de St Maur.[20] It was only normal for these monks to wonder whether "their" man might not also have constructed the famous chapel of Saint Louis in the Palais de la Cité, and in the absence of any documentary proof to the contrary the attribution has come to be regarded almost as fact.[21]

If it is difficult for me to attribute St Denis to Pierre de Montreuil, however, I find it well nigh impossible to credit him with the Ste Chapelle. He did take over a few features of the palatine chapel for his work at St Germain des Prés, such as the row of crockets following the curve of

19. Pierre de Monsiaux (Mousseaux?), Master of the Works of the City of Paris in 1257, and Guillaume de St Pathos are not known from inscriptions.

20. For Eudes, see A. Thévet, *Les vrais portraits et vies des hommes illustres . . .*, Paris, 1584, ff. 503–504; for Pierre, see H. Verlet, "Les bâtiments monastiques de l'abbaye de Saint-Germain des Prés", *Paris et l'Ile-de-France*, IX, 1957–1958, pp. 9–68, esp. p. 20. Hébert, *Dictionnaire pittoresque et historique,* Paris, 1766, vol. 2, pp. 181, 185 and 191, is a good illustration of the inclusion of all three names.

21. Cf. Grodecki (1962), pp. 64, 66: ". . . dans l'état actuel des connaissances il nous est interdit de conclure et de retrancher la Sainte-Chapelle de l'oeuvre de Pierre de Montreuil".

the dado arcades, and it is likely that the size of the Virgin chapel reflected
the spaciousness of the king's building. But beyond general similarities
that are to be expected of two chapels constructed within a few years of
one another in the same city – the earlier of which was the most prestigious
building of the entire century – the manner of composition in each monu-
ment is distinct and opposed. Pierre de Montreuil's design is characterized
by the clear and strong linkage of dado and windows. This feature was
categorically rejected in the Ste Chapelle, where the horizontal division
between the stories is accentuated by a heavy cornice and *glacis* and where
there are four lancets in the wide windows but only three arches in the
dado, so that beyond the apse bays the eye cannot even glide from one
story to the other.

There is good reason to think that whoever built the Ste Chapelle came
from the north of France. One of the tell-tale signs is the presence of
gables over the windows, a feature of Cambrai Cathedral and then of
Tournai, the latter contemporary with Louis' chapel (Pls. 18, 20, 64).[22]
There are a number of other features that relate the building to Amiens,
so many, in fact, that I have little hesitation in advancing Thomas de
Cormont, the successor of Robert de Luzarches at Amiens, as the archi-
tect of the royal chapel.

The argument is not new but it is telling, all the same.[23] It rests on the
strong similarity between certain parts of Amiens, particularly the radiat-
ing chapels, and the design of the Ste Chapelle. The windows at Amiens,
for example, are all but identical with those in the apse bays at Paris: two
tall lancets surmounted by three trilobes piled up to fill the summit of the
arch (Pls. 64, 67, 68). Even the arches are similar, although those at Paris
are somewhat hidden by the gable. Another set of parallels can be found
in the lower chapel. The pattern of the dado, for instance, is the same as
the one at Amiens, even to the presence of trefoils in the arches and tiny
trilobes in the spandrels (Pls. 65, 66). At Paris, the latter have been a bit

22. J. Bony in the Charles T. Mathews Lectures, New York, 1961.
23. Cf. G. Durand, *Monographie de l'église Notre-Dame, cathédrale d'Amiens*, Amiens-Paris, vol. 1,
1900, pp. 34 and 274–275. See also Appendix A.

expanded and moulded, but that is to be expected of a second, revised version of a design. And the short, broad window formed by a triangle with curved sides could only derive from the famous windows at the ends of the aisles of Amiens (Pl. 70).[24] The latter were designed with the particular purpose of lighting otherwise dark portions of the building and of echoing harmoniously the curves of the tympana below. The forms are handled differently at the Ste Chapelle, to be sure, and the proportions are not the same. The little glazed trefoils that take up the space between the straight ledge and the curve were probably copied from the thirteenth-century tribune windows in the nave of Notre Dame. But the derivation from Amiens, even if from an older part of the monument, is indisputable. The mouldings of the Ste Chapelle also resemble closely those in the chapels at Amiens, including the rib profiles and the heavy, pointed imposts. And lastly, both the Amiens chapels and the king's chapel preserve the integrity of the individual stories.

Naturally not all the details of the chapel derive from the cathedral. Many of them come from Paris itself, as for instance the great four-lancet windows, which were based upon the tracery of the chapels added to the nave of Notre Dame (Pl. 32; the present gables were an invention of Viollet-le-Duc). The smaller four-lancet pattern in the central story of the Treasury, with trilobes in the arches, probably had the same source (Pl. 71).[25] And the terminal wall of Saint Louis' building, including the decoration of all four spandrels around the rose and the gable closing the roof, was based upon the north transept of St Denis (Pls. 48, 62c). The three large, blind arches on the inner wall were also taken from St Denis. But these features only serve to reinforce the connection with Amiens, for as I pointed out earlier, the traditions of design in the Picard cathedral were closely bound up with Paris and any architect returning to the capital could be expected to look with sympathy on local forms. Thus the pattern of the trefoil arches and quadrilobes of the dado in the upper

24. P. Frankl (*Gothic architecture*, Harmondsworth, 1962, p. 103) thought they originated in the king's chapel.
25. In the first and second chapels at Notre Dame, the trilobes are inserted into oculi.

chapel was current in Paris in the late 1220s and was probably the source for the blind arcading in the transept terminals of about 1233 at Amiens (Pl. 19).

The importance of the king's work makes it seem unlikely that the architect of the Ste Chapelle would have been only a foreman at Amiens. The chief architect himself probably left, turning over the work to a younger, less experienced man, a description that fits Thomas de Cormont and his son, Regnault, in all essentials. The *chantier* of the Ste Chapelle must have been fairly large, and a number of the masons seem later to have taken other work in the area of Paris or gone off to distant places from there. This suggests that the master of Amiens may have brought some of his assistants with him when he came to Paris, perhaps in the same way that Robert de Luzarches once took sculptors with him from Paris to Amiens. It is in fact very likely that at least some of the Ste Chapelle sculptors came with Thomas de Cormont from the Picard cathedral.

In view of its far-reaching consequences, the precise date of the royal chapel assumes considerable importance. Strangely enough, however, even after several centuries of historical studies devoted to the building, there is still no general agreement as to when this best-known of Gothic chapels was designed. The Crown of Thorns arrived in Paris in August 1239, and a second shipment of relics, including the fragment of the True Cross, in September 1241. The project could scarcely have been conceived before the first of these dates, before the most important relic was in hand. And if it was conceived after 1239, there is every likelihood that the execution was deferred pending the arrival of the second relics. But there is no reason to assume that construction was put off much beyond 1241, the date generally accepted by older authors for the start of the work.[26] In

26. F. Gebelin interpreted the 1244 (for him, 1243) bull as indicating that the chapel had not yet been begun, but he confused a future perfect tense with a perfect subjunctive (*cum . . . duxeris,* in note 6 above), which has no absolute time value (*La Sainte-Chapelle et la Conciergerie,* 3rd ed., Paris, 1943, pp. 8–9). Grodecki (1962, pp. 12, 14) repeated the errors of date as well as interpretation. M. Félibien, *Histoire de Paris,* vol. 1, p. 297, and J. Filleau de la Chaise, *Histoire de Saint Louis,* Paris, 1688, vol. 1, p. 310, placed the début of work in 1241–1242; Jaillot, *Recherches,* vol. 1, 1783, pp. 10–11, arrived at the same conclusion. Even M. Aubert, *Monographie de l'église de Senlis,* Senlis, 1910, pp. 89–90, dated it about 1240 on stylistic grounds.

the following years Louis was on campaign against Henry III in Poitou and it is difficult to place the beginning of the work as late as 1244, when he vowed to lead a crusade to Jerusalem. The first mention of the actual building comes in the papal bull of 1244, granting permission for the founding of a college of canons. Then, in January 1246, the organization was formally created and guardians were appointed for the building. This date seems to mark the completion of the body of the monument.[27] In 1248 the statutes of the college were revised and its income enlarged, and the chapel was dedicated on 26 April, at which time it was certainly complete in all its details.

Other Royal Workshops in the 1240s

The about-face in royal patronage marked by the Ste Chapelle was reflected at once in two other royal projects of the same time, one a cathedral and the other a priory.[28] These are in fact the only other royal churches from the 1240s. At Tours, work on the cathedral continued apace. The upper stories seem to have been undertaken before the king left for Jerusalem, and it is in these parts that the intervention of the Ste Chapelle can be seen (Pl. 36).[29] The window tracery was clearly based upon the patterns of the royal chapel. The broad windows of the choir literally copy those in the chapel in Paris and the hemicycle window is a variant of the one in the chapel apse, with a triplet in place of the doublet. The enlargement was probably due to the width of the hemicycle bays that had been established when the piers were implanted in the 1230s, but the three trilobes at the top are an unequivocal evocation of Thomas de Cormont's design. And the choir triforium is a modernized version of the chapel dado.

27. Other cases where the appointment of guardians seems related to the termination of construction are Amiens (Durand, *Amiens,* vol. 1, p. 29) and Auxerre (R. Branner, *Burgundian Gothic Architecture,* London, 1960, p. 107).

28. A chapel dedicated to Saint Martin was ordered by Louis at Vincennes on the eve of his departure for the Crusade in 1248, but it is uncertain whether it was constructed or not (Félibien, *Histoire de Paris,* vol. 1, p. 320).

29. See H. Boissonnot, *Histoire et description de la cathédrale de Tours,* Paris, 1920, p. 72. F. Salet (*La cathédrale de Tours,* Paris, 1949) seems to distribute the parts unevenly before and after the Crusade, leaving a great amount to be done between 1254 and c. 1260. A slightly earlier date is archaeologically also acceptable.

The early affiliation of Tours with Royaumont can still be felt in the ample, two-part triforium and in the absence of linkage with the clerestory. The choir triforium recalls not only Royaumont but also Gonesse and may even be a distant reflection of the story first planned for St Denis in the campaign of 1231, before the arrival of the St Denis Master. It is a broad, slow design that fails to predict the more rapid movement of the windows above, despite the same number of units in each story. Obviously the Ste Chapelle, with its own emphasis on the integrity of the stories, offered no incentive to change the relationship between the triforium and clerestory. Moreover the structure of the upper parts of Tours is surprisingly retrogressive, for there is no exterior passage, but there is a heavy drip wall and cornice, both signs of excessive caution more than two decades after Amiens. In brief, the Royaumont inheritance lies heavy upon Tours. The large panels of wall in the triforium detract from the effect of the thin, delicate design and the contribution of the carefully planned triforium screens is somewhat negated by the isolation of one story from the other. The early purism of Tours apparently could not be forgotten.

The other royal work of the 1240s is in some ways even more interesting. It is the choir of Nogent les Vierges, a priory of Benedictine Fécamp lying on the Oise River not far from Royaumont (Pl. 72). In 1241 Saint Louis was there for an exhibition of the relics of Saints Brigid and Maura, a ceremony obviously intended to open a campaign for building funds.[30] The king seems to have been so moved by the sight of the bones that he undertook to rebuild the choir of the church for the prior, probably sending a mason out from Paris for the job in 1242 or 1243. This man knew the Ste Chapelle – at least as much of it as had been erected before he left Paris – but he was not one of the Amiénois masters there. He was a local man, as is proven by such details as the plan of the imposts and the panels of wall and deep frames around the windows,

30. Abbé Delettre, *Histoire du diocèse de Beauvais* . . ., vol. 2, Beauvais, 1842, p. 296; cf. A. Mäkelt, *Mittelalterliche Landkirchen aus dem Entstehungsgebiete der Gotik* (Beiträge zur Bauwissenschaft, 7), Berlin, 1906, pp. 56–58, and Butler, *Lives of the Saints*, ed. Thurston and Attwater, New York, 1956, vol. 3, p. 88.

which he took from Royaumont. He had clearly been directed to create something seemly but not too expensive, for the imposts are not moulded and there are no wall-ribs in the work. But even though it does not stand comparison with the Ste Chapelle or with Tours, it is a country cousin of both. The window pattern is a triplet below three lobed forms in the same spirit as Tours and like it related to the king's chapel. The entire effect of richness is concentrated in these windows, which act like sparkling gems as they transmit light to the otherwise plain interior. Partly for this reason and partly because it is a spacious, light pavilion housing the sanctuary, the chevet of Nogent is a success despite its lack of "finish".

Paris in the 1240s

Trends in architecture in Paris outside the royal shops were varied in the 1240s, but they reveal a gradual coagulation, a tendency to move in the same direction and to fuse into a style. The affiliations with Amiens became more pronounced at this time, undoubtedly because of the appointment of an Amiénois master to design the Ste Chapelle. But it is impossible to say whether the influence was carried by the masons this man brought with him to work on the chapel – masons who may have taken other jobs on the side – or whether it was due to renewed direct contact with the Picard cathedral – to be quite specific, to Parisian masons who travelled to Amiens to study the building. If the neo-classical balance of the St Denis Master was replaced by the tenser, more highly decorated style of Robert de Luzarches and his followers, however, this does not mean that older buildings such as Royaumont and St Denis ceased to play recognizable roles. On the contrary, the Court Style was to a very large extent based upon the designs and partis created in the 1230s, and the process of imitation became quite developed in the following decade. What changed was the *tone* of design. Elegance was now placed on a more equal footing with monumentality. Although not fully achieved until the 1250s, the aim set forth at the time of the Ste Chapelle was an overall surface pattern of fine effects, with a distinct emphasis on the interrelation of the parts. Linearism came to dominate Parisian design,

and certain kinds of verticality were stressed. The role of colour in architecture was also revised at this time.

There were three trends in the 1240s in Paris outside the *chantier* of the Ste Chapelle, each clearly distinguishable by the sets of forms that were used. One is represented by Pierre de Montreuil and the anonymous master of the last three chapels added to the north side of the nave of Notre Dame; the second by the master of the narthex of the Temple and his colleagues; and the third by Jean de Chelles' north transept at the cathedral. In some cases these were reflected in outlying areas as far as Meaux.

Pierre de Montreuil's attested early works already reveal a marked degree of virtuosity. The Virgin chapel at St Germain des Prés was a large, single space measuring 32·50 by 9·50 by 15·30 metres tall, very nearly the size of the Ste Chapelle. His refectory of 1239, at St Germain, was also a single space no less than 10·40 metres wide by 15·50 metres tall.[31] It broke with traditional design, represented by the refectory of St Martin des Champs about 1235 (Pl. 86), by eschewing the row of supports down the centre. Thus the Ste Chapelle was not the first enlargement of the small, "subsidiary" building to large proportions in Paris. Pierre de Montreuil's tall, vast volumes enclosed by thin shells in fact mask a resurgence of the Parisian manner of the twelfth century, of the desire to build big and light that can be found in the first work at Notre Dame and even in Suger's St Denis.

The refectory of St Germain was an elaborately finished building. It had windows filled with stained-glass representing such themes as the life and martyrdom of Saint Vincent; the corbels and the lector's niche were finely carved, and a statue adorned the trumeau of the portal to the cloister.[32] It is interesting to note that the architect used bar tracery in all the windows, although for those in the side walls he retained the twin-lancet-and-oculus pattern (Pl. 77). This form, usually in plate tracery,

31 See Verlet, "Bâtiments" (1957–1958).

32. See P. Verdier, "The Window of Saint Vincent . . .", *Journal, Walters Art Gallery*, XXV–XXVI, 1962–1963, pp. 39–99. Verdier states that the refectory "was the first work of Pierre de Montreuil" (p. 66).

was the exclusive one in refectories and monastic halls throughout the thirteenth century, from Chelles, St Denis (Pl. 100) and St Martin des Champs through Ourscamp and beyond, even when the arrangement of the stonework had become a *tour de force*. At St Germain, the window above the niche, which probably protruded slightly on the outside of the building, was surmounted by a crocketed gable (Pl. 83), and the buttresses seem to have been garnished by colonnettes at the corners.[33]

Like the three easternmost chapels of the nave of Notre Dame, the Virgin chapel at St Germain des Prés was characterized by the strong vertical accent of shafts that rose from the pavement into the window tracery (Pls. 73, 76). Both works were begun about 1245 – the date is certain for the Virgin chapel – and both were indebted for this feature to the south transept of St Denis, as noted in the last chapter. The "bay" of the Virgin chapel that has been reassembled in the garden of St Germain is misleading, for it is composed entirely of minor mullions probably coming from the apse, whereas other fragments prove that these alternated with heavier mullions placed in the centre of the four-lancet windows in the straight bays, as at St Denis or in the chapels at Notre Dame (Pl. 79). Pierre de Montreuil did not use this feature in his refectory, but there the dado was plain (Pl. 78). In the Virgin chapel, however, the dado was highly decorated with lobed arches edged with fine crockets, the whole detached two to three inches from the wall to form a screen.

The Virgin chapel is said to have had a rose window like the one in the Ste Chapelle and the gable was pierced with a large circular motif and was flanked by two elaborate spires, also like the king's chapel.[34] But the buttresses were not capped by pinnacles and there were no gables above the windows (Pl. 82). The chapels at Notre Dame were closer to the

33. The buttress form is indicated by the gargoyles now in the garden of St Germain, which could not have come from the Virgin chapel. Corner colonnettes were frequent at the time; cf. Amiens (façade), Tours (chapels), or the Temple narthex. But their combination with a single gargoyle was perhaps paralleled only in one bay (the pulpit bay?) of the former Jacobin church in Paris (Y. Christ, *Eglises de Paris actuelles et disparues*, Paris, 1947, pl. 41 a).

34. Verlet, "Bâtiments" (1957–1958), p. 24. See also the Dagoty rendering in R.-A. Weigert, "Plans et vues de Saint-Germain des Prés", *Paris et l'Ile-de-France*, IX, 1957–1958, pp. 105–137, no. 128 and pl. xvi.

royal work in both ways, for the buttresses seem to have had some sort of decoration below the cornice level, perhaps not unlike the present one, and the windows were originally surmounted by deep gables that terminated where the gargoyles are now located (Pls. 84, 87).[35]

The window tracery of the two works is more difficult to compare because the major source for the Virgin chapel is the engraving of 1687 in the *Monasticon Gallicanum*, which is scarcely a model of precision (Pl. 82). But Pierre de Montreuil's windows were not as tall as those in the Ste Chapelle and their proportions seem to have been even squatter than those in the Cathedral chapels. The apse bays had two lancets beneath an oculus,

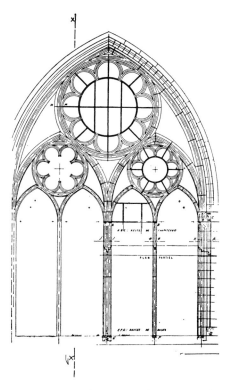

Fig. 7. Paris, St Germain des Prés, refectory window (Minost).

35. The other nave chapels had pedimental gables. In the eighteenth century, these were restored and the deep gables over the three eastern chapels on the north were altered to conform to the shape of the others. Viollet-le-Duc, restoring the south chapels, did exactly the reverse, placing deep gables where none had been before.

once again unlike the royal chapel. The window from the west wall of the refectory, with its large oculus at the top and much smaller ones below (Fig. 7), may give us a fairly good idea of Pierre de Montreuil's large chapel windows, and it is also very close to the tracery in the chapels of Notre Dame (Pl. 87). The master of the Virgin chapel again revealed his preoccupation with fine scale and subtle effects by the plan and size of the mullions and the large number of lobes within the oculi, and the fragments now in the garden of St Germain support this assessment of his style. The master of the nave chapels had a similar aim, for he designed socles and imposts with many slight gradations of plane and he placed arrises on the shafts and arcades at the entrance to his chapels. Both men were touched only incidentally by the Ste Chapelle and not at all by Amiens, but the tone of their work was new and looked forward to the following decade.

It was also at this time that a new movement in the coloration of architecture seems to have had its origin. As with all earlier thirteenth-century churches, the windows of the Ste Chapelle are filled with stained-glass in which the dominant colours are deep reds and rich blues. But in the Virgin chapel only the apse windows were glazed in this manner, the remainder of the openings containing grisaille glass, perhaps accented by bits of colour here and there.[36] The effect was probably similar to the one still produced at St Germer (Pl. 106): the dark hues of the apse lend it a certain air of mystery, but the grisaille in the other bays lets in a cold, nacreous light that strikes the fine surface effects with some force and brings them out fully. The deep colours of the Ste Chapelle glass would have rendered much of the detail in the Virgin chapel difficult to see. The new emphasis on grisaille which, as Lafond pointed out, probably originated in Paris around the mid-century, may therefore have been a response to the new aims of the architecture. Both were to be even more closely co-ordinated in subsequent decades.

36. J. Lafond, "Le vitrail en Normandie de 1250 à 1300", *Bulletin monumental*, CXI, 1953, pp. 317–358, esp. p. 322; P. Verdier, "The Window of Saint Vincent", p. 91. I fail to understand Verdier's interpretation of Le Vieil's description of the chapel glass to mean the three *axial* windows were also in grisaille (pp. 92–93).

The Temple and the Treasury

The narthex of the church of the Knights Templar was probably built before the Ste Chapelle, but it embodied a theme that was to characterize another aspect of Parisian architecture in the 1240s. The Temple was one of the major centres of administrative and court life.[37] It was there that the king kept his fisc and also entertained foreign dignitaries such as Henry III and his suite during a stay in Paris. When the prior of the Temple undertook to enlarge the church, it was therefore an event of some consequence in the architectural world of Paris. The work consisted of the addition of an open porch and an enclosed upper story to the west of the twelfth-century rotunda (Pl. 81).[38] The porch contained light, unglazed tracery resting directly on the ground, and above there were huge, four-lancet windows starting at the upper pavement level. The buttresses, which are plain below and ornamented with corner colonnettes above the springers, are nearly identical with those in the radiating chapels of Tours. But it is the windows that are striking, for barring a difference in the lobing of the oculus, the pattern is the same as the one used in the first and second chapels on the south side of the nave of Notre Dame (Pl. 31). Each pair of lancets is surmounted by a trilobe, and a modest oculus rides in the summit of the opening. The trilobe group may have originated in the triforium of Royaumont – we will shortly see it in the same position in several other buildings – and like the window of the fifth southern chapel of the cathedral nave, the pattern was to enjoy a considerable vogue in the years to come.

The first and perhaps the most significant copy was in Regnault de Cormont's very first design at Amiens, the windows in the western wall of the transept (Pl. 88). At that time Regnault was at the start of his long career and he had not as yet begun to experiment in the ways that are to be seen in the later eastern walls of the transept or in the choir. He was

37. H. de Curzon, *La maison du Temple de Paris, histoire et description*, Paris, 1888.
38. The arrangement was therefore something like the one in the Templar church at Laon (E. Lambert, "L'architecture des Templiers", *Bulletin monumental*, CXII, 1954, pp. 7–60 and 129–165, esp. p. 55).

still working within the well-defined limits concerning the integrity of the stories that had been set up by Robert de Luzarches and continued by his father, Thomas. The extent of Regnault's independence can be seen in the adjacent bay, where the same number of units is used in each story. But the trilobe surmounting the triplet, while it belongs to the same family as the doublet, has a history of its own. It was one of the original patterns at Amiens, appearing in the triforium, but it had never been used there as a window or in bar tracery before 1242–1243. We have arleady seen it at Cambronne half a decade before (Pl. 14), however, and it was at home in the Oise Valley, for example at Senlis and some other churches in the area.[39] It even appeared in Jean de Chelles' work on the north transept of Notre Dame. Its use by Regnault de Cormont was a bit like the need to reaffirm the Amiénois origin of the form. Indeed he made it the theme of his work over the next quarter-century at Amiens (Pl. 101).

Stemming directly from this milieu and mingling Amiénois and Parisian forms, was the priory of St Martin aux Bois, which was probably begun about 1245 (Pl. 89).[40] The lateral aisle windows (not shown in the illustration) are Dionysian and the mouldings, imposts and the form of the holes in the central story of the nave are from the Ste Chapelle. But the tall proportions and the handling of the forms are Amiénois.[41] The architect voided the walls completely, he employed an extremely thin structure and he made the mullions unbelievably tall. The responds in the apse are in fact hardly thicker than the central mullions in the clerestory of Amiens, and much finer than those in the Ste Chapelle. The apse is of course strengthened on the exterior, where there are deep buttresses and a reinforced dripwall above the windows. But the architect obviously was more interested in the effect inside the church, and this is nothing short of prodigious. The apse is an enormous grill, a taut, transomed cage with

39. E.g. Cramoisy.

40. J. Vergnet-Ruiz and J. Vanuxem, "L'église de l'abbaye de Saint-Martin aux Bois", *Bulletin monumental*, CIII, 1945, pp. 136–173, where a later date is suggested.

41. Very tall, narrow spaces were also made at Bury, Triel and the eastern bays of the aisles of Montataire, undoubtedly under the inspiration of Amiens.

mullions and responds alike obeying the same light, staccato beat. Here, one of the ideals of the *chantier* of Amiens found its full expression.

Perhaps the most distinctive examples of trilobe tracery in the 1240s were to be found in the Ste Chapelle Treasury (Pl. 71). Cast in the form of a chapel, this small building aped its larger sister's finials and gables, but the tracery followed different patterns. In the top story a trilobe rested on two trefoil arches, while below there was a four-lancet window like those in the Temple, but with trilobes throughout. It would seem as if here Thomas de Cormont created a less formal, less monumental design, in which he gave an even greater place to Parisian forms than he did in the chapel proper. In both works, however, the extent of his inventiveness and his borrowing is amply apparent.

Just how pervasive yet varied a single family of tracery patterns could become can be seen in two closely related monuments, St Sulpice de Favières and the cathedral of Meaux. St Sulpice, a parish made famous by a pilgrimage in the early thirteenth century, had been attached to the Royal Domain about 1240, and a new church was undertaken a few years later, shortly after 1245 (Pl. 90).[42] The plan is an extremely simple one, containing a nave of six bays ending in a polygonal apse and aisles without chapels. The elevation has three stories, with a triforium passage and another passage running around the exterior of the clerestory. The St Sulpice Master was familiar with the Ste Chapelle, for he copied the dado of the lower chapel and used simplified versions of the upper chapel windows in his aisles. He also knew the work of the St Denis Master – the chapel at St Germain en Laye as well as the abbey – for he used a Rémois passage that is both vaulted and covered by slabs (the latter in the apse). He included perhaps the most characteristic feature of St Germain, the pierced spandrel, in both walls of the triforium and in the windows of the ground story of the apse. His piers are the most recent type designed by the St Denis Master, with three shafts rising to the vaults, and he understood the function of this design, for he made

42. Y. Sjöberg, "Saint-Sulpice de Favières", *Congrès archéologique*, CIII, 1944, pp. 246–264, where a slightly later date is advanced.

the volumes open widely into one another. The effect is enhanced by replacing the rectangular main arcades of the abbey with "pointed" ones that conceal the thickness of the wall, a detail that was becoming popular in the early 1240s through Amiens and the Ste Chapelle. It is interesting to see the same wall-respond used in the apse as in the nave, for this gives unity to the effects even though extra shafts had to be added to support the wall-ribs in the nave, as we have seen at Tours. But the dominant pattern of the building is the doublet surmounted by a trilobe, by now a familiar motif to us, which is used in both upper stories of the church.

Strange as it seems, however, the triforium was modelled upon Royaumont and Amiens. If the linkage and the spandrel trilobes were to be removed, that story could be called a modernized version of the Cistercian abbey. The story is also rather tall with reference to the clerestory, recalling the Parisian elevations of the 1220s, and thanks to its proportions and to the ornamented spandrels, it also seems wide. The slowness of St Sulpice is augmented by the strong horizontals and by the use of the St Denis Master's arch-in-square motif. The limited linkage, however – only three out of five clerestory mullions passing through the string-course into the triforium – is like Robert de Luzarches' elevation at Amiens, and we shall see this particular form of it being repeated in Paris in the later 1250s. Thus St Sulpice is a résumé of older motifs and details from the capital, brought up to date and subsumed by an original and inventive mind. If it was not built by a royal workshop, the pilgrimage church nonetheless reflects one important trend in court taste in the mid-1240s.

The cathedral of Meaux represents the same trend nearly a decade later, but by that time it was sorely out of date (Pl. 91). The late twelfth-century chevet was remodelled by Master Gautier de Varinfroy, who had been working at Evreux and who was hired by the bishop of Meaux in 1253.[43] The plan and elevation of four stories were left over from the old work, and the tribunes were merely suppressed – completely in the hemi-

43. V. Mortet and P. Deschamps, *Recueil de textes*, Paris, 1929, pp. 283–284.

cycle but only partially in the choir. The result is striking, since it lays bare for us the process of design even more clearly than St Sulpice. In addition to the features just mentioned in the pilgrimage church, the hemicycle piers at Meaux were taken from the hemicycle of St Denis and the choir piers (just visible above the stalls in the illustration) from St Leu d'Esserent; the tribune arcade and the clerestory above were copied from the two stories of tracery in the Temple narthex and were used in the same respective order, while the triforium in the hemicycle was taken literally from the Treasury. Even discounting the harsh restoration of the present century, the design of Meaux fails to come alive and one is left with an impression of a rather dry, archaeological combination. St Sulpice shows that the fault lay with the architect rather than with the method.

Jean de Chelles

The third trend in Parisian design in the 1240s is represented by Jean de Chelles' façade at Notre Dame, which rises like an enormous, laminated plaque to close off the volume of the transept (Pl. 92). It is eclectic, like Meaux and St Sulpice, and like Pierre de Montreuil's work it is elegant and fine. Related to Amiens and the Ste Chapelle as well as to St Denis and St Nicaise at Reims, it subsumes these sources into a coherent design.

There is no documentary evidence to relate Jean de Chelles to the north side of Notre Dame, but an inscription close to the ground on the south transept façade states that he laid the foundations for that work in February 1258.[44] Since the north transept is earlier than the south, it has reasonably been assumed that this architect designed and executed the north façade, then began the south one and died shortly thereafter, his name being commemorated on a part of the work that was carried out by his successor. And since the details of the façade are quite close to those of the adjacent nave chapels, which were erected about 1245, it would seem as if Jean de Chelles' transept was begun about 1246-1247 and

44. M. Aubert, *Notre-Dame de Paris*, 2nd ed., Paris, 1929, p. 138.

carried out slowly over about a decade. The crusade was undoubtedly responsible for this delay.[45]

St Denis was the chief source for the new north façade at the cathedral. Both designs contain the same elements, some of them even handled in the same manner. The gable has a rosette in the centre, with six recessed circles containing pierced trilobes, and three heavily ornamented motifs in the corners. At either side is a polygonal aedicula with a short spire, capping the buttresses that outline the narrow rectangle down to the ground. Below is the great rose, set into a square, the spandrels ornamented or glazed. The rose at Notre Dame obeys the dictates of more recent design than St Denis, however, for one set of forms is expressed in prominent mouldings and extends the full length of the radius, while a second set is recessed and limited to the outer circle. Jean de Chelles preferred the multiple planes and hierarchic organization of the St Denis Master's later work to the simple, flat pattern of his north transept rose. Moreover Jean tied the buttresses more closely into the design, linking the *glacis* to the cornices and balustrades. Some of these changes may first have been made by Thomas de Cormont at the Ste Chapelle, for he undoubtedly also used St Denis as a basic pattern for his façade there. But the glazed triforium below the rose of the cathedral does not appear in the more modest façade of the chapel and is clearly Dionysian.

Neither St Denis nor the Ste Chapelle could provide a ground-story pattern that was usable at Notre Dame, however, and Jean de Chelles turned to the recent façade of St Nicaise at Reims for this part (Pl. 94). He took Hugh Libergier's series of gables and compressed them to fit into a single, broad bay, at the same time increasing their verticality. They decidedly lap over the balustrade and gallery above, and the contrast between oblique and horizontal is as marked as is the sliding of one

45. For a similar analysis of Notre Dame, see W. Gross, *Die abendländische Architektur um 1300*, Stuttgart, 1947, pp. 103, 106. There is every likelihood that the pattern of the tall, rectangular front rising from a low band of horizontals, which was taken from St Denis, had its ultimate origin in the twelfth-century transept façades of Notre Dame: there were no towers flanking the main vessel there, and it is very uncertain whether the transept tribune walls were embodied in the design, although they must have filled the angles of horizontal and vertical.

plane behind another. The oculus was pierced in the central gable to permit us to judge the nature of this effect more accurately. Moreover the architect underlined the oblique rise of the gables and their staggered height by contrasting them with strictly level pinnacles and with groups of three small but equal gables crowning niches next to the portal. And then, as if in fear of losing his main point, he re-emphasized the oblique at the edge of the design with a tall pinnacle affixed to the face of the buttress. All these parts lie in a plane in front of the façade wall, and the general flatness of the design is accidented by the use of the pointed buttress, the bases of pinnacles as well as of niches being turned 45°. The device is also used to conceal the slight projection of the terminal gables beyond the alignment of the portal. The effect is not one of depth, however, but of texture, of the play forward and back between two adjacent planes, of the thickness of the materials with which the façade is constructed. The niches, for instance, were revolutionary in the design of Gothic portals for they carried the sculpture into the wall – there could be no statue-columns here, but only statues – and at the same time they permitted the intervening colonnettes to descend to the plinth, linking both parts of the embrasure firmly to the archivolts. The reference to metalwork is unmistakable, for the whole ground story is construed like the plates of a heavy copper-gilt shrine, with chased panels and with edges of cusps, crockets and flowers. The fineness of these parts is appropriately placed close to the viewer, while the more monumental forms of the gallery and the rose tower above him.

The interior of the transept is also based upon St Denis (Pl. 93). Rose, glazed spandrels and gallery rise upon a story of solid wall that is decorated only by three tall but blind arches and pierced by a rather small doorway. The innovations of the Ste Chapelle, such as columns to support the arches and richly carved ornament in the spandrels, are absent, Jean de Chelles preferring the St Denis Master's strange and awkward design with large areas of unadorned wall flowing above and between the arches. Both of the solutions used at Amiens in the early 1230s were consistently rejected in Paris although one – the north transept, with two tall arches

placed at the extremities of the wall – was imitated at Troyes about 1241 and the other (Pl. 19) was a harmonious design covering the entire ground story. An all-over pattern was not to be proposed in Paris until some years later, in Pierre de Montreuil's south transept.

Jean de Chelles' faithfulness to the older Parisian tradition is all the more evident since it is obvious that he gave considerable attention to the decorative character of the transept terminal. The lateral arches, for instance, are closely related to the windows in the adjacent nave chapels as well as to those in the Ste Chapelle. The tracery is in the bar technique but here it is the masonry of the wall behind that has been adapted to the arches rather than the reverse. The outer arches are hemmed by delicate flowers on fine, curving stems (Pl. 95). But the central tympanum is more important, for there Jean de Chelles formulated a pattern that was to have a phenomenal success in later Gothic design. Above two cusped arches he placed a curved triangle filled with three tapered arches and three lobed roundels. A leaf-head occupies the centre and the lower arches hang from a horizontal bar that is actually the diameter of a circle.[46] The basic motif of three arches and three roundels was to inspire countless imitations during the remainder of the thirteenth and the fourteenth centuries.

The pattern of the triforium, while generally based upon St Denis, also contains significant variations (Pl. 59). The arches are edged with tiny leaves that join a similar cornice, taken, as was the same detail in Pierre de Montreuil's Virgin chapel, from the heavier dado of the Ste Chapelle. The tympana contain quadrilobes turned on their sides. Like the poly-lobed cusping of the rosettes in the ground story, the latter probably originated in the clerestory of Amiens. The trilobe and triplet that decorate the lateral walls of the transept at clerestory level have already been mentioned.

The three trends just outlined had many features in common. They all

46. One would expect the tapered arches to radiate from the centre to the points of the curved triangle at angles of 120° (cf. the top of Pl. 114). The arrangement, like many of the earliest tracery patterns, probably reveals a certain naïveté of approach to geometry.

made reference to metalwork in the handling of forms and of decorative details. More important, however, the change of scale announced at St Denis was carried further, the building becoming more accessible and intimate than ever. This was achieved through the co-ordination of surface effects over the entire monument and also, strange to say, through the unification of the volumes. By this I do not mean there was a re-hearsal of the vastnesses of Chartres, but rather that the spatial compart-ments, whatever their size, were opened and their limits less severely marked.[47] Internal divisions were minimized or suppressed, so that the spaces could coalesce more easily. And significantly enough, different kinds of buildings now tended to be designed at the same size, churches becoming smaller and chapels and ancillary buildings larger. There was also a change of scale in the parts, capitals, imposts and shafts growing smaller and finer. Both shifts may be summed up in the arcades of St Sulpice, where the tapered profile seems to thin the wall and merely to suggest a separation of the spaces, while arches of similar curve appear in all the bays and give the interior a striking unity of effect. This was to be the pattern of the future.

Le Mans

Throughout the works of the middle decades of the thirteenth century, window tracery was clearly ascendant in the process of design. Tracery fascinated men like Thomas de Cormont and Jean de Chelles, providing them with the most fertile field for endeavour and in return receiving their constant attention. Tracery has been given considerable attention here for that reason and also because it was still in the period of its youth and provides one of the surest ways of isolating hands and shops. Al-though not situated near the capital, the cathedral of Le Mans bears directly on this subject and merits a moment of consideration.[48]

47. Cf. Gross, p. 122.
48. Most recently, see F. Salet, "La cathédrale du Mans", *Congrès archéologique*, CXIX, 1961, pp. 18–58 and L. Mussat, *Le style gothique de l'ouest de la France,* Paris, 1963, pp. 121–133. A firm date of 1254 for the termination of work is provided by the stained-glass (see L. Grodecki in *Cong. arch., loc. cit.*, pp. 61 and 90).

The chevet of Le Mans Cathedral was dedicated in 1254 and the clerestory must have been constructed during the preceding five or six years. The language of the forms is like a dialect when compared with the ceremonious and measured speech of Jean de Chelles, but it is a dialect of Paris all the same. The windows are of three sizes – narrow in the eastern bays of the apse, larger in the western ones, and quite broad in the choir (Pls. 96, 97, 98). Each pair is matched, north and south, as if to prove beyond any doubt that the differences in pattern were deliberate. On the axis of the church (Pl. 97 left), is a window similar to those in the apse of St Denis; this is flanked by two imitating the apse of the Ste Chapelle, and these in turn by a pair of the same sort but with trefoil arches and an inverted trilobe at the top. The bays of intermediate width have this last pattern above a triplet and triplets form the basis for the designs of the first two pairs of choir windows. The eastern set has two triplets with quadrilobes in the tympana, the upper ones turned on their sides as in the north transept of Notre Dame, while the central set has large trilobes as at Amiens. Finally, the western pair of windows has two doublets below turned quadrilobes.

The effect of the clerestory at Le Mans is that of a chapel set like a crown on the very top of the structure. Taken out of its context for the purposes at hand here, it is clearly the most inventive composition of the entire decade. Variation is the norm rather than the exception, and the performance is indeed dazzling. At small scale or large, in doublet or triplet, and in trilobe and quadrilobe turned right-side up, inverted or placed sideways, the forms seem to be possessed of a life all their own. The master of Le Mans was not only thoroughly at ease with the techniques and patterns of tracery, he was also at home within the Amiénois tradition. Reference is made to all the basic Parisian patterns of tracery derived from Amiens except the twin-lancet-and-trilobe – patterns which we have seen at the Ste Chapelle, at Tours, at Nogent, at Notre Dame. And Amiens itself is cited in the juxtaposition of two triplets and two doublets in the western bays. This reference to Amiens in its way underlines the Parisian character of the work, for it reproduces the situation of the

1240s in the capital at Le Mans and serves to reinforce its Parisian credentials. The mullion sections, the rib profiles and the capitals confirm this provenance.

Far from proving that in the mid-thirteenth century any pattern of window tracery could be employed by anybody anywhere, without reference to its place of origin, Le Mans shows exactly the reverse. In 1250 tracery was still only a generation old and many of the patterns had made their appearance less than a decade before. The destruction of monuments which may have contained similar patterns may seem to cast a statistical doubt on the validity of the demonstration, but that is an argument *ex nihilo* and history cannot be built on empty premises. There *is* evidence that such forms as the doublet below three trilobes or the triplet below a single trilobe were important new forms at Paris and Amiens in the 1240s, as I have tried to show. The same conclusion cannot be drawn in Champagne or Normandy or from monuments such as those deriving from Cambrai or Soissons.

From the point of view of tracery, Champagne and its affiliates form a particularly interesting contrast with Paris and Le Mans at mid-century. Eastern France was dominated by the Nicasian pattern of a quadrilobe above two arches, the latter also generally but not always trefoiled and unextradossed (Pls. 102, 103). The list of examples is long and uninteresting,[49] and the single major exception to the canon was to be found at Strasbourg – not in the aisle or clerestory windows,[50] but in the choir screen (before 1252), where the quadrilobes were turned on their sides

49. In the extreme bays of the transept at Troyes Cathedral (after 1240); in the Reims palimpsest (c. 1250, see R. Branner, "Drawings from a thirteenth-century architect's shop: the Reims palimpsest", *Journal, Society of Architectural Historians*, XVIII, 1958, pp. 9–21); in the gallery and engraved drawings for the façade of Soissons Cathedral (c. 1260; see F. Brunet, "La restauration de la cathédrale de Soissons", *Bulletin monumental*, LXXXVII, 1928, pp. 65–99, esp. fig. 17); at Mont St Quentin (begun between 1241 and 1257; *Monasticon Gallicanum*, pl. 89); in Strasbourg "A" (Pl. 128; one triplet of the St Maur type is used, however); in the nave of Strasbourg (c.1240–1250) and at St Amand itself (Pls. 102, 103).

50. The nave and aisles of Strasbourg repeat and enlarge a design from Reims Cathedral later taken up in the chapels of St Nicaise at Reims (Ch. Givelet, *L'église et l'abbaye de Saint-Nicaise de Reims*, Reims, 1897, pl. foll. p. 74).

(Pl. 85).[51] The screen, with its seven gabled arches, has been called a derivative of Libergier's façade at St Nicaise and it therefore stands in somewhat the same relationship to Champagne as does Jean de Chelles' transept at Notre Dame. But even if there were no other influences at work on the choir screens – a question that must remain open at the present time – the contrast with Le Mans is striking. For all the strength of design exhibited by a succession of highly individualistic masters at Strasbourg, the choir screen went merely one small step beyond the tracery pattern of St Nicaise; Le Mans, on the other hand, absolutely revelled in the intricacy of tracery designs. Clearly Paris had become the leading centre for this work.[52]

<p style="text-align:center">★ ★ ★</p>

Although the trends in Parisian architecture of the 1240s that have been outlined above were fairly distinct from one another, they also kept running together. This was not only because of the constant re-use of the same sources, but also because of a gradual evolution in taste that required increasingly unified treatment of the disparate elements. Furthermore the architects unquestionably knew each other and must have had a normal curiosity about each other's work. This period of increasing stability in Parisian forms was ushered in by the Ste Chapelle. But if

51. See H. Reinhardt, "Le jubé de la cathédrale de Strasbourg et ses origines rémoises", *Bulletin, Société des amis de la cathédrale de Strasbourg*, ser. 2, VI, 1951, pp. 19–28. The quadrilobes in the balustrade look like a Parisian form made heavier by a local accent.

52. A variety of tracery designs developed in the area around Tournai after the mid-century, it is true, ones that were generically related to such early examples as the south choir bay at Essomes. At Tournai Cathedral (choir), at St Walburga in Oudenarde (chevet aisles), at St Thierry (dedicated in 1273 and now destroyed; in his interior view of Reims, Bibl. Mun., MS 1600 [N. 864], Dom Cotron may inadvertently have shifted the four-lancet window from choir to hemicycle; cf. *Monasticon Gallicanum*, pl. 95), and in the "gallery" of façade "B" of the Reims palimpsest, which is close to the source of the choir of León Cathedral, the arches were organized in rhythmic patterns of units unequal in size or in number. This may have been due to local tradition, for twelfth and early thirteenth-century triforia in the area generally contained alternating patterns (e.g. the nave and transept of the Niklaaskerk at Ghent or O. L. Vrouwkerk van Pamele at Oudenarde). The examples of window tracery are later than the Parisian ones discussed here, however—only Tournai is contemporary with Le Mans, and it is the head of the series—and the types did not have a success comparable to those of Paris. They were in fact superseded by Parisian types in the last quarter of the century.

Thomas de Cormont replaced the St Denis Master in royal favour, he did not, on the other hand, fix the entire future of the Court Style. In many ways the chapel was already a rather old-fashioned building by 1245 and it was only one, albeit for a while the leading one, among the many threads with which the architects of the maturing style were to weave the fabric of their work. Amiens itself continued to be directly represented in the pattern, and the shapes of Rémois design were by no means totally omitted. In this sense the Court Style can be called a test of the value of models and a speculation upon the interchangeability of parts in the Gothic church. It was also monumental yet refined, comprehensive in scope but elegant, metallic and stony. After Louis' return from the Crusade, it was to spread from Paris to all the regions under the king's influence and to foreign parts as well.

The Court Style

THE various trends discernible in Parisian architecture of the 1240s merged into a coherent style in the following decades. The change was one of degree and tone rather than of abrupt or incisive innovation, but it was no less well-marked. The tendency toward the total unity of the building was carried much further than ever before. While the compartmentalization of space could never be completely effaced as long as Gothic ribbed vaults were used, it was now minimized so that the volumes could flow into one another with greater ease. The Court Style thus signalled the ultimate success of one of the two great visions with which the thirteenth century had opened, that of Bourges Cathedral, with its five aisles of staggered height; but the parti of Bourges ceased to be the only embodiment of the vision, for it was now possible to give almost the same sense of total openness and unity to the Chartrain basilica of three aisles. With the spatial unity of the Court Style came a number of fusions and ellipses. Emphasis on the correspondence between parts was a thing of the past, and elements that were once distinct from each other were now firmly and inextricably woven together. All areas of the building were more uniformly illuminated through the more extensive use of grisaille glass, and the fine surface effects were made to shimmer with a sort of pearly iridescence. The effects were now more evenly distributed over the entire monument, so that plain and decorated areas no longer contrasted with one another. Shafts became so thin as to belie any possible role as supports. At the same time the design was "sharpened", especially in windows, where colonnettes dwindled in size and the trapezoidal bulk of the mullions became more prominent. Clear, hard edges accentuated the linearism of the surface. Even the iron frames

for the stained glass were straightened into trellises, as if to prolong the effects of the masonry into the voids themselves. This was also the start of the period of virtuoso calligraphy. Plans and parchment drawings were regularly used in the process of construction, probably for the first time, and simple geometric procedures were deliberately distorted in order to produce tracery designs that looked "right" (see Pl. 114). Excessive refinements such as the accolade or the mouchette were still in the future, however, and until the death of Louis IX, at least, the Court Style was stable and serene.

During the Crusade of 1248–1254 most building operations in the capital were suspended or slowed down, but this did not interrupt the development of architectural ideas.[1] It gave them a chance to germinate, and in the renewal of activity after the king's return, they came forth in full flower. Unfortunately very few buildings have survived from this time in Paris, and in order to form a picture of the Court Style we must look for reflections of it elsewhere. After 1254, in other words, Paris cannot be considered independently of the provinces that were in the *mouvance* of the king, although we must always bear in mind that differences were likely to exist between the centre and the periphery.

The Royal Workshops

After 1254 the Crown sponsored two different kinds of projects. One was the formal architecture of the court, with which we will be primarily concerned. The other was the simpler, less hieratic style of certain public or quasi-public works, and this "poor" style merits some consideration, if only because it serves as a foil to the first.

Joinville's simile of the king illuminating his kingdom with abbeys, convents and hospitals like an artist illuminating a manuscript, referred particularly to the time following Louis' Crusade.[2] After his experience in the Holy Land, the king seems to have been more deeply convinced

1. Perhaps only Lys, Blanche's Cistercian convent, was under construction at the time (from 1244 to 1252). See ch. 3, note 5.
2. See ch. 1, note 21.

than ever of the necessity of carrying the message of Christianity directly to the people and of the value of the various Mendicant orders in doing so.[3] In this sense his support of the friars – not only of the Dominicans and Franciscans, but also of such groups as the Carmelites, the Guillemins, the Blancs-Manteaux and the canons of Ste Croix – was an expression of policy, a social as well as a spiritual programme. The hospitals, which were staffed by religious orders, represented another side of the same effort. The king saw to it that all the groups were given satisfactory buildings to live and work in, more often than not putting up new monuments for this purpose.

Saint Louis' hospitals are very imperfectly known to us. The Quinze-Vingts, a home for the blind which the king seems to have enlarged in 1260, is totally lost.[4] But the Hôtels-Dieu of Compiègne (1257) and Pontoise (1259) can at least partly be described. Both were hospitals in the proper sense of the word, intended for the care of the temporarily ill, and were dominated by a great infirmary. In each case this was a hall of two aisles separated by columns and probably covered by a single wooden roof, a very old parti found frequently in castles and monasteries.[5] The stone side walls and gable-ends provided the only area for architectural

3. Cf. Lester K. Little, "Saint Louis' Involvement with the Friars", *Church History*, XXXIII, 1964, pp. 1–24, for a detailed analysis of this question. I am indebted to Professor Little for making his material available to me before publication.

4. For the Quinze-Vingts, see L. Le Grand, "Les Quinze-Vingts depuis leur fondation jusqu'à leur translation au faubourg St.-Antoine", *Mémoires, Société de l'histoire de Paris*, XIII, 1886, pp. 107–260 and XIV, 1887, pp. 1–208; a new oratory was planned in 1283, which Piganiol de la Force said was built by a De Montreuil (Eudes?), and another was built in the late fourteenth century. For hospitals in general, see D. L. Mackay, *Les hôpitaux et la charité à Paris au XIIIe siècle*, Paris, 1923, and L. Le Grand, "Maisons-Dieu et leurs statuts au XIIIe siècle", *Revue des questions historiques*, LX, 1896, pp. 95–134. In addition to the Hôtels-Dieu at Compiègne and Pontoise, Louis IX is credited with the one at Vernon and with extensive enlargements to the one in Paris. See also U. Craemer, *Das Hospital als Bautyp des Mittelalters*, Cologne, 1963.

5. Maurice de Sully's episcopal palace in Paris had a hall of two aisles, as does the château of Blois. Despite the monastic habit of vaulting refectories, which normally had two aisles, hospitals or infirmaries do not seem to have been vaulted as a matter of course in the Ile de France at that time; the one at Brie Comte Robert seems exceptional. Probably only Angevin hospitals had three aisles and vaults as early as the second half of the twelfth century (Angers; Le Mans), and this form appeared in the Ile de France at the end of the thirteenth century (Ourscamp). The Cistercians also occasionally used three aisles and vaults in their secondary buildings (M. Aubert-A. de Maillé, *L'architecture cistercienne en France*, 2nd ed., Paris, 1947, *passim*).

display. Divided by a central buttress into two asymmetrical bays, the gable-end was difficult to weld into a unified design.[6] At Pontoise it had three superimposed windows in each bay, like many medieval refectories and dormitories.[7] At Compiègne, which survives, the pattern is the same, although there the gable-end is broader and lower than usual (Pl. 125).[8] Each bay has its own minor gable at the same angle as the main one, a plain portal flanked by narrow lancets and a twin-lancet-and-oculus window above, with three orders on the jambs and in the archivolts. The resemblance of the upper windows to those in the Synodal Hall at Sens (after 1267) is striking. Despite this richness of effect, however, the Hôtel-Dieu at Compiègne was a simple building in which it would be difficult to identify royal or Parisian elements.

The convents built by the king for Mendicant and other orders were distinguished largely by their chapels. Indeed, if one takes literally the lists of Louis IX's buildings provided by his early biographers,[9] it would appear that royal architecture in the period after 1254 was dominated by chapels, and this is probably not far from the truth. The poor orders eschewed the regular church plans of older, wealthier orders, and such features as transepts, ambulatories, oriented or radiating chapels and towers were generally omitted in favour of simple or even haphazard plans: the Dominicans were famous for the casual manner in which they added a new aisle or sanctuary to an older building without regard for symmetry or reliance on ritual in the disposition of the elements.[10] A

6. Unified gable-ends were occasionally designed in the thirteenth century, but it was necessary to omit the buttress and scan the surface with arcades, as at the Hôtel Vauluisant at Provins, the episcopal palace at Auxerre or the chapel once lying north of the former Temple in Paris.

7. See J. Depoin, "Saint Louis et l'Hôtel-Dieu de Pontoise", *Mémoires, Société historique et archéologique de l'arrondissement de Pontoise et du Vexin*, II, 1880, pp. 27–45, and a view in Paris, Bibl. Nat., Est., Va 420.

8. See Magdelaine, "La tour de Saint-Louis et la salle souterraine de l'Hôtel-Dieu de Compiègne", *Bulletin Société des antiquaires de Picardie*, III, 1847, pp. 155–161, and A. Verdier, *Architecture civile et domestique au moyen âge et à la renaissance*, Paris, 1857, vol. 2, esp. pp. 143–151.

9. E.g. Guillaume de Chartres, Geoffroy de Beaulieu, or even Joinville, Guillaume Nangis or Guillaume de St Pathus. See especially the *Recueil des historiens des Gaules*, vol. 20.

10. See esp. G. Meersseman, "L'architecture des Dominicains au XIIIe siècle", *Archivum fratrum praedicatorum*, XVI, 1946, pp. 136–190, and R. Krautheimer, *Die Kirchen der Bettelorden in Deutschland*, Cologne, 1925, pp. 117–122.

plain chapel generally lay at the base of their accretive architecture, and the same form usually sufficed for the other orders as well.[11] Unfortunately all have been destroyed and most – the Guillemins (1256), Ste Croix de la Bretonnerie (1259), the Carmelites (1260), the Blancs-Manteaux (1263) in Paris, the Mathurins at Fontainebleau (1260) and nearly all the royal Franciscan and Dominican convents – will probably never be known at all.[12] Among those that can be partly recovered are the chapels of the Franciscan sisters at Longchamp, built in 1256 for Louis' sister, Isabelle; the Carthusians in Paris (after 1257); and the Dominicans at Rouen (1257).[13] All three revealed that King Louis was aware of the orders' desire for simple, unsophisticated and unceremonious architecture and that he himself followed the advice he once gave to his son-in-law, Count Thibault de Navarre, who was building a convent for the Domini-

11. The convent of the Dominicans at Paris was a typical example of the accretive churches of the order. For the best plan, see E. Lambert in *Bulletin monumental*, CIV, 1946, p. 179. Louis IX is said to have completed the church and built the dormitory and school with part of the fine he levied on Enguerrand de Coucy in 1259 (J. B. M. Jaillot, *Recherches critiques, historiques et topographiques sur la ville de Paris*, Paris, 1772, vol. 4, Quartier St Benoît, p. 125, and M. Félibien, *Histoire de Paris*, vol. 1, p. 261); in 1266 the refectory was called "new" (J. Quicherat, "La rue et le château Hautefeuille à Paris", *Mémoires, Société nationale des antiquaires de France*, ser. 5, II, 1881, pp. 9–44, esp. p. 38). But it is difficult if not impossible to re-establish and to date the campaigns of construction exactly. See also ch. 6, note 19.

12. For the *Guillemins*: J. B. M. Jaillot, *Recherches critiques . . .*, vol. 3, Paris, 1782, Quartier Ste Avoie, pp. 20–25; for *Ste Croix de la Bretonnerie, ibid.*, pp. 31–33; H. Bonnardot, "Iconographie du vieux Paris", *Revue universelle des arts*, IX, 1859, pp. 216–217; J. Lebeuf, *Histoire de la ville et de tout le diocèse de Paris,* rectifications by F. Bournon, Paris, 1890, pp. 63–64; for the *Carmelites*: Félibien, *Histoire de Paris*, vol. 1, pp. 353–354; Bournon, pp. 218–219 (the 1319 chapel, alone, is known; see Paris, Bibl. Nat., Est., Va 259 g and A. Lenoir, *Statistique monumental de Paris*, Paris, 1867, pp. 190–193 and atlas, vol. 2); for the *Quinze-Vingts*: L. Le Grand, "Les Quinze-Vingts . . .", 1886 and 1887; for the *Blancs-Manteaux*: Jaillot, p. 18; Félibien, pp. 374–375; Bournon, p. 65; see also *Bulletin monumental*, XCIII, 1934, pp. 110–111 for the excavations; the 1674 plans are in Paris, Arch. Nat., N III Seine 9, and probably represent the late thirteenth-century chapel; for the *Mathurins*: A. Bray, "Les origines de Fontainebleau", *Bulletin monumental*, XCIV, 1935, pp. 171–214, esp. 203–213; F. Herbet, *Le château de Fontainebleau*, Paris, 1937; for the Dominicans at Mâcon: Ch. Rohault de Fleury, *Gallia Dominicana*, Paris, 1903, vol. 2, *sub verb.* "Mâcon".

13. For *Longchamp*: G. Duchesne, *Histoire de l'abbaye royale de Longchamp (1255–1789)*, 2nd ed., Paris, 1906 (from *Bulletin, Société historique d'Auteuil-Passy*); the most reliable iconographic documents are in Paris, Bibl. Nat., Est., Ve 53 g; for the *Carthusians*: A.-L. Millin, *Antiquités nationales*, vol. 5, Paris, 1798–1799, lii; Jaillot, vol. 5, Quartier du Luxembourg, pp. 43–46; Bournon, p. 78; P. Mahler, *La chartreuse de Vauvert . . .*, Paris, 1909 (from *Bulletin, Société historique du IVe arrondissement*); plans are in Paris, Arch. Nat., N IV Seine 20, and Bibl. Nat., Est., Va 265 d; for the *Dominicans* at Rouen: P. Chirol, "Ancien couvent des Jacobins à Rouen", *Bulletin, Commission des antiquités de la Seine-Inférieure*, XX, 1949, pp. 61–77.

cans at Provins, namely, not to spend too much money on it lest he endanger the friars' souls.[14] The Longchamp chapel was enormous, measuring 12 by 50 metres, but it was undoubtedly unvaulted and seems to have had simple lancet windows with a slightly larger one on axis. The Carthusian chapel, which was years in the building, had the same features, with an elaborate four-lancet window in the western wall. And the Dominican church at Rouen had a great window in the eastern wall, containing two triplets beneath three oculi that looked like the central motif in the gables at St Denis, Notre Dame or the Ste Chapelle (Pl. 115). This feature, at least, was clearly Parisian in origin, and in the next chapter we shall see how the Mendicants consistently exported Parisian forms in the 1240s and 1250s.

Another group of buildings, probably more finished and elaborate, was related to the royal foundations just mentioned, and that was the university colleges. As with the convents, the dates of foundation of the colleges have sometimes been taken as the dates of the buildings, which often were not put up until many years later. Of those which were in fact erected in the third quarter of the century, however, none is recoverable except the chapel and cloister at Cluny college (Pl. 80).[15] The context of the university may have had a certain effect on the style of the architecture although it is impossible to know whether this particular college was more or less ornate than its contemporaries. The remains now in the Cluny Museum indicate that it contained a moderate amount of sculpted parts, such as keystones and capitals, but there is nothing to suggest the elaboration of a building such as the Ste Chapelle. The cloister, dormitory and refectory were begun in 1269 under Abbot Yves de Poyson (d. 1275), and the cloister was finished and the chapel built under Abbot Yves de Chasant; both were probably ready in 1278. The chapel was smaller than

14. Joinville, *Vie de saint Louis*, ch. 34.
15. Dom P. Anger, *Le collège de Cluny*, Paris, 1916. See also Paris, Bibl. Nat., Est., Va 260 a; Carnavalet Museum, Coll. Leymonerey, II, nos. 864, 869; Bibliothèque historique de la ville de Paris, MS 237, Fonds Vacquer, D 45, f. 1, and D. 47, f. 25; and *Magasin pittoresque*, IV, 1836, p. 292. The second Pernot view is published by Y. Christ, *Eglises de Paris actuelles et disparues*, Paris, 1947, no. 39.

the one at Longchamp, measuring 30·50 by 9·10 metres on the inside, but it was vaulted. Each bay, straight and turning alike, contained a triplet window with three pointed trilobes, the lower two inverted. While they belonged to the same family as those of the Ste Chapelle or Le Mans, the windows were restricted in width in the lateral bays and surrounded by large panels of wall as at Nogent or the clerestory at Royaumont. According to Le Vieil, they were filled with grisaille glass, so that they probably admitted a good amount of light to the interior despite their limited size.[16] A heavy, sculpted cornice ran above the windows, but there were no gables and the buttresses were not ornamented. The façade of the refectory and chapter-house, which lay at right angles to the western end of the chapel, had two bays separated by a buttress, like the hospitals just mentioned, and each half of the crowning gable contained an oculus with lobed forms similar to the one in the north transept gable of Notre Dame. The south walk of the cloister was composed of large arches housing two smaller ones and an oculus, with trefoils in the spandrels not unlike the triforia of St Sulpice de Favières or Meaux, while the north walk resembled the arcade of the Ste Chapelle tribune, which will be discussed below (Pl. 63).

The Courtly Works

Despite Joinville's beautiful image about illumination, however, it would be a mistake to assume that such buildings, no matter how costly they were or how long they took to put up, represented the only or even the major expression of royal taste. The king's biographers wrote after his death, at the behest of parties interested in his canonization, or after his inclusion in the list of saints, and they naturally emphasized the monastic and religious points of view. If Louis was not the same person in 1254 that he had been in 1248, and if he imitated the austerity of the friars as closely as he dared in his personal habits,[17] he nonetheless did not impose his

16. Cited in P. Verdier, "The Window of Saint Vincent . . .", *Journal, Walters Art Gallery*, XXV–XXVI, 1962–1963, p. 92.

17. For the many examples, see Little, "Saint Louis' Involvement . . .".

point of view on others and he did not use it as the only basis for his architectural and artistic policies. It is interesting to note that the golden reliquary-crown of 1267 containing one of the thorns from the Ste Chapelle is a rich and highly decorated object, but it was sent to the Dominicans at Liége, who, like all the members of their order, practised asceticism; whereas to the secular and wealthy Augustinians of St Maurice d'Agaune, in 1262, Louis sent another thorn in an elegant but very severe and restrained container.[18] A similar "reversal" seems to have occurred at Royaumont, where the sanctuary of the church grew so crowded with objects that the general chapter of 1263 had to reprove the abbot and order him to remove the "pictures and images and sculptures, curtains and columns with angels recently placed around the main altar and return to the old humility and simplicity of the order".[19] Such beautification could scarcely have been effected without the approval of the king, for the sanctuary of Royaumont housed the tombs of his sons and daughters. Louis also continued to beautify his castles with chapels intended for his own use and that of the court. A chapel dedicated to St Vaast, for example, was erected in the royal château of Pontoise after his return from Palestine. In 1258 he put up another one, with two stories, in his château at Corbeil, and from 1261 to 1264 he had St Maurice built in the château of Senlis.[20] All are unfortunately destroyed. But lest we conclude that they were sober and austere, it should be noted that St Maurice, at least, was likened to the Ste Chapelle by its pre-Revolutionary admirers, and that Louis instituted in it the liturgical practices and customs

18. See the exhibition catalogue, *Saint Louis à la Sainte-Chapelle* (Archives de France), Paris, 1960, nos. 224 and 233.

19. J. Canivez, *Statuta capitulorum generalium*, A° 1263 (*Bibliothèque, Revue d'histoire ecclésiastique*, fasc. 9–14), vol. 3, p. 11.

20. For Pontoise, Abbé Trou, *Recherches historiques, archéologiques et biographiques sur la ville de Pontoise*, Pontoise, 1841, p. 66; for Corbeil, A. Dufour, "Le château royal de Corbeil et la Sainte-Chapelle de Saint Louis", *Bulletin, Société historique et archéologique de Corbeil, d'Etampes et du Hurepoix*, XIII, 1907, pp. 144–146 (the fragments are not identifiable at the present time); see also Lebeuf, *Histoire*, vol. 11, pp. 203–204; for Senlis, L. Graves, *Précis statistiques des cantons du département de l'Oise*, Beauvais, 1862, p. 139; E. Muller, "Rues, places et monuments de Senlis", *Mémoires, Comité archéologique de Senlis*, ser. 2, VII, 1881, pp. 194–195; for the texts, see *Recueil des historiens des Gaules*, vol. 20, pp. 52 and 76, and *Gallia christiana*, vol. 10, cc. 1522–1523 (the church was sometimes called a basilica).

of his chapel in Paris. There is every likelihood that reflections and imitations of these more elaborate works exist among other buildings of the Court Style, and we shall shortly examine the chapel at St Germer from this point of view. But the only demonstrably original royal work of this sort that can be studied in any detail is the tribune for relics in the Ste Chapelle.

The Ste Chapelle tribune was probably constructed when Louis decided to convert the Treasury of the chapel into a library after his return from the Crusade (Pl. 63).[21] It is a platform placed behind the main altar and joined to the sides of the chapel by an arcade. In plan it is shaped like an apse, fitting snugly into the axial bay of the building, and two small spiral staircases at the eastern side lead up to the baldachin, which surmounted the reliquaries. Like the dado of the chapel, the gilded tribune was conceived as an extension of the gold and silver shrines containing the relics. The platform bears statues as well as imitation enamels and it may have held painted medallions similar to those in the dado. The baldachin is topped by towers and spires that seem more like an enlargement of the motifs of a reliquary than they do a reduction of monumental architecture. The single formal innovation of the work was the systematic use of the pointed trefoil in the arcade.

Delicate as it may be, however, the Ste Chapelle tribune cannot be considered a major work by any stretch of the imagination. In order to form a broader idea of Louis' private chapels from the 1250s and 1260s, we must turn to the Lady chapel at St Germer de Fly, which belonged to a group of related buildings from the later 1250s lying to the north of the capital.

The Northern Tier

The chapel at St Germer was probably begun in 1259.[22] Like some English Lady chapels, it is a large, almost free-standing structure placed to the

21. F. Gebelin, *La Sainte-Chapelle*, 3rd ed., Paris, 1943, pp. 52–57. The entire work was thoroughly restored in the last century.

22. A. Besnard, *L'église de Saint-Germer de Fly*, Paris, 1913. For the confusion in the literature as to whether the chapel was begun or dedicated in 1259, see Graves, *Précis*, pp. 374–375.

east of the chevet of the great church and connected to it by a vestibule (Pl. 99). A balustrade and gables crown the exterior, and the prominent buttresses are encircled by the cornice and topped by small, polygonal aediculae probably copied from those that were being erected by Matthieu de Vendôme on the nave of St Denis.[23] Gables and balustrades also ornament the vestibule, and gabled arcades adorn the two stair turrets that flank the western end. Many of the details closely resemble the work of Jean de Chelles at Notre Dame and there can be little question as to their immediate provenance. It is the relationship to the Ste Chapelle, however, that is intriguing. The gables separated by tall, severe buttresses, the continuous cornice and the broad windows all recall the chapel in Paris. Unless we are prepared to accept it as a frank revival some fifteen years later, there is every reason to suppose that it reflects a tradition of palatine chapels deriving from the Ste Chapelle and including sites such as Corbeil, Pontoise and Senlis.

The interior of St Germer also bears a certain resemblance to the Ste Chapelle (Pl. 104). The rose-in-square, the balustraded passages and the blind arcade on the dado of the west wall are slightly more elaborate versions of the king's chapel, and the lateral windows are very close in form to those in Paris. The organization of the wall differs, of course, for the major mullions descend through a cornice to the pavement in the limited linkage that Paris took from Amiens in the 1240s, and the dado arcade everywhere corresponds in number of units to the lancets above. The effect is more integrated than at St Sulpice de Favières, for example, for the rectangular shapes are retained without over-stressing the integrity of each story and the correspondence of units permits the eye to jump the thin band of the cornice without difficulty.

The striking feature of St Germer is the completely unified treatment of the wall. Arches, shafts, mouldings, all form a single, coherent pattern in which no part seems out of place or irrelevant. The window tracery is at the same scale as the responds, and the thin lines ripple from bay to

23. See Crosby, *L'abbaye royale de Saint-Denis*, pl. 28; see also Appendix C.

bay down the length of the chapel with the same ease as they flow from the plinth into the vaults. In the vestibule (Pl. 105) the windows are deeply recessed behind a trefoiled arch and the linkage is complete. But the respond arrangement is more complex on the portal than in the chapel, for there are two base lines as well as two impost lines, and they overlap in the support for the diagonal rib. The ellipsis emphasizes the unity as well as the distinctness of the parts.

Many of the same features characterize the triforium and clerestory of Beauvais, a site with strong administrative and artistic links to St Germer (Pl 107).[24] The cathedral had been begun in 1225, but the upper stories, which were finished before 1272, were probably undertaken only about 1255, when Guillaume de Grez was bishop and Renaud de Nanteuil, nephew and cousin of bishops and dignitaries at Beauvais and Reims, was dean of the chapter. Beauvais had a long-standing feud with the king, reaching back to 1233 when Louis had dispossessed the bishop and seized the *regalia*. But the officers of the see were very close to court circles despite their pursuit of an anti-royal policy: Guillaume de Grez, for example, was a close friend of Robert de Sorbon, one of the king's intimates. It is therefore not surprising to find Parisian forms appearing in this last and greatest of the Ile de France cathedrals. The bays of the hemicycle of Beauvais, the only part of the last campaign to survive the collapse of the vaults in 1284, have mullions descending into the triforium. The slightly indented spandrels of the latter story look more like those of Gallardon or St Père at Chartres, but that may be because the story as a whole is extremely fine, with subtle mouldings that remind us once again of metalwork.[25] The linkage is unlike that in the apse of St Germer, where the presence of two planes of mouldings means that only the outer one passes into the dado, at the edges of the bay (Pl. 106). The narrow bays in the abbey chapel, rather than being a compressed version of the

24. Most recently, see my "Le maître de la cathédrale de Beauvais", *Art de France*, II, 1962, pp. 77–92, with bibliography. I am still in disagreement with M. Salet's estimate of the number of architects involved, or the changes of design (*Bulletin monumental*, CXX, 1962, pp. 78–79).

25. See R. de Lasteyrie, *L'architecture religieuse en France à l'époque gothique*, Paris, 1926, vol. 2, p. 18.

chief elements of the broad bays, are therefore an almost literal repetition of one-half the latter. If the same rule was followed at Beauvais, then the destroyed great bays of the choir had four lancets with linkage at every mullion, in the manner of St Denis or the vestibule of St Germer. In the apse tracery of both cathedral and chapel, an old Parisian pattern was revived and expanded into what was to become an important new member of the repertory. That was the inclusion of a secondary arch as well as a lobed form within the head of each lancet, a pattern we have seen in rudimentary form much earlier at Paris and Amiens (Pls. 19, 25). At Beauvais and St Germer, the subsidiary elements are recessed and spring from the sides of the mullions. The design differs from "normal" tracery of the time in that the secondary arch is repeated on the same axis and at the same scale as the lancet-head. This amounts to a contradiction of the principles that had heretofore ruled tracery patterns – reduction in size and bilateral symmetry around the lancet axis, which meant that each reduplication was at smaller scale and on either side of the axis of the preceding form. The cardinal advantage of the new design was that it furnished a way of complicating the patterning in the upper part of the window without requiring additional width.

The arch-within-the-lancet also characterizes the last building in the area from the later 1250s, the priory of Chambly (Pl. 109).[26] In the chapels it is the sole pattern in the narrow windows, and in the apse it appears in two of the three lancets in each bay. More significant, however, is the triplet beneath a large oculus. Although it originated in the Aisne Valley earlier in the century, this form seems to have vanished from there and from neighbouring Champagne after about 1240, when it began to appear in the Paris region (Pl. 90, at the end of the side-aisle). But it did not become prominent in the Ile de France until after 1255, and then it was employed in a number of Parisian works, for example at the Jacobins (Pl. 108).[27] The combination of the triplet and the arch-within-the-lancet

26. Ab. Marsaux, *Monographie de l'église de Chambly*, Beauvais, 1889; A. Raquenet, *Petits édifices historiques*, I-II, 1891–1893, pp. 229–240.
27. The drawing of the Dominicans' window is in Paris, Carnavalet Museum, Coll. Leymonerey,

at Chambly is noteworthy, for it shows at a glance that tracery patterns were becoming more complex than ever. The apse windows in fact appear to contain two triplets superimposed like a palimpsest, a traditional one with a taller lancet in the centre and an "inverted" one adapted to the large oculus. If the first is actually in two different planes, the trefoils in the arches nonetheless give it a certain consistency and the light coming through the stained-glass makes it difficult to see the forms other than in silhouette. This kind of double-entendre was to become more frequent in the last decades of the century. Another important aspect of Chambly is the general treatment of the effects. More than in the apse of St Germer – like the vestibule of the Lady chapel at the abbey, or like the gable-end of the Hôtel Dieu at Compiègne – the wall-rib is multiplied until it becomes a deep, undulating frame for the window. The solids at Chambly, no matter how decorated one may find them, have reasserted their strength and impinge upon the window openings. No monument can be in greater contrast to St Martin aux Bois (Pl. 89), built only a decade earlier in the same area, for one is tall and totally glazed and the other is broader, denser and more guarded. Chambly is the kind of conservative, routine design that becomes possible after a style has reached its maturity.

Jean des Champs

The name of one architect working in this area around 1260 was destined to be remembered by posterity. This was Jean des Champs, master of the cathedral of Clermont Ferrand, which was begun probably as a result of the king's visit to that city in 1262 for the marriage of the Dauphin.[28] Many of the details, especially the window forms (Pl. 110), are very close to ones that were in use in the Beauvais-Chambly area in the '50s.

II, no. 960. It is described as "intérieur mis en vue par l'emplacement de la rue Soufflot", in 1877, and may have represented the angle between the cloister (left) and the capitular hall (right) on the plan published by Lambert (see note 11 above). The same form appears in the westernmost bay of the nave of St Denis (Formigé, *L'abbaye royale* [1960], fig. 75) and in the south choir chapels at Notre Dame.

28. See Appendix B.

Other details – the four-lancet window in the choir chapel, the three gabled arches of the triforium as well as the arcade tracery itself (Pl. 111) and the non-projecting transept – reveal the architect's first-hand knowledge of Notre Dame and other Parisian buildings. Perhaps most significant is his use of Dionysian piers in both hemicycle and choir.[29]

It has sometimes been suggested that Jean des Champs' building, together with the other great central and south-western French cathedrals, is academic. This might seem to be borne out by a contemporary text, Pope Clement IV's statement in his 1268 bull for a new cathedral of Narbonne, which he said was ". . . to imitate the noble and magnificently worked churches . . . which are built in the kingdom of France".[30] But this point of view does not catch the character of Clermont as a cathedral in the Court Style, nor does it bring out the architect's sensitivity. More than a generation had passed since a cathedral was designed in the Ile de France, and in some ways Clermont seems old-fashioned to us simply because it continues to use standard elements such as an ambulatory and radiating chapels (Fig. 8) or a three-story elevation. Actually the ground plan contains several features that appear odd when compared with earlier cathedrals, particularly the deep radiating chapels and their restriction to the eastern bays of the hemicycle, and these mark it as a member of a new group that was forming in the 1260s and that included monuments such as the cathedral of Evreux.[31] The elevation also contains new features. One of these is the panel-like treatment of the triforium and clerestory, which are linked together and framed in each bay by a narrow strip of wall. The origins of this design were discussed above, in relation to Agnetz (Pl. 12), and both Clermont and the cathedral of León in Spain adopted the recessed parti at about the same time. The triforium

29. There are colonnettes on the ambulatory side of the hemicycle piers, but this was not uncommon after Troyes Cathedral (1208 ff.); it probably occurred at St Quentin (after 1215) and can also be seen at Beauvais (1225). It is also fairly frequent in Burgundy, e.g. St Père sous Vézelay and the nave of Clamecy.

30. R. Rey in *Congrès archéologique*, CXII, 1954, p. 456. See also E. Mâle, "L'architecture gothique du midi de la France", *Revue des deux mondes*, ser. 7, XXXI, 1926, pp. 826–857.

31. Lasteyrie, *L'architecture religieuse*, vol. 1, p. 142.

gables were also quite recent in this story: they may have originated at Amiens (Pl. 101), but they spread rapidly to such places as St Thierry in the north-east as well as Clermont in the south.[32]

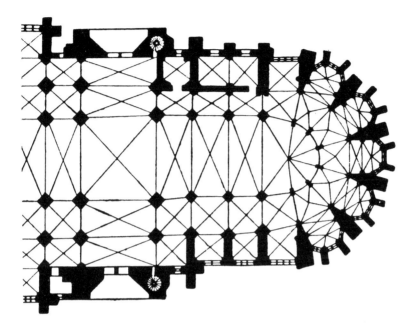

Fig. 8. Clermont Ferrand, Cathedral, chevet (Schürenberg).

The originality of Clermont does not depend upon the combination of up-to-date details alone, however, but also on the way such details were made to serve the general conception of the monument. If we take exception to the cathedral because it is not a cage of glass, we have missed the point. Jean des Champs stressed another tendency of the Court Style,

32. See Reims, Bibl. Mun., MS N 864 (Dom Cotron), p. 444, and H. Bertrand, "Saint-Thierry . . .", *Annuaire-bulletin, Société des amis du vieux Reims*, 1929-1930, pp. 83–116. The generalization of gables in triforia does not obviate the derivation of the series of three gabled arches from Jean de Chelles' façade at Notre Dame, nor does the fact that at Clermont, as at St Urbain at Troyes (Pl. 117), the group may be reduced to two: groups of three are found on the buttresses of the façade of Reims Cathedral, as will be noted below, and we therefore seem to be in the presence of a formal coincidence.

the restrained side that descended from Royaumont and that was to flower in the fourteenth and fifteenth centuries when the simple conquest of light was no longer an ideal. Perhaps because mid-thirteenth-century stained glass included a lot of grisaille, the architect revived the dark triforium and limited the choir windows in width, despite the fact that some of the light would be absorbed by the dark red stone with which the monument was built.[33] As at Nogent (Pl. 72), the windows sparkle within their dark frames, and their impact is augmented. At the same time the calligraphic effects of the masonry were not extended across all surfaces but were restricted to the responds and to the panels in the upper stories. The wall of Clermont resembles a brittle, laminated sheet just as much as does the north transept of Notre Dame, but the means used to produce this effect differ. Clermont also shares with northern monuments a very thin general structure and a pervasive space. The volumes open widely into one another through broad arcades that have nearly the same shape in the hemicycle as in the choir. Combined with the tall proportions of the aisles and the impressive height of the vaults, they produce the same kind of openness one finds in northern examples of the Court Style. For these reasons it seems correct to call Clermont a monument geographically displaced to an area where large buildings were still needed and still desired. Jean des Champs opened up the vast provinces of central and southern France to the Parisian mode, and if some of the monuments where he and his immediate successors worked bear a strong resemblance to one another, that is more a proof of the contention already made in this book, that personal styles changed slowly in the thirteenth century, than it is evidence of an academic mentality.

There is one case in the period under discussion where one can measure the slowness with which an architect's style changed over a period of some fifteen to twenty years, and that is Pierre de Montreuil. Having begun the refectory at St Germain des Prés in 1239 and the Virgin chapel in 1245, he is next heard from in connection with Notre Dame in Paris,

33. L. Schürenberg, *Die kirchliche Baukunst* (1934), pp. 17–20; L. Grodecki, *Vitraux de France*, Paris, 1947, p. 25.

where he was Master of the Works in 1265. Since the south transept of the cathedral is homogeneous from the plinth to the gable, the traditional attribution of the design to a single man may be accepted. And since the work was begun in 1258 by Jean de Chelles, who must have died a short time later when the inscription bearing his name was placed near the base of the façade, it was likely Pierre who took over, probably late in 1260 or in 1261,[34] and it is to him that the design of the façade may be assigned. He died in 1267.

Pierre de Montreuil and the Master of the Porte Rouge

The south transept façade of Notre Dame was possibly the grandest work undertaken in Paris in the 1260s (Pl. 112). It was perhaps for reasons of harmony that the design followed the model of the north façade in nearly every major respect. The general disposition of the stories is the same, from the five gables flanking the portal to the galleries, the rose window and the pediment and towerlets. Inside the transept the eastern and western walls are covered with tiers of blind tracery corresponding to the stories of the terminal, so that every part of the addition is equally ornamented (Pls. 113, 114). At the summit of the south transept wall is a great blind window with a splendid three-lobed design set in a curved triangle, like the blind arcade behind the north portal. Gables were placed above the arcading in the ground story to provide greater horizontal continuity to the design.

Everywhere, however, one finds evidence of an endeavour to give the design greater sharpness and coherence. On the outside Jean de Chelles' three gabled niches contained by the intermediate gables were replaced by three niches beneath an arch which echoes the larger and smaller arches to either side, and strong horizontals divide the three central tympana at about the same level, so that a careful gradation in size can be felt from buttress to portal. Statues in niches were added to the buttresses

34. M. Aubert, *Notre-Dame* (1929), pp. 153–155. Pierre probably entered the cathedral service after November 1260, when he still did not bear the title of Master of the Works; see above, ch. 1, note 34.

at the gallery level, and those at the level of the rose were enlarged to reach the cornice, the form being repeated on the lateral faces of the buttresses. Every other mullion in the triforium was made to descend into the blind story below, in the manner of the limited linkage we have seen at Amiens and St Sulpice (Pls. 1, 90). Overlappings and interpenetrations are more pronounced than in the north transept, not only in the gallery but also in the pinnacles of the ground story, which mount through the entire balustrade. And on the interior, for the first time in Parisian design, the transept terminal was considered as a whole to be subdivided rather than as a more or less happy juxtaposition of separate elements.

All the details of Pierre de Montreuil's design are more thoroughly worked than those of Jean de Chelles, and the motifs are more elaborate. Two features stand out in particular. One is the curved triangle, which has been further reduced in size from Jean de Chelles' blind tympanum until it is a mere frame for the trilobe; it appears in the outer ring of the rose window and in the spandrels, in the oculus of the gable and in the peak of the triforium arcade (Pl. 112). The second feature is the trilobe itself, which now is more often pointed. Small as they seem, these details alter the whole tonality of the design. Everywhere they appear, the curved triangle and the pointed trilobe give direction, moving forcefully from the centre rather than revolving slowly around it.[35] This lends the work a greater feeling of counterpoint and contributes to the sense of a purposeful organization of surface patterns. Forms were no longer simply scattered or juxtaposed, now they were organically interrelated. The stage was set for the end-of-century involutions.

Before taking up the question of the change in Pierre de Montreuil's style, we must ask to what degree the forms of the south transept were a kind of *koiné*. A comparison with the chapel at St Germer, which was strictly contemporary with the transept façade, if not a year or two older, is informative in this regard (Pl. 104). Many of the details are strikingly similar to those in the south transept, for example the limited linkage, the

35. Cf. W. Gross, *Die abendländische Architektur* . . . (1947), p. 113.

pointed trefoils (in the chapel dado) and the curved triangle (in the chapel rose). In fact there is virtually no part of Pierre de Montreuil's work that cannot be found either in the chapel or in Jean de Chelles' façade at Notre Dame, and we shall shortly see that another monument, St Urbain at Troyes, can be added to this list of representative Parisian designs. Even the integrated composition of the south transept was not an isolated phenomenon. Pierre de Montreuil can therefore be seen as a man fully attuned to the tenor of his day, an expert exponent of current customs but not a profound innovator with a highly personal style. Many great reputations have been built on less substantial grounds than this. Pierre's fame also seems to have been due to the facts that Paris was an ever more popular centre and that the south transept of the cathedral was probably the only large work in hand in the capital in the 1260s. It was certainly the most spectacular.

If my estimate of the situation is correct, the question of Pierre de Montreuil's change of style loses much of its importance. In 1239 and 1245 he sided with the followers of the St Denis Master, in addition giving his works a considerable degree of refinement and spatial unity. By 1260–1261, however, the popularity of St Denis had long been superseded by that of Amiens, and Pierre followed the general trend. Nothing prevented him from linking every mullion in the gallery of his façade as he had done in the Virgin chapel (Pl. 73), but nothing prevented him from affirming the separation of the stories, either, as Jean de Chelles had done more recently on the north transept (Pl. 92). Limited linkage had been gaining ground since about 1245 and by 1260 it seems to have become a standard feature of Parisian design, so that Pierre's use of the pattern in reality attests only to his position in the middle of the road. This in turn suggests that the development of his style from 1240 to 1260 was probably not by abrupt, over-night changes, but by slow, evolutionary degrees. That was the mood also of Parisian architecture during the entire second half of the thirteenth century.

If the difference between the designs of Jean de Chelles and Pierre de Montreuil at Notre Dame was largely one of tone, the same difference

separates the latter from his distinguished successor at the cathedral, whom I shall call the Master of the Porte Rouge (Pl. 118).[36] Begun before 1271, the small portal and the three adjoining chapels form the lowest part of a more extensive project which included reworking the tribunes and adding flying buttresses to strengthen the main vaults, similar to the work undertaken in the nave of Notre Dame in the 1230s. Only one choir buttress may have been completed – at least only one is extant, above the wall separating the first and second chapels (counting from the right in Pl. 118) – and it is capped by an aedicula penetrated by a pinnacle and spire identical with those between the gables of the transept and chapels.

The choir chapels were conceived as elements in a continuous row, somewhat like the ground stories of the transepts but having unlimited extension. A large gable surmounts each window and a short one spans each buttress, while pinnacles were intended to rise between them and to cross a light balustrade that runs behind (only the western pairs were completed). The buttress faces disappear almost wholly behind free-standing tracery and pedestals meant to hold statues. Even more than the transept, the choir chapels were treated as a unified design, a frieze stretching out to encircle the entire cathedral. Only the small Porte Rouge, with its pierced gable and sculpture, provides a variation in this rich but repetitive ensemble. Moreover the solidity of the lowest parts, whether of smooth masonry or of glass, contrasts sharply with the holes in the gable that give vistas of indeterminate depth above. This feature is present in the ground stories of both transept façades but only in the choir chapels does it achieve a fully mannered effect. Inside the chapels the same limited linkage as on the south transept was used. And in the bay behind the Porte Rouge, where there is no terminal dado because of the doorway, the window tracery was repeated on the eastern and western walls in

36. An attribution to Pierre de Montreuil is traditional (Aubert, *loc. cit.*), but it should probably be revised, for the forms vary as much from those of the south transept as the latter do from the north façade. The only date of value for the choir chapels is the death of Alphonse de Poitiers in 1271, before which time he founded the first north chapel ("capellaniam . . . ad altare situm in capella S. Agnetis . . .", Aubert, p. 142).

order to provide a completely ornamented "box", once again as in the south transept bay.

Although the choir chapels were not without followers in Paris, it was the more sober and restrained transept design that was to become a model for other architects and that was to spell "Paris" wherever it appeared. But the latter was not Pierre de Montreuil's creation, it was Jean de Chelles', and despite the demand for balance and harmony at opposite ends of the transept of Notre Dame, Pierre de Montreuil must be called the first of a long series of imitators.

The rose window set in a square above a glazed gallery serves to trace the diffusion of Parisian designs from the capital to the fringes of the Royal Domain and ultimately to far-flung cities of Europe. The pattern first formed about 1235 at St Denis was obviously considered a more successful means of integrating the great wheel into the elevation of the façade than was the contemporary solution of the transepts at Reims Cathedral, for instance. Reims, with its tall, pierced arch above and its solid lower spandrels (Pl. 5), had an impact on local design, but beyond a few cases where the centripetal rose was copied, it failed to stimulate Gothic architects at large. Hugh Libergier's solution of a great traceried window at St Nicaise had a wider influence but it, too, remained marginal (Pl. 22). It was the St Denis Master's design, as repeated and elaborated by Jean de Chelles, that was accorded an overwhelming success. It was used throughout the thirteenth and fourteenth centuries, at Troyes, Poitiers, Tours and Marmoutiers, Clermont Ferrand, Carcassonne, Châlons sur Marne and Amiens, among many other places, and it was probably the source for the rose-in-square of such Italian façades as Siena and Orvieto.

Two factors in the history of the design give us a deeper insight into the nature and influence of the Court Style. It was not widely copied until after about 1260, that is, after the Court Style had matured and Paris was universally recognized as the arbiter of architectural fashion. And the rose-in-square was independent of the gable series in the ground story. Jean de Chelles failed to create an acceptable general design, and his successors

either grafted older gable-runs on to the elevation or left them off completely.[37] Only one master, from Strasbourg, whose work will be discussed in the next chapter, took Jean de Chelles' whole design as the basis for a new elevation.

Parisian Reflections

The possible mutations of Parisian forms were many, and their flexibility in different combinations was probably one reason for their enormous success in the later thirteenth century. They mingled easily with local forms to produce sequences of unending variety, precisely the desiderandum of architecture after the mid-century. The architect of that time could express himself as fully in the calligraphic techniques of contemporary design as men of other generations could by manipulating masses or volumes, and this was undoubtedly one of the reasons that architectural drawing received a new impulse in the mid-thirteenth century. One of the outstanding examples of the Court Style to combine Parisian and local elements is the church of St Urbain at Troyes. St Urbain cannot be called a Parisian building simply transplanted to Champagne in the same sense as Clermont was to the Massif Central. But neither can it be understood purely on the basis of its Champenois forebears, without any Parisian background.

St Urbain was founded in 1262 by the French pope, Urban IV, to commemorate his patron saint as well as to memorialize the site of his father's former house in Troyes. He cited two precedents for such an act, Saint Gregory's Benedictine abbey of St Andrew on the Coelian Hill in Rome and Gregory IX's Joachite abbey at Anagni, both established in the popes' private domains.[38] Urban gave nearly £30,000 for the institution, which he

37. The three-gable run mentioned by R. Wortmann, *Der Westbau des Strassburger Münsters* (diss.), Freiburg im Breisgau, 1957, p. 59, which can be expanded to include the transept façades of Tours, Clermont Ferrand and Rouen, probably derived from a design such as the St Christophe portal on the nave of Amiens, rather than being a reduction of the five-gable series. Reductions are known, of course, such as from St Nicaise to Châlons Cathedral (transept).

38. The charter is in Ch. Lalore, *Collection des principaux cartulaires du diocèse de Troyes*, vol. 5, Troyes, 1880, p. 111–113. The mention of the Joachite abbey is strange, since the writings of Joachim of Flore had been condemned in 1260. For St Urbain, see F. Salet, "Saint-Urbain de Troyes", *Congrès archéologique*, CXIII, 1955, pp. 98–122.

intended to be a house of prayer open to the public, and which he placed under the supervision of a college of twelve canons, including a dean, cantor and treasurer. The pope died before the work could be finished, and not only had it already been interrupted several times by the nuns who once owned the land on which it arose, but there was also some question as to the proper management of the funds by John the Englishman, the co-ordinator and controller of the work.[39] The apse and transept of the small building were largely terminated by 1266, but the nave and façade were completed only in the nineteenth century.

The regional background of St Urbain was both Champenois and Burgundian. The west front has a screened portal, a design of Hugh Libergier's for St Nicaise at Reims that was perpetuated in the area at St Julien du Sault, Puiseaux and Chaumont.[40] Two other forms – five-part vaults in the aisles and the respond of five shafts, each supporting a different rib of the vault – were even more local, appearing in the 1208 campaign at the cathedral of Troyes, which lies just down the street (Pl. 116). The lateral openings from choir to chapel were probably adapted from Notre Dame at Dijon,[41] and one of the most enchanting parts of St Urbain, the projecting gables at the summit of the elevation on the exterior, can be found in the ground story of nearby St Amand sur Fion (Pl. 117). All this was Champenois and shows the architectural currents as well as the persistence of certain forms in the region during the first half of the thirteenth century. St Amand, begun about 1250–1255, is particularly valuable because it reveals the continued impact of Hugh Libergier's work in the decade preceding St Urbain.

The Parisian elements in the collegiate church at Troyes can now be picked out more easily. Perhaps the most salient is the row of three

39. See my "A Note on Pierre de Montreuil", *Art Bulletin* (1962), for the probable position of Johannes Anglicus. A. Roserot (*Dictionnaire historique de la Champagne méridionale*, vol. 3, c. 1603) noted that he was a relative of Jean Langlois, beneficial priest of the cathedral, who made his will on 17 November 1274. Both may have been related to Jean l'Anglois, a cleric of Troyes who was in Constantinople in 1215–1216 (A. de Riant, *Exuviae sacrae Constantinopolitanae*, vol. 2, pp. 105–106).

40. See my *Burgundian Gothic Architecture*, London, 1960, p. 88.

41. *Ibid.*, p. 58.

gabled arches on the exterior of the triforium, which recalls a detail on Jean de Chelles' façade at Notre Dame. The large gable above the clerestory, albeit Champenois in its projection, has motifs that came from the Ste Chapelle Treasury (Pl. 71). And almost all the tracery patterns were Parisian: the triplet window of the apse, which had been virtually abandoned in Champagne after about 1235, but not in the Ile de France, where it appeared at Chaalis (Pl. 50) and in variants at Nogent and Tours (Pls. 36, 72); the twin-lancet-and-trilobe in the choir clerestory (compare Pls. 90, 91), and the arch-within-the-lancet that we noted at Beauvais and St Germer. Except for St Nicaise, which we can recreate only in our imaginations, nothing in Champagne particularly prepared the lightness and fineness of St Urbain. The contrast with St Amand is in this respect striking. Paris, on the other hand, was well able to provide examples of openwork balustrades, perfect linkage, minuscule ribs and mullions and total glazing between supports.

In some ways St Urbain was unique and stood outside historical affiliations. But its Parisian connections were strong and it shared many features with such contemporary works as Pierre de Montreuil's transept façade. The scale is intimate, the spaces are open (note the deep windows in the chapel, Pl. 116), the mouldings are precious and the tracery patterns form many variations on a few basic themes. Moreover the stained glass, with its small figures surrounded by large areas of grisaille and its rectilinear irons, is the perfect complement for the stonework.[42] The shrine-like character of the building is even more pronounced on the exterior, which is covered with pinnacles and finials of varying size. In every sense this little church would unquestionably have satisfied its patron's wishes for an exquisite object to commemorate his birthplace, one designed in the finest and most elegant manner of the time.

Another extension of the Court Style far from Paris can be found at

42. L. Grodecki, "Les vitraux de Saint-Urbain de Troyes", *Congrès archéologique*, CXIII, 1955, pp. 123–138. M. Grodecki steps beyond the intention of metaphor when he says "l'accord entre l'architecture et les vitraux est, dans ce choeur, si étroit que l'édifice – comme la Sainte-Chapelle de Paris – semble avoir été conçu en fonction de cette vitrerie et non point d'une autre" (p. 123).

Carcassonne, which reveals the benefits of not having a new Ile de France cathedral to copy.[43] The south French city revolted against royal control in 1240 and was at once taken over and emptied by the king's troops. In 1247 the people were recalled and settled across the Aude from the old city in a veritable *bastide* built in the manner of Aigues-Mortes and the other French and English fortified towns of the south-west. But the cathedral chapter did not recuperate its fortunes so easily, and it was not until 1267 that a new chevet was agreed upon and not until 1269 that the king granted the chapter the two "canes" of public road necessary for the proposed enlargement. The plan of St Nazaire is Cistercian, with three chapels opening off the transept on either side of a projecting apse (Pl. 119).[44] The chapels are separated by low walls like sections of dado, with open tracery above (Pl. 120).[45] All the vaults are at the same level, so that the volumes create a hall, and the elaborately decorated walls act as thin closures surrounding and penetrating the interior. The mullions are linked to the dado, and the tracery of the doublet windows is similar to that in the apse of St Germer, with curved triangles replacing the oculi.[46] These details, taken together with the presence of statues on the apse responds, point to the origin of the design in Paris.[47] But obviously under no circumstances could one confuse St Nazaire with a northern Gothic cathedral.

The interest of the non-episcopal plan of Carcassonne is real, for it is

43. See J. Poux, *La cité de Carcassonne, Précis historique, archéologique et descriptif*, 1925, pp. 174–211, and R. Rey, *L'art gothique du midi de la France*, Paris, 1934, pp. 195–200.

44. It is possible that the first Gothic chevet was to have an apse flanked by only one chapel on either side, as the Romanesque chevet probably did (J. Mahul, *Cartulaire et archives des communes de l'ancien diocèse de l'arrondissement administratif de Carcassonne*, vol. 5, Paris, 1867, p. 621). This suggestion receives some support from the archaeological examination of the building, for the other chapels were added in later campaigns.

45. The effect of these screens is not unlike that of the perforated walls in Norman monuments, for instance in the chevets of Rouen and Bayeux cathedrals, between the ambulatory and the oriented chapels.

46. The radiating chapels of Utrecht Cathedral, which was founded in 1254 but not carried forward for nearly twenty years, has similar forms over a Soissons plan. See F. A. J. Vermeulen, *Handboek tot de Geschiedenis der Nederlandsche Bouwkunst*, vol. 1, The Hague, 1928, pp. 410–414.

47. The colonnette with arris is also used (Poux, p. 203). The chapel of Bishop Guillaume Radulphe, of 1263, shows an earlier stage of northern forms at Carcassonne (the peak is visible in Pl. 119).

almost unique among cathedrals erected on royal French land in the thirteenth century. Were it not for the Parisian elements, one might think it reflected the adoption and enlargement of Cistercian plans that the Italian friars were making at the same time.[48] Compared with Carcassonne, Clermont is more of a regulation French design, although it was no less forward-looking at its date. The modernity of both monu-

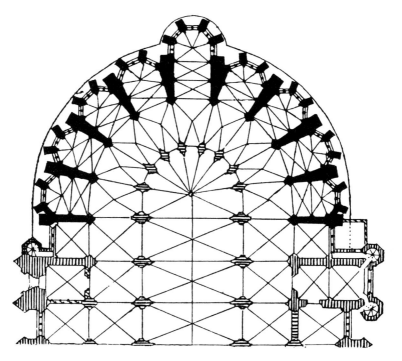

Fig. 9. Orléans, Ste Croix (Chennesseau).

ments is stressed by the lone and last royal cathedral of the Ile de France, Orléans (Fig. 9).[49] Begun in 1287, Orléans represents a complete retrogression. Here, in fact, is the outstanding example of academic thinking of the time: there are no less than nine deep chapels around the ambulatory,

48. E.g. San Francesco in Bologna (1246?) and Il Santo in Padua, or the Frari and Santi Giovanni e Paolo in Venice. Cf. R. Wagner-Rieger, "Zur Typologie italienischer Bettelordenskirchen", *Römische historische Mitteilungen*, II, 1957–1958, pp. 266 ff.

49. G. Chennesseau, *Sainte-Croix d'Orléans*, Paris, 1921.

two more than the most elaborate Gothic plans containing radiating chapels in preceding decades; the windows have heavy frames but they scarcely fill the bays and are surmounted on the outside by an enormous cornice; and on the interior there is a strict division between the windows and the dado. Orléans is an amalgam of the least modern ideas executed on a gigantic scale, ponderous and insensitive, especially when compared with Carcassonne and the Court Style of the 1260s.

★ ★ ★

Despite its many variations, Parisian design ran a predictable course after 1245 and after 1255 that course became almost fixed. There was no longer any question of imitating High Gothic, but rather of imitating the copies, of combining and recombining parts of famous local buildings, a continuing search for new effects within a constantly contracting horizon. The repetitions provide an excellent yardstick by which to measure the changes in tone that characterize the development of the Court Style. From the Ste Chapelle to St Germer, walls were welded together and surface patterns became less bulky, while from Jean de Chelles' transept to Pierre de Montreuil's, the parts were subtly but inextricably interwoven and given greater sharpness of definition. Even decorative details followed the general trend, the independent trilobe of the 1240s moving to the framed one of the '50s and this in turn to the pointed one of the '60s. But Parisian design never lost its monumentality, even though the calm and resolution of High Gothic were submerged in active, intricate detail. When the weight of the building dissolved, the struts of the mullions remained to provide a stable substitute. Even in the fourteenth century the Court Style of Paris can be recognized by these qualities and stands out from the other Gothic styles of Europe.

Opus Francigenum

ROM the time of its inception in the twelfth century, Gothic archi-
tecture was continually being exported from northern France to
distant parts of Europe. During the reign of Louis IX, Paris made
an important contribution to this movement, but it was a complex one
and must be carefully gauged. In the second half of the thirteenth century
older centres such as Soissons and Reims still exerted a distinct influence
abroad.[1] Beyond any doubt, however, the single most potent source of
Gothic forms after 1240 was Paris, and this was due in no small part to the
fact that it was the capital of France. "It is a fair assumption," in the words
of Robert Fawtier, "that the prestige of the Capetian monarchy helped
to create a preference for the artistic styles favoured in the royal domain
and the great royal city of Paris."[2] The capital was also an international
centre. Pierre de Montreuil's epithet, "teacher of masons" (1267),[3]
suggests that there were many apprentices in the city – as there were pre-
lates, dignitaries and students from all over Europe – and such a situation
is itself a kind of testimony to the importance attached to Parisian forms.
Architects went there to perfect their education and returned home with a
pocketful of ideas and drawings. There was also another side to the
pattern, for some patrons were inspired not so much by the intrinsic
beauty of the Court Style or even by its general prestige, as by the mean-

1. The plan of Soissons, for example, was used at Tournai and Utrecht, by the Dominicans at
Metz, and at Bayonne, while the plan of Braine served for St Maximin du Var (1279). Reims not
only inspired a development at Cambrai, Trier, Cologne and Marburg, but also sent masons to
Metz Cathedral in the late 1250s.
2. R. Fawtier, *The Capetian Kings of France*, London, 1960, p. 222.
3. For the epitaph, see H. Verlet, "Les bâtiments monastiques . . .", *Paris et l'Ile-de-France*, IX,
1957–1958, p. 20, note 4.

ing of several particular buildings and their association with the king of France. The exportation of Parisian style may therefore be examined from the iconographic as well as the formal point of view.

The Role of the Mendicant Orders

The Dominicans and Franciscans played a small but illuminating part in the diffusion of Parisian designs abroad. Both orders were founded in the early thirteenth century with an ideal of poverty and without strong traditions of monasticism.[4] They were urban as well as austere, and their popularity was nothing short of phenomenal. At first they were usually housed in buildings that already existed, and as late as the 1230s, wherever they were obliged to enlarge their churches or to put up new ones, the friars built in local style.[5] But in the 1240s a shift took place in their architectural practice, and they began to disseminate Gothic designs from north France across Europe.[6] It was then that they took up Parisian forms.

4. See R. Krautheimer, *Die Kirche der Bettelorden in Deutschland,* Cologne, 1925, esp. pp. 117–122, and G. Meersseman, "L'architecture des Dominicains . . .", *Archivum fratrum Praedicatorum,* XVI, 1946, pp. 136–190.

5. E.g. the Dominicans at Eisenach, Koblenz or Konstanz and the Franciscans at Seligenthal (see Krautheimer); or the Franciscans at Majorca (M. Durliat, *L'art dans le royaume de Majorque,* Toulouse, 1962, pp. 72–74), a primitive type related to Syria but also widely used locally (cf. Fortunato de Selgas, "San Félix de Játiva y las iglesias valencianas del siglo XIII", *Boletín, Sociedad español de excursiones,* XI, 1903, pp. 50–59 and 77–88). A remark must be made here about the Jacobins at Toulouse. In their reading of the texts, recent authors have failed to include a sufficient number of campaigns (E. Lambert, "L'église et le couvent des Jacobins de Toulouse", *Bulletin monumental,* CIV, 1946, pp. 5–50; Ch. Higounet, "La chronologie de la construction de l'église des Jacobins à Toulouse", *ibid.,* CVII, 1949, pp. 85–100; M. Prin, "La première église des frères prêcheurs de Toulouse, d'après les fouilles", *Annales du Midi,* LXVII, 1955, pp. 5–18; E. Lambert, "Les églises à deux nefs chez les Jacobins", *ibid.,* LXVIII, 1956, pp. 165–167). The church of 1230 must have been a simple chapel of one aisle, enlarged to the south by the addition of a second aisle after the purchase of land in 1234 (Prin's building), while a third church (perhaps resembling Lambert's two-aisled one) was begun in 1245–1246. Meersseman (pp. 150, 158) noted the friars' need to rebuild often at the start when they were located in large cities. The fragments of the 1234 church at Toulouse are in local style.

6. The exception was of course Assisi (1228–1236), which was unquestionably designed by a northerner and largely executed by Frenchmen. The architect must have been acquainted with eastern Burgundy (perhaps Dijon), and he certainly knew Reims, for he used a window with twin shafts on the central mullion in the transept; the nave and apse windows also fit into the pattern described in ch. 2, concerning the parallelism between plate and bar techniques in the 1220s. The relationship of the general parti of the upper church to Angevin Gothic design – the oversized

By the 1240s the friars were asked less and less often to preach in the parishes because their popularity tended to alienate the local clergy, and they simultaneously found their congregations growing, so that further enlargements to their own churches became necessary. Meersseman has noted systematic expansion in Dominican houses all over Europe at that time.[7] Almost without exception, the monuments and parts of monuments that have survived from the 1240s and 1250s reveal the presence of up-to-date Parisian forms. We must not, of course, expect complex elevations or elaborate frontispieces, for with few exceptions these were antipathetic to the friars, and the anomalous plans of most Mendicant churches rule out many other identifying features. But there are some elements, particularly window tracery, that suffice to distinguish Parisian origins at that early date. Indeed it would seem as if the friars carried tracery patterns abroad from Paris in the same way the Cistercians carried the ribbed vault from Burgundy a century before.

Among the first Mendicant monuments to suggest the widespread diffusion of Parisian forms is a small group of churches in the Rhine Valley and Bavaria. These buildings have many features in common, especially in their simple five or seven-part apses, which are characterized by a single story of tall windows. In the Dominicans' church at Regensburg (about 1246) and the Franciscans' at Cologne (about 1248, Pl. 122), the tracery consists of twin lancets surmounted by an oculus, and a trilobe crowns the doublet in the Dominicans' at Koblenz (after a fire in 1245).[8]

volumes, the wall-passage above a tall dado, and the large buttresses – has often been remarked, but in Anjou itself the type had not been used for some time and foreign examples from the thirteenth century show little if any relationship to Assisi. But the wall of Assisi can be considered a variant of the Rémois passage; tall dadoes flanking cubical spaces are known in the purlieus of Reims, even if not on the scale of San Francesco (cf. Ch.-H. Besnard, "Boult-sur-Suippe", *Congrès archéologique*, LXXVIII, 1911, vol. 2, pp. 170–185). See B. Kleinschmidt, *Die Basilica San Francesco in Assisi*, vol. 1, Berlin, 1915, for documents and views. I. Supino's view (*La basilica di San Francesco d'Assisi*, Bologna, 1924) does not seem tenable. See p. 147 below.

7. Meersseman, p. 159.

8. For Koblenz, see F. Michel in *Kunstdenkmäler der Rheinprovinz*, vol. 20, pt. 1, Düsseldorf, 1937, pp. 228–240; for Cologne, A. Verbeek in *id.*, Beiheft 2, Essen, 1950, pp. 141–159, and Rahtgens in *Kunstdenkmäler der Rheinprovinz*, vol. 7, pt. 2, Düsseldorf, 1929, pp. 1–41 – the hall-church nave was of course not Parisian; for Regensburg, Mader in *Die Kunstdenkmäler von Bayern*, vol. 22, pt. 2, Munich, 1933, pp. 59–76.

It is important to note that the pattern with the oculus, which is often compared to the windows of St Elizabeth at Marburg (1235), is in reality quite different from the latter.[9] At Marburg, the oculus moulding is independent of the framing arch, as in Jean d'Orbais' windows in the chapels of Reims Cathedral and in the early series deriving from them on the territory of the Empire; at Regensburg and Cologne, on the other hand, the more recent design with merged mouldings was employed, indicating renewed contact with France. The parti of Marburg was also an older one with two stories of windows, whereas the friars' apses followed the more modern design of a single tall story. A French example of the same type has fortunately survived at Montataire in the Oise Valley (about 1243-1244, Pl. 124).[10] Montataire reveals its connections with the capital by its forms as well as its location, for it is in reality a combination of the hemicycle windows of St Denis with the decorated altar-slab of the Ste Chapelle. The relationship to St Denis is particularly noticeable in the proportions of the windows, which are much taller than they are in the other early French monuments with similar tracery, such as the hemicycles of Essomes or Cambrai and Tournai. In Germany the windows were to be elongated even further. This is not to suggest that Montataire itself was the source for Cologne or Regensburg, but it does show that the type was a reality in Paris in the early 1240s.[11] The doublet-and-trilobe of Koblenz was also Parisian, as we have seen. And the early date of the friar churches in Germany is significant, for they were contemporary with the later parts of the Ste Chapelle and followed the St Denis Master rather closely. While this alone does not prove a Parisian provenance, it certainly strengthens the case.

The German group was not unique, for friar architecture of the 1240s and '50s in the south-west of Europe also made use of northern forms. St

9. Each church was executed by local workmen, in all probability, for Regensburg smacks of Cistercian details while Cologne (esp. the capitals) bears a striking resemblance to the cathedral there. For Marburg, see H.-A. von Stockhausen, "Zur ältesten Baugeschichte der Elizabethkirche in Marburg a.d. Lahn", *Zeitschrift für Kunstgeschichte* IX, 1940, pp. 175-187, with bibliography.

10. A. Mäkelt, *Mittelalterliche Landkirchen* (Beiträge zur Bauwissenschaft 7), 1906, pp. 71-77.

11. Another case is Bray, a decade later (L. Caudel, "Notice sur le prieuré de Bray", *Mémoires, Comité archéologique de Senlis*, 1855-1856, pp. 109-128).

Catherine's at Barcelona, begun about 1243, is an excellent example.[12] The lower windows of the apse, which were ready in 1252, contained three oculi above a triplet, and the upper windows, designed in a second campaign that ended in 1262, had a single oculus above a triplet (Pl. 137). If the nineteenth-century drawings of the church are accurate, the lobing may have had a look of later Italian work about it (although Wren's tracery at Old St Paul's looks the same; see Pl. 123). But taken in conjunction with the large, twelve-lobed rose window in the western wall, which had curved triangles along the rim and bore other resemblances to the south transept of Notre Dame, Parisian sources again seem indicated.[13] The relationship is strengthened by the appearance of both the doublet and the triplet in the Dominican church at Agen, which was begun in the mid-1250s (Pl. 126).[14] This triplet was to be the dominant pattern in local Mendicant architecture throughout the next century, including the churches of both orders at Toulouse. Agen, incidentally, is a building with two aisles of equal width, vaulted throughout, and must not be confused with the unequal aisles of the early Dominican buildings at Paris and Toulouse that resulted from enlarging the original, simple chapels. Like the Templar church of St Jacques at St Germain de Corbeil built during the last years of Louis IX's reign, or even like Nogent, it was all of a piece and probably was based upon the parti of a monastic refectory or capitular hall.[15]

In the extreme north the friars also used Parisian forms. The apse of the Dominicans at Louvain (1256), for instance, imitated the apse of the Ste Chapelle, and the great window in the eastern wall of the Dominicans at Rouen (1257) was also Parisian, as we have seen above (Pl. 115).[16]

12. A. Casademunt, *Santa Catalina*, Barcelona, 1886; see also L. Torres Balbas, *Arquitectura gótica* (Ars Hispaniae), Madrid, 1952, p. 124.

13. The Barcelona rose dated from the late 1260s.

14. Ch. Rohault de Fleury, *Gallia dominicana*, Paris, 1903, vol. 1, *sub verb.* Agen. Lunettes with oculi, similar to those in the nave tribunes of Notre Dame, are to be found in the "chapels" at Agen, but it is not certain whether they are restorer's inventions or not.

15. J. Lebeuf, *Histoire de . . . Paris*, vol. 13, pp. 133–134.

16. For Louvain, R. M. Lemaire, *Les origines du style gothique en Brabant*, pt. 2, vol. 1, Antwerp, 1949, pp. 37–45; for Rouen, see ch. 5.

It is difficult to find firm evidence as to whether or not the sources for this early diffusion were the friars' own houses in Paris. The great church of the Cordeliers was destroyed by fire in 1580 and replaced by a late Gothic building similar to the church at Orly or St Jacques du Haut Pas in the capital; no representation from before the fire is known.[17] And the pre-Revolutionary view of the Jacobins by Garnerey, who is usually reliable, seems to show four-lancet windows with three oculi, possibly of the type employed in the nave chapels of Notre Dame.[18] Nineteenth-century demolitions on the site turned up, in addition, only one triplet, which has already been mentioned (Pl. 108), and one doublet beneath a trilobe (similar to those in the Ste Chapelle Treasury), the latter located on the southern edge of the convent but difficult to place and date exactly.[19] The variety of window patterns in Mendicant houses abroad suggests that the Dominicans and Franciscans probably drew their inspiration from monuments in the capital other than their own churches.

The friars were also men of their age, of course, and they participated in the general diffusion of Gothic forms from northern France. Thus at Regensburg and Cologne they pierced the apse buttresses with exterior passages in the manner of Chartres, Le Mans and Tours. Once again Marburg, where a similar passage can be found, was probably not the

17. The chevet plan is in A. Berty, *Topographie du vieux Paris* (Histoire générale de Paris), vol. 5, Région occidentale de l'université, Paris, 1887, foll. p. 340; it is based upon Vacquer's excavation plan (Paris, Carnavalet Museum, Topographie, 106 B 1), but no remains were found for the chevet and Vacquer's radiating chapels are purely imaginary. The best evidence for the plan of the chevet is the Gondoin project of 1769 (Paris, Bibl. Nat., Est., Va 443) and the 1704 plan in Paris, Arch. Nat., N III Seine 99. These match other sixteenth-century plans (E.-J. Ciprut, "L'église Saint-Jacques du Haut Pas", *Paris et l'Ile-de-France*, XII, 1961, pp. 57–73). Berty propagated a second error by printing 1282 for 1582, the start of the reconstruction (p. 340); this was copied by V. Mortet, "Note sur l'architecte de l'église des Cordeliers de Paris au XIIIe siècle", *Bulletin monumental*, LXIV, 1899, pp. 70–72, who then inferred the master was probably Eudes de Montreuil – an extraordinary mistake for this usually careful scholar and ample testimony to the degree to which the De Montreuils have dominated modern thinking on this period. There does not in fact seem to be evidence to connect Eudes to the Cordeliers, although work was undertaken there with the money given by the king; there is no evidence that Eudes worked for Saint Louis at all – he was Master of the Works to Philip the Fair.
18. Y. Christ, *Eglises de Paris*, no. 41. The three western bays seem to differ from the rest and were perhaps one of the numerous additions made to the church over the ages.
19. Copies of an etching of 1880 showing the doublet are in Paris, Bibl. Nat., Est., Va 259 i, and Carnavalet, Topographie 95 A; for the plan, see also ch. 5, note 11.

source for this feature, for it was also employed in the mid-thirteenth century at other sites where an influence from the Lahn Valley was not possible; the chapels of León Cathedral in Spain (1255), where the passage is also associated with the two-lancet-and-oculus window, of the latest French type, is a case in point (Pl. 140). This movement was comparable to the renewed diffusion of a closely related type which the friars did not use after Assisi but which helps us to place their designs in better perspective – the interior or Rémois passage from northern France. The latter appeared at Naumburg, Pforte, Regensburg Cathedral and Bayonne Cathedral, always associated with the same window, and Westminster should probably be listed as the earliest member of this group.[20] Both the interior and the exterior passage were also represented in Paris, the one at St Denis and the other at Vétheuil (about 1220, Pl. 121), and it would be incorrect to exclude the capital from its proper share in contemporary movements even if it were not the unique source for all the forms that have come under discussion here.

Parisian Pickings

Three widely separated cathedrals attest to the influence of Parisian design after 1250, undoubtedly as the result of professional visits to the capital. They are León, Freiburg im Breisgau and Old St Paul's in London. The cathedral of León was begun in 1255 by the bishop, Don Martín Fernandez.[21] This man was a friend and protégé of Alfonso X the Wise, a cousin of Louis IX who ascended the throne of León and Castille in 1252. The bishop is said to have held the position of royal notary, which would have made him a member of the king's household, and he was undoubtedly a familiar personage in court circles. Alfonso was instrumental in his election to the see of León in 1254 and took a direct interest

20. For Naumburg, see W. Schlesinger, *Meissner Dom und Naumburger Westchor,* Münster-Cologne, 1952, with bibliography; for Pforte, Borgner in *Bau- und Kunstdenkmäler der Provinz Sachsen,* vol. 26, 1905, pp. 70 ff.; for Bayonne, E. Lambert, *L'art gothique en Espagne aux XIIe et XIIIe siècles,* Paris, 1931, pp. 250–257. The Liebfrauenkirche at Trier must be excluded, since, like Marburg, it has two stories of windows of the oldest Reims pattern.

21. For León, see Lambert, *L'art gothique* (1931), pp. 238–250, and Torres Balbas, *Arquitectura gótica* (1952), pp. 84–94.

in the new cathedral which was founded a year later. Although León was no longer to be the capital of a kingdom, the cathedral was certainly looked upon as a mark of the bishop's and the king's prestige. The master charged with the work was Henrique of Burgos, the second architect to direct the construction of the cathedral in the king's own capital city.

Whether or not Henrique was Spanish or French by birth is incidental to our purpose here, for his work on the Puerta del Sarmental façade of Burgos in the 1240s shows that he was intimately familiar with Champenois and Picard designs of the previous decade. The rose follows the centripetal pattern of the ones in the transept of Reims Cathedral, and the gallery above is a modernized version of the choir aisle window of Amiens.[22] Henrique's work at León also has strong Rémois overtones – in plan, as Lambert pointed out, and also in the presence of a three-portal, towerless transept façade, which appeared among the anonymous drawings of the Reims palimpsest (Pl. 140).[23] But this must not obscure other relationships for us, for Paris also played a distinct, if minor, role in the design of León. The towers that rise above the outer aisles of the Spanish chevet are a reduction of those surrounding the transept at St Denis (Pl. 100).[24] The disappearance of a western pair can also be noted in the movement from Laon to Lausanne or Tournai to Madgeburg.[25] And while the radiating chapels of León have an exterior passage associated with two-lancet-and-oculus windows, like the German friars' churches, we should not overlook the presence of an interior passage of the Dionysian variety in the choir aisles. Lest there be any confusion as to the provenance of this parti, it should be noted that the wall-rib rests on two colonnettes, one of which stops at the base of the passage while the other descends to the floor, precisely as at St Germain en Laye (Pl. 135). Finally, the triplet window surmounted by trilobes (in the clerestory, by

22. Cf. F. B. Deknatel, "The thirteenth-century Gothic Sculpture of the Cathedrals of Burgos and León", *Art Bulletin*, XVII, 1935, pp. 242–289.

23. See Branner in *Journal, Society of Architectural Historians*, XVII, 1958, pp. 9–21.

24. Lambert suggests Chartres as a source, but the relations in plan are closer to St Denis; moreover León, unlike Chartres, has no transept towers.

25. See my "The Transept of Cambrai Cathedral", in press with the *Festschrift für Ernst Gall*.

a flattened quadrilobe at the summit) recalls Amiens and the work of the royal French *chantiers* in the 1240s, in the same way as does the clerestory of Le Mans. Master Henrique was familiar with the ideas that developed in the ambiance of Reims in the 1230s, to be sure – in one way León might even be considered an example of the secondary Rémois milieux discussed in an earlier chapter.[26] But he also knew Parisian buildings at first hand. The most plausible explanation of this mixture is that Martín Fernandez sent him back to France in 1253 or 1254, and that he went to Paris as well as to sites to the north-east, adding a number of details to his already large repertory.

The Parisian features of Old St Paul's Cathedral in London have long been recognized.[27] Begun in 1258, probably to rival Westminster, the new east end of the cathedral used forms from the French capital in much the same way as did León (Pl. 131). There is no precise counterpart on the Continent to the enormous fenestration of the east front, but the narrow lancets and the transom are not unlike those of St Martin aux Bois (Pl. 89).[28] The rose with decorated spandrels has often been likened to Pierre de Montreuil's design in the south transept of Notre Dame, and the similarity is indeed striking, especially if one can interpret the rim of the circle in Hollar's drawing as a misunderstanding of a row of curved triangles.[29] The French architect's gallery may have been the source for the triforium in London, which had two lancets beneath a trilobe contained by a curved triangle (Pl. 114). The aisle windows, which were repeated on the east front, contained a triplet very similar to the one at Lys (Pl. 123), with the central arch doubled to occupy the space between the oculi (in the manner

26. The source for the elevation and piers of León is probably Agnetz (Pl. 12); see R. Parmentier, "L'église d'Agnetz", *Bulletin monumental*, LXXIV, 1910, pp. 470–488.

27. See P. Brieger, *English Art, 1216–1307* (Oxford History of English Art), Oxford, 1957, pp. 232–237, and J. M. Hastings, *St Stephen's Chapel*, Cambridge, 1955, pp. 5–12.

28. The church at Linas (Seine-et-Oise) also has a rose above seven lancets.

29. Curious international relations seem to have existed in the late thirteenth century around such forms. The London rose is not unlike the one at Barcelona (Pl. 137) or at Uppsala (G. Boethius and A. L. Romdahl, *Uppsala Domkyrka*, Uppsala, 1935, fig. 58) or Clermont Ferrand. Likewise the "transom", while related to St Martin aux Bois, also recalls the triforia of Altenberg (Fig. 14) and Limoges. P. Héliot, "Les triforiums-grillos," *Bulletin, Commission royale des monuments et des sites*, XIV, 1963, pp. 269–287, was received too late to use.

of St Urbain, where it can just be seen in Pls. 116 and 117), and the regular clerestory windows followed the triplet pattern of Chaalis or St Maur (Pls. 17, 50).[30] The buttress with mouldings at the corners and small spires was not unlike the last form used at Notre Dame, on the chevet chapels of the 1270s. The intermediate pair at Old St Paul's, above the aisle windows, was probably an attempt to give the cathedral the old French silhouette of two batteries.

Like the master of Old St Paul's and Henrique of Burgos, the master of Freiburg Cathedral was trained in one tradition and stepped outside it to borrow forms from Paris. The nave of Freiburg was undertaken no later than 1250 as a reduced version of the nave of Strasbourg, which lies not far down the Rhine River. The mouldings, the parti of the aisle with its Rémois passage and the early windows are all Strasbourgeois, as Reinhardt has demonstrated.[31] But in the prolongation of the work to the west, about 1255, Parisian elements made their appearance (Pl. 130).[32] The dado arcade, for example, is clearly copied from St Denis or St Germain en Laye, and the decorative rose-in-square at the end of the aisle is also Dionysian, although at an even more modest scale than was shortly to be employed at St Germer. This suggests that the triplet window may also have been from the vicinity of Paris, perhaps from a building such as the abbot's chapel at Chaalis. The early date of the aisles at Freiburg suggests that the master was, for a short while at least, in advance of his more famous colleagues down the Rhine.

The Strasbourgeois milieu, for all its Burgundian and Rémois origins and its strength of character, turned several times to Paris for ideas. The most famous case is the first elevation for the façade of the cathedral of

30. The origin of the tiny trilobe at the peak of the arch can be seen at Lys (Pl. 16) and was related to the trilobe in the arch-within-the-lancet of such windows as the one at the end of the aisle at St Sulpice (Pl. 90).

31. H. Reinhardt, "La nef de la cathédrale de Strasbourg", *Bulletin, Société des amis de la cathédrale de Strasbourg*, ser. 2, IV, 1937, pp. 3–28.

32. W. Noack, "Das Langhaus des Freiburger Münsters", *Schau-ins-Land* (Breisgau Geschichtsverein 77), 1959, pp. 32–48. I cannot agree with Dr Noack that a triforium was ever planned in the nave of Freiburg.

33. R. Wortmann, *Der Westbau des Strassburger Münsters*, (diss.) Freiburg, 1957, pp. 44–61.

Strasbourg (Riss A, Pl. 128).[33] Not only was the rose-in-square above the glazed gallery of this parchment drawing taken from Paris, but the progressive gable series was also adopted for the central bay, with the all-important arcading behind it. Certain elements, such as the arch housing three niches beneath the intermediate gable, paralleled the ground story of Pierre de Montreuil's façade, but the curved triangle is not present at all, so that the Strasbourg parchment can be dated shortly after the start of that work at Paris, about 1265. The artist of this design was a spiritual son of Jean de Chelles, far more than the men who made the façades of Poitiers or Troyes or Clermont. If his work seems more ornate and at a finer and less substantial scale than the transept of Paris, it is nonetheless considerably more monumental than the later designs at Strasbourg and than the actual façade as it was finally built. No one comparing the enormous parchments in the Musée de l'Oeuvre can fail to be impressed with the dignity and control of the first drawing, which is the smallest of all in real size, or for that matter with its fundamentally Parisian character. If it marked a certain departure from the tradition of the nave of the cathedral, it also set up an ideal that the succeeding architects at Strasbourg used as a starting-point for their ventures into extreme refinement.

The last example of Parisian usage within the purlieus of Strasbourg that can be examined here is Wimpfen im Thal (1269).[34] The people who came from all sides to see the new church and praise the architect were unquestionably under the impression that they were looking at a work in the Parisian mode of the Gothic style. The chronicler stressed the decorated character of the building and proudly indicated that the master not only was very skilled but also had recently come from the city of Paris. The church contains several distinctive citations from Notre Dame, particularly the gable series, the panels and the three gabled niches on the south transept (Pl. 129). And the statues of saints in the apse, which the chronicler singled out for attention, are quite clearly a reference to the Ste Chapelle. No one can disagree with Dehio's observation that the

34. A. Feigl, *Die Stiftskirche zu Wimpfen und ihr Skulpturenschmuck*, (diss.) Halle, 1907; F. Arens-R. Bührlen, *Die Kunstdenkmäler in Wimpfen am Neckar*, 2nd ed., Mainz, 1958.

architect had learned his craft at Strasbourg, but neither can he be denied a personal, working knowledge of Parisian forms.[35]

The foregoing examples, selected for their diversity as well as their coherence, make amply evident the nature and the mechanism of the influence of the Court Style abroad. It was largely a thing of bits and pieces – window tracery, arcades and the like – which could be combined in various ways with other elements. They seem to have been carried by men like Henrique of Burgos and the master of Wimpfen, who came to Paris having already learned their craft elsewhere. As more and more forms passed from Paris into the great circle of which it was the centre, however, their provenance became less and less meaningful. If Europe was first educated in royal Gothic design by Paris, it soon began to think for itself and went far beyond the precepts of its tutor. But one group of patrons was not as concerned with an education in forms as with the meaning that lay behind them, and it is in their monuments – Cologne Cathedral and the abbeys based upon Royaumont – that we find perhaps the most complete understanding of the Court Style.

Westminster and Cologne

Westminster Abbey and Cologne Cathedral have many things in common, not the least important of which is their indebtedness to Parisian prototypes. Both are enormous buildings, with ambulatories and radiating chapels and with aisled transepts of nine bays. And both took for their models the Ste Chapelle and other monuments that had recently been erected for the king of France and his courtiers. But there the resemblances end. Master Henry of Westminster was an Englishman born and bred, who looked at French buildings through the eyes of a foreigner, while Master Gerard of Cologne was French-trained from the start of his career and completely at home in the French manner. This difference goes far toward explaining the divergent and in some ways opposed interpretations they gave to the French originals.

Westminster was the shrine of Edward the Confessor, who had founded

35. G. Dehio and G. von Bezold, *Die kirchliche Baukunst des Abendlandes*, vol. 2, p. 38, note 1.

the Benedictine abbey and was buried there in 1066.[36] Standing outside the city of London, the abbey was not far from the king's palace and must have seemed like a royal symbol, especially to Londoners, who were often at odds with their monarchs.[37] In 1220 a Lady chapel was added to the eastern end of the church and while this may mark the start of a new building, the work was not carried forward. Then in 1245 the present building, on completely new lines, was begun by King Henry III. The reasons for the new project are fairly complex and require some explanation.

In the mid-1230s, after several serious political and financial setbacks, King Henry became particularly pious and devoted to Edward, whose cult was beginning to achieve national status. On at least four occasions he ordered a picture of the saint to be painted in one of his various chapels, and in 1241, at a cost said to have reached 100,000 marks, he had a new shrine for Edward started. He also had a special tribune constructed in the transept of the new abbey church. From it he could follow the services at the main altar – he was almost fanatical about hearing mass – and also look down upon Edward's tomb. In 1253 he changed his will, electing to be buried at Westminster rather than at New Temple. As it turned out, the remains of the saint were transferred to the new shrine in 1269 and when Henry died, in 1271, he was laid to rest in the very tomb from which Edward had just been taken. There can be no clearer illustration of Henry's obsession with the saint, an attitude that was already well developed by 1245.

Henry III was also a francophile, and his brother-in-law, Louis IX, was one of his favourite models. When the king of England returned from France in 1254, he had parts of Westminster decorated in the same way as the Temple hall he had seen in Paris.[38] In 1250 he ordered St Stephen's chapel to be painted with figures of the twelve Apostles, probably in

36. See my "Westminster Abbey and the French Court Style", *Journal, Society of Architectural Historians*, XXIII, 1964, pp. 3–18.

37. Brieger, *English Art*, pp. 106–107.

38. P. Tudor-Craig, "The Painted Chamber at Westminster", *Archaeological Journal*, CXIV, 1957, pp. 92–105.

imitation of the Ste Chapelle statues. And in 1247 he held a ceremony, which he asked Matthew Paris to write down, with which he marked the reception of the relic of the Holy Blood in England. Like Louis and the True Cross, Henry, amid a conclave of nobles and prelates, received the relic personally at St Paul's and carried it to Westminster, where the Bishop of Norwich pronounced the sermon, saying, "England takes joy and glories in the possession of such a treasure no less than France in obtaining the Holy Cross, which my lord the king of France rightly esteems"; Matthew added that Henry had taken for his model on this occasion "the king of the Franks, who in his own person did honour to the Cross at Paris".[39]

Henry's chief adviser in artistic matters was Edward of Westminster, a goldsmith and the son of a goldsmith, a man well equipped to cater to the king's passion for jewellery and precious objects. Both men must have been profoundly affected by the concept of the Ste Chapelle as a monumental reliquary, which was set forth in the papal bull of 24 May 1244. That probably explains the initiation of the new project as well as its rich detailing and finish, which were extraordinary even in England and which were undoubtedly intended to make of Westminster a sort of super-shrine to rival and surpass the French chapel. It also explains why Master Henry, the king's mason, was apparently sent at once to study the Ste Chapelle and other recent buildings in and around Paris, particularly Notre Dame, Royaumont and St Denis.

Having had occasion elsewhere to question the traditional derivation of the Continental elements at Westminster from such north French sites as Amiens and Reims, I will restrict myself here to the positive side of the problem, namely, that all the major foreign features at the abbey could be found in and around Paris in 1244–1245. The plan, for example, was based upon Royaumont, with the size and number of the chapels altered to fit around the early thirteenth-century Lady chapel on the site (Pl. 127). The tall, narrow elevation was also copied from Royaumont, as is

39. *Chronica major*, vol. 4, pp. 640–644.

clear from the distribution of the elements, especially the tall clerestory and the absence of linkage to the triforium (Pl. 133). Westminster's fame of course is based in no small degree upon its introduction of bar tracery into England, and in this realm the sources were clearly Parisian. The pattern of the clerestory and chapel tracery, as we have seen, belonged to the first wave of designs to be exported from the French capital, and the deep frame surrounding the upper windows strongly resembles the one at Royaumont. The tracery of the triforium screen looks like the apse windows in the lower story of the Ste Chapelle, and this pattern appears on the exterior of the abbey in the tribune, where it stands next to the curved triangle which also came from Paris (Pl. 132). The double arcade of the triforium, which Webb likened to the gallery at Worcester, might equally well have been developed from the twin arcades of the gallery joining the towers at Notre Dame.[40] The north transept rose at Westminster has long been compared with the north transept rose of Notre Dame, although it is likely that one model – the Ste Chapelle – was used for both.[41] And the five arches beneath it in King Henry's abbey characterized the façades of the Royaumont group of the 1220s that was mentioned earlier. The chapter and cloister of Westminster, which differ in tone from the design of the church, also had Parisian sources – the chapter windows recalling in all essentials the south nave chapels of Notre Dame, and the richer, freer tracery of the vestibule (Fig. 10) and east walk of the cloister resembling Nogent and Tours, both royal French *chantiers* active in the early 1240s.[42] The rib profiles of Westminster might have been moulded on those of Nogent, so close are they to the ones in Louis' building.

Edward the Confessor's church was tall, but Henry's was even taller, and the narrow, elongated space had strong French overtones for contemporary Englishmen. So did the plan with radiating chapels, which

40. G. Webb, *Architecture in Britain. The Middle Ages* (Pelican History of Art), Harmondsworth, 1956, p. 99. See L. Le Rouzic, *Le trésor de Notre-Dame de Paris*, Paris, 1948, fig. p. 114.
41. The original Ste Chapelle rose can be seen in the Très Riches Heures, but the detail is so small as to be almost useless archaeologically.
42. The absence of a clerestory passage at Westminster recalls the upper story of Tours.

was virtually unique in England at that time, and there is some reason to think that both features had connotations of royalness at the abbey.[43] Thus the facsimile of the royal French monuments was complete, and it

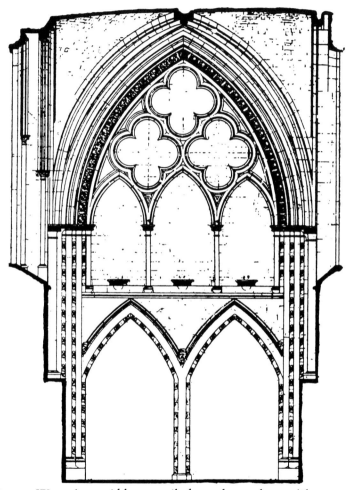

Fig. 10. Westminster Abbey, vestibule to chapter house (Shearman)

only remained to polish the Purbeck shafts, to sculpt the spandrels with figures and leaves and to surmount the arcades with incised and gilded

43. For the royal connotations of height, see Guy de Bazoches in R. de Lasteyrie, *Cartulaire général de Paris* (Histoire générale de Paris), Paris, 1887, vol. 1, p. 439 (*c.* 1175 A.D.); and Matthew Paris, *Chronica major*, vol. 4, pp. 279–280.

diaperwork, in order to create an enormous and dazzling reliquary for the remains of Saint Edward.

At Cologne, none of these features was found necessary except the plan and the height. The dado is plain, and there are no sculpted spandrels and none of the diaperwork or the imitation enamels that decorate the dado of the Ste Chapelle. Nonetheless the canons and the archbishop of Cologne probably thought they were getting a fair reproduction of the French chapel, at least one adapted to their particular purpose. The building was to be light and elegant, especially in comparison with local architecture of the previous hundred years. It was to have the very same intricate windows as the French work, and the hemicycle piers were even to support statues of the saints. It was probably with the idea of a replica in mind that the canons hired one of Saint Louis' masons to build their church.

The archaeological relationship between Cologne and the Ste Chapelle has often been remarked.[44] Some students, however, prefer to emphasize the similarities between Cologne and Amiens. The plans of both cathedrals, particularly the eastern ends, are very close to one another (Figs. 11, 12); the window tracery in the chapels is nearly identical (Pl. 136), and the rib mouldings are of the same family. But the differences between the two monuments are equally revealing. The piers separating the chapels from one another and the four-lancet windows of the aisles are not the same as those at Amiens, and all the windows at Cologne are framed on the exterior by heavy, crocketed arches. Such details can be multiplied without changing their basic import, to wit, that Cologne was connected to Amiens only indirectly, through the Ste Chapelle. The chapel was too small to contain all the features of the cathedral but it acted as a funnel, a

44. See F. de Verneilh, "La cathédrale de Cologne", *Annales archéologiques*, VII, 1847, pp. 57–69, and VIII, 1848, pp. 117–135; F. de Roisin, "Les cathédrales de Cologne et d'Amiens", *ibid.*, VII, 1847, pp. 178–187; Ch. Pfitzner, "Die Anfänge der Kölner Dombaus und die Pariser Bauschule der erste Hälfte des 13. Jahrhunderts", *Zeitschrift der deutschen Vereins für Kunstwissenschaft*, IV, 1937, pp. 203–217. See also H. Rosenau, *Der Kölner Dom* (Kölnische Geschichtsverein 7), Cologne, 1931, and M. Geimer, *Der Kölner Domchor und die Rheinische Hochgotik* (Kunstgeschichtliche Forschungen des Rheinischen Vereins für Denkmalpflege und Heimatschütz, 1), Bonn, 1937; P. Clemen, *Der Dom zu Köln* (Kunstdenkmäler der Rheinprovinz, 6.3), Düsseldorf, 1937.

flask in which certain elements were added to the combination of in-
gredients before the mixture was allowed to flow out at the other end.
The aisle windows are a case in point, for the ones at Cologne are literal
copies of those in the Ste Chapelle with variations only in lobing, and the
latter were derived from the nave chapels of Notre Dame, not from the
more primitive design of Amiens. Another Parisian ingredient at Cologne
is the St Denis Master's compound pier, a form totally missing from

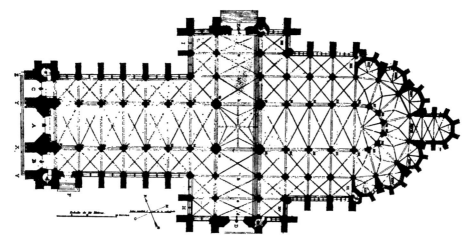

Fig. 11. Amiens, Cathedral (Durand).

Amiens (Pl. 134).[45] Some of the masons who worked on the chapel in
Paris must have come from Amiens with Thomas de Cormont, as I
suggested above, and they would have had at their disposal the entire
spectrum of early and mid-Amiénois forms, in addition to a knowledge of
their sources at Beauvais and Reims as well as of recent Parisian work.
Master Gerard, the designer of Cologne, was undoubtedly such a man.
He probably had little scope for expression in Paris, especially since he
does not seem to have been in charge of the work. But when he went to
Cologne, incidentally in the very same year in which the Ste Chapelle
was dedicated (1248), his Amiénois and Parisian background served him

45. See W. Gross, *Die abendländische Architektur* (1947), p. 18. Gross stresses the regularity and
"exemplarity" of Cologne (p. 21), as does Frankl (*Gothic Architecture* [1962], p. 127); but this may
simply be an expression of the older French attitude we have already noted at Royaumont and
Tours (see ch. 3 above), and that can also be found in the hemicycle of Amiens.

well and there he was able to express himself fully.[46] In this way Cologne was a major successor to Amiens as well as one of the most imposing statements of Parisian style in a foreign land.

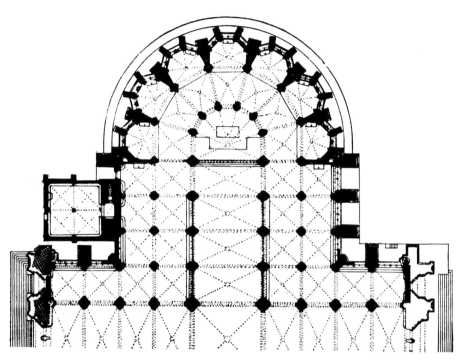

Fig. 12. Cologne, Cathedral (Clemen).

The reason for this exportation in its own way paralleled Henry III's reason for rebuilding Westminster. Matthew Paris called St Peter's Cathedral at Cologne *quasi mater et matrona* of German churches, a statement showing that the cathedral had a place on both the national and international scenes.[47] The re-construction was decided upon by the

46. Contrary to Frankl's opinion (p. 126, taken from Pfitzner), the piscinas of Cologne take the form of the tracery in the lower story of the narthex of the Temple (Pl. 81), with trilobes in the small oculi. The continuous ring of leaves running without capitals around the whole arch *anticipates* the work of both Pierre de Montreuil and the Porte Rouge Master at Notre Dame by more than a decade. An arcaded piscina with leaves on the rim is found in one of the south nave chapels in Paris.

47. *Chronica major*, vol. 5, p. 753.

chapter on 13 April 1248, when funds were allocated to the work, and
although the document recording the decision gives no reason, it is not
difficult to see that the canons wanted to create a new and splendid setting
for the relics of the Three Magi which Frederick Barbarossa had brought
from Milan in 1162.[48] These relics were highly venerated at Cologne,
almost as if in competition with relics that had been in the possession of
other German bishoprics for a much longer time, such as the nails from
the Crucifixion preserved at Trier. A magnificent gold shrine had been
made for the Magi in the late twelfth century, and Archbishop Englebert
(1216–1225) had already conceived the idea of erecting a new church to
house it, promising the huge sum of £1,450 a year for the work to the
then insolvent chapter.[49] The desire to increase the stature and renown
of the Three Kings at Cologne can also be seen in the indulgence granted
in 1247 by Innocent IV to all those visiting the cathedral on their feast-
day.[50] Shortly after the preliminary work on the new monument began,
there was a fire in the *chantier*, and as a result, on 21 May 1248, the pope
issued an indulgence intended to augment the building funds of the
chapter.[51] Innocent urged the faithful to contribute to the work "out of
reverence for God and the Three Kings", and significantly enough the
Magi are the only saints mentioned in the charter. According to Renais-
sance chronicles, which have a ring of truth about them, the shrine origin-
ally stood in the middle of the old Ottonian church and was to be located
in the crossing of the Gothic church when it was ready.[52] Clearly the
new building was intended as an enormous reliquary for the Magi.

 This idea must have been inspired by Louis' chapel in Paris. There is
also just a bare possibility that the authorities at Cologne wanted to use
the new monument to exalt the Holy Roman Emperor. The appearance

48. *Monumenta Germaniae historica*, Scriptores, vol. 16, p. 735.
49. Clemen, p. 50.
50. L. Ennen and G. Eckertz, *Quellen zur Geschichte der Stadt Köln*, vol. 2, Cologne, 1863,
p. 258.
51. *Ibid.*, pp. 277–278.
52. *Ibid.*, pp. 280–281 (Conrad von Isernhoff, 1526); cf. H. Crombach, *Primitiarum gentium seu
historiae sanctorum trium regum magorum . . .*, Cologne, 1654, p. 800 (I am indebted to Dr. Herbert
Rode for this reference).

of a fully-fledged French Gothic cathedral on the soil of German-speaking peoples was totally unheard of at the time and could only have been construed as in direct opposition to the old imperial ideals that had been given form in the architecture of Aachen and the great basilicas of the Rhine. From the time of its foundation, the cathedral of Cologne was referred to as the "Summus", a term accurately describing the inordinate height of the work, and height, as I have just pointed out, had distinctly royal connotations in the thirteenth century.[53] We must also not forget that at this time Emperor Frederic II had been deposed by the pope and the diadem had been offered to Louis IX's brother, Robert d'Artois. Traditions were vanishing on every side and new forms and alignments were being sought. In 1248 William of Holland, the second of Frederic's "replacements", held official title to the throne; he was present at the inauguration of Cologne Cathedral on 5 August and Archbishop Conrad von Hochstaden was to crown him at Aachen exactly six weeks later. Thoughts of the Christian *imperium* obviously lay heavy on Cologne in 1248 and the Gothic cathedral may have been an attempt to replace traditional imperial iconography with more modern forms based upon French examples.

Conrad von Hochstaden's francophilia did not stop with his cathedral, however, for in 1255 he laid the foundation stone of the new Cistercian church at Altenberg, that was to be a copy of Royaumont.[54] Altenberg is usually related to Cologne Cathedral, and while Walter, the architect, did employ some of the forms current in Cologne, they belonged to Mendicant rather than cathedral circles. Altenberg might be called a Cistercian version of the cathedral in the same way that Longpont and Royaumont were reductions of High Gothic cathedrals earlier in the century, were it not that it represents renewed direct contact with the old Cistercian elements in French court design. The plan, with its seven radiating chapels and one underdeveloped transept arm, is as close to

53. Cf. "Combustus est Summus", in the Annals of St Gereon under the year 1248 (*Mon. ger. Hist.*, Scriptores, vol. 16, p. 734).

54. See P. Clemen in *Kunstdenkmäler der Rheinprovinz*, vol. 5, pt. 2, Düsseldorf, 1901, pp. 11–49. I have preferred to analyse Altenberg rather than Xanten (1263), which was also in Conrad's circle.

Royaumont as it is to Cologne (Fig. 13); the triplet window surmounted by three trilobes in the choir aisles was clearly taken from royal French sources such as Tours, and the simplified structure of the upper parts recalls Tours in the same way as does Westminster (Fig. 14).

Iconographic reasons almost certainly lay behind this choice. Altenberg

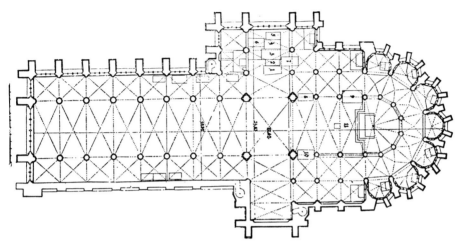

Fig. 13. Altenberg, plan (Clemen).

was the necropolis of the counts of Berg, and in 1246 Count Adolf IV had been persuaded by his brother-in-law, the archbishop, to join the revolt against Frederic II. The form of the new building may therefore in a way have become an expression of dynastic sentiment, an attitude that is supported by the fact that both Adolf and his brother, Duke Walram of Limburg, assisted Conrad at the founding ceremony. On the other hand King Louis had just returned from the Crusade in 1255 and despite the failure of the expedition he was now more than ever regarded throughout Europe as *rex christianissimus* because of his pious endeavour. The authorities at Cologne were on good and even intimate terms with him; Conrad, for instance, sent relics to Royaumont in 1260.[55] The archbishop and his metropolitan chapter had turned to French

55. *Gallia christiana*, vol. 9, cc. 842–843.

sources in 1248, and it was almost inevitable for Abbot Giseler and his architect to follow suit in 1255. And while the Ste Chapelle and Amiens, an episcopal church, served for the cathedral, Royaumont was the obvious source for a Cistercian abbey.

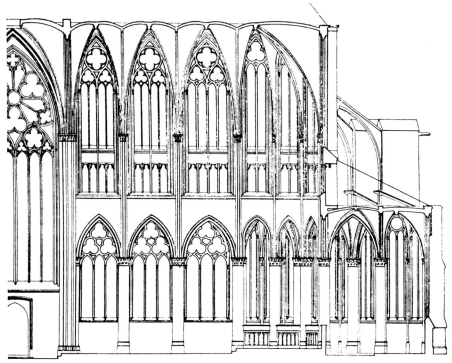

Fig. 14. Altenberg, section (Clemen).

Royaumont was considered something of a dynastic emblem by the Capetians themselves. When Louis' brother, Charles d'Anjou, became king of the Two Sicilies and established his authority by defeating the claimants to the throne, he set about erecting monuments to celebrate his victories and to stand as symbols of his rule.[56] Although he may not have formulated a comprehensive programme for this purpose, there can be no question that he relied heavily on family traditions for the inspiration of individual works. One of two Cistercian abbeys he founded in 1274,

56. E. Bertaux, "Les artistes français au service des rois angevins de Naples", *Gazettes des beaux-arts*, ser. 3, XXXIV, 1905, pp. 313–325.

commemorating the defeat of Conradin at the battle of Tagliacozzo, was
dedicated to the Virgin of the Victory, recalling his grandfather's Notre
Dame de la Victoire which was erected outside Senlis to perpetuate the
memory of the battle of Bouvines. The other abbey was called Realvalle
in souvenir of Royaumont, in Charles' words "quod et propinquitate
nominis ei assimilare studuimus", and a monk from Royaumont was
charged with finding an emplacement for the building. But it was the
Franciscans at Naples who reaped the architectural harvest.[57] Their church
was formally based upon Royaumont, with seven polygonal radiating
chapels and a short choir (Fig. 15), and it also contained current if
simplified forms of French tracery. San Lorenzo at Naples was a direct,
formal extension of the Court Style to southern Italy, a conscious expres-
sion of Capetian hegemony by Charles, indicating that in the 1270s
Royaumont more than ever retained its royal associations.[58]

The crowning example of this theme was unquestionably the church
of St Louis at Poissy.[59] After the king's canonization in 1297, his grandson,
Philip the Fair, set about creating the monuments and emblems that
normally follow such an act and that in this particular case were intended
to glorify the dynasty. Louis IX was the first Capetian saint, elevated to
this rank more than a hundred years after both England and the Empire
had been similarly honoured in the persons of Edward the Confessor and
Charlemagne, and Philip the Fair had worked long and hard to achieve
his purpose. The programmes undertaken were correspondingly elaborate
and grandiose. Louis' body was raised from its tomb at St Denis and placed
in a finer receptacle. His head was taken to the Ste Chapelle and his heart
was sent to Poissy where he had been baptized. Dominican sisters were
placed in charge of the shrine. In 1303 Philip also founded a church
dedicated to Saint Louis in his residence at Neuville aux Bois, which he
staffed with Victorine regulars from Ste Catherine du Val des Ecoliers and

57. R. Wagner-Rieger, "S. Lorenzo Maggiore-il Coro", *Napoli nobilissima*, I, 1961, pp. 1–7.
58. Charles' architects – Henri and Gautier d'Assonne, Baucelin de Linais, Thibaud de Saumur
and Pierre d'Angicourt – were all Frenchmen.
59. See Dom. L. H. Cottineau, *Répertoire topo-bibliographique des abbayes et prieurés*, vol. 2, Paris,
1937, c. 2307.

which he called Royallieu, clearly referring both to his grandfather and to the latter's foundation of Royaumont.[60]

The form of Royallieu is unknown to us, but the form of St Louis at Poissy, begun in 1298, is preserved in two large drawings in the Bibliothèque Nationale in Paris (Pls. 138, 139). The church was a full-fledged

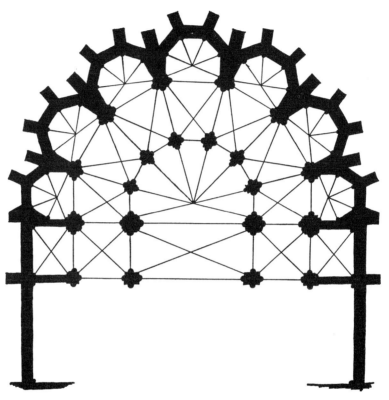

Fig. 15. Naples, San Lorenzo, plan (after Bertaux).

example of the best manner of the Court Style, as one would expect of a royal work with such a programme. Gables surmounted the windows and balustrades the cornices, while the transept had a great rose with glazed spandrels. All the forms used in the decoration of the exterior, including the window tracery, were already in existence during King Louis' lifetime, for example at St Germer, and the same probably held true of the

60. See P. Guynemer, *Cartulaire de Royallieu*, Compiègne, 1911, p. vi.

interior elements. Although the elevation very likely had only two stories, the plan was a quotation of Royaumont, with a simple transept as at San Lorenzo. It was entirely appropriate that this church should copy the king's favourite retreat, the first church he had erected during his reign.

<p align="center">★ ★ ★</p>

When St Louis at Poissy was being planned, the rest of Europe was moving ahead, leaving Paris in contemplation of its own dignified past. Until the Black Death and beyond, Parisian architects seem to have been content with their own tradition, repeating and refining the old models to produce extraordinary essays in elegance and sophistication. What had once been stimulating and meaningful behaviour turned into routine etiquette that was unable to contend with the virile, vigorous actions of other peoples and other climes. All over the western world about 1300, at Florence, at Gerona, at Wells, architects were again experimenting with volumes and massing, studying new surface effects and different lighting schemes. That movement, which inaugurated the late Gothic style, was non- or even anti-Parisian in nature. The Court Style of Saint Louis nonetheless left its mark upon an epoch. It contributed directly to the formation of another court style in London in the last decades of the thirteenth century,[61] and for a while it was considered the epitome of Gothic design by Europeans at large. But we must not think that the study of Parisian Gothic exhausts all that Gothic architecture of the thirteenth century has to offer. Other, non-courtly milieux existed both in France and abroad, and there are indications that there were movements around the periphery that never touched Paris at all. These questions could not be explored here nor could the more pertinent one of the absorption (and rejection) of Parisian elements in foreign lands. And the most fundamental question of all, that of Gothic mannerism, has been deliberately avoided since it is far too vast and complex a matter for the scope of this book. Perhaps these pages will some day be of service to the hardy individual who tackles that problem.

61. See J. M. Hastings, *St Stephen's Chapel* (1955).

The Chronology of Amiens Cathedral

I F the assumptions made in this book are correct, namely, that Thomas de Cormont went to Paris to design the Ste Chapelle for Louis IX and that the royal chapel was begun shortly after September 1241, then some of the generally accepted dates of Amiens Cathedral must be revised by a few years.

Whoever reads the text of Georges Durand's admirable monograph on Amiens cannot help noticing that the author was a trifle disturbed about where to place the suture between the central and eastern parts of the ground story of the building. He noted the continuity of forms from nave to transept to choir, as opposed to the new forms found in the ambulatory and radiating chapels. But he nevertheless placed the suture in the transept, noting the change in the height of the cornice stones in the eastern bay of the north wall of the north arm, as well as the abrupt termination of the band of sculpture running along the base of the triforium at the north-east crossing pier. The charter of 1236 seemed to provide him with a real date. It contains the renewal of the decision to destroy the parish church of St Firmin le Confesseur, the site of which was needed for the Gothic cathedral; the renewal was made presumably at the time the demolition was to be effected. The parish church was to be rebuilt on the site of the Hôtel Dieu, which was in turn to be moved elsewhere, and members of the Hôtel Dieu delayed the second part of the operation until 1238. But that does not mean the demolition of St Firmin was put off until that date, for space for parish services was provided in one of the aisles of the nave of the Gothic cathedral in the 1236 charter. According to tradition, the old church of St Firmin stood on the site of the Gothic north transept, which therefore could not have been begun until shortly after 1236.

The shift of forms from choir aisles to radiating chapels suggests that another architect designed the eastern part of the cathedral: there are new window forms, a new dado, new profiles in the ribs and detached colonnettes, which were not employed in the nave. This second master would have been Thomas de Cormont, who, according to the labyrinth laid in 1288, succeeded Robert de Luzarches. Thomas must have been a member of Robert's shop, as the accuracy of the alignments and the similarity of certain details of the work show; he was also a Picard, as his name indicates, and he was probably one of a number of local men hired by Robert to work on the nave of the cathedral. He did not succeed to the post of chief architect only when the radiating chapels were taken in hand, however. Although the new forms are found in the chapels, in the westernmost pair they are on one side of the parti-wall with the choir aisles and could not have been constructed independently of the latter. Thomas de Cormont therefore seems to

have begun his tour of duty by putting into place pieces that had been prepared by his predecessor. At what point then did Thomas take over? Probably when the ground stories of the transept terminals were being completed. The upper edge of this story on the south arm bore an inscription which seems to have mentioned Robert's name and which therefore may have been comparable to the inscription mentioning Jean de Chelles on the south transept of Notre Dame in Paris. One might assume in both cases that the inscriptions were picked by the successors of the masters mentioned.

The real dates of the parts are of greater concern, however. Using Pagès, an eighteenth-century writer who recorded local tradition, Durand assumed that the old church of St Firmin lay on the site of the present north transept. But an exact spot, such as toward the western or toward the eastern half, cannot be determined, and the transept itself is open to some question. Durand remarked that the transept terminals must have been put up very shortly after the nave and the western aisle of the transept, because of the strong similarities of the forms, and he also noted that the body of the nave was undoubtedly complete in 1233 when the policing of a temporary choir was arranged in the eastern bays of the new work. He stressed the date of 1236, since at that time provision was made for parish services in the aisle of the Gothic nave, but 1236 was only a *terminus ante quem* for the completion of the nave. 1233 was more real, and it must be emphasized here. If we accept 1233 rather than 1236, we may assume that the transept terminals (and parts of the eastern aisles which, on Durand's own analysis, go with them) were begun at the earlier date or even a year or two before, and that when the parish church came down, the choir aisles were ready to go up at once, followed by the radiating chapels. These parts involved foundations, it is true, but they did not rise high above the ground and they were relatively simple to construct: the elaborate scaffolds required in the upper stories were not necessary, nor did the stones have to be raised very far. If the church of St Firmin lay on the site of the north choir aisles rather than the transept, this demonstration is even easier to justify. Such an assumption is not out of the question, for the Gallo-Roman wall is presumed to have passed through the north side of the cathedral somewhere near the line separating the first and second choir-aisle bays (counting from the transept aisle). Hence the early chronology of Amiens would be as follows:

1218/1220 – 1233: nave and west aisles of transept (Robert de Luzarches)

c. 1230–1233: ground story of transept terminals in the works (Robert de Luzarches succeeded by Thomas de Cormont)

1236 (or before, depending on where old St Firmin was actually located): east aisles of transept; choir aisles, followed by radiating chapels (Thomas de Cormont).

It should be noted that this chronology places the eastern end of Amiens a bit closer in time to its immediate source, the chevet of Beauvais, which was begun in 1225, and also makes it contemporary with Tours.

For the extent of Regnault de Cormont's work, see Durand, pp. 25–39. It is difficult to agree with Durand that no work was undertaken before 1258 in this campaign. Viollet-le-Duc noted traces of fire – presumably that of 1258 – above the vaults of the radiating chapels, but he remarked that they did not appear on the courses of the triforium, directly above, which were fresh and clean (*Dictionnaire* II.325). He therefore assumed that the latter were put up after 1258. But we are not at liberty to extend this conclusion to the entire chevet, as did Viollet-le-Duc; there is no reason to assume that more than the hemicycle bays of the triforium and clerestory were not erected until after the fire of 1258. The latter might have been – indeed, they probably were – erected immediately after the fire, but it is clear that the choir bays were already in the works in the mid- or early 1250s, and that the third campaign was undertaken in the early 1240s, when Thomas de Cormont abruptly left the shop to go to Paris. The third campaign opened with the construction of the windows in the uncompleted central and outer bays of the west wall of the transept. The campaign continued with the triforium and clerestory of the eastern wall, where a regular progression is to be noted in the design. Then the upper walls of the chevet were erected and the transept and chevet were vaulted. Work seems to have been slow, especially during the Crusade (1248–1254), when the bishop was away with the king, and we must not forget that this campaign was almost exclusively concentrated in the upper stories, which were more difficult and lengthy to construct because they involved raising the stones to considerable heights. Even if the hemicycle clerestory was erected only in 1258, the whole monument was not ready for some eleven years more, a decade probably devoted to the vaulting. Regnault de Cormont placed the labyrinth in 1288 and hence may have been active for more than forty-six years at Amiens, but that is not impossible, especially if he was a young man when he succeeded his father as chief architect.

G. Durand, *Monographie de l'église Notre-Dame, cathédrale d'Amiens*, Amiens-Paris, 1901.

The Date of Clermont Ferrand Cathedral

THE following dates are generally accepted as marking significant points in the history of the construction of the cathedral of Clermont Ferrand:

1248: the inception of the Gothic church by Master Jean des Champs. The date is said to come from his tomb but is known only through a copy that was made in 1480 when the tomb was moved, and that was repeated by Dufraisse (p. 505); the 1480 copy has since been lost.

1262: the presence of Louis IX and members of his court at Clermont for the marriage of his son, Philip, to Isabella of Aragon; as an example to the court, Louis is said to have given money to the canons for the reconstruction (Dufraisse, pp. 497–498).

1263: G. de Cabezat, dean of the chapter, expresses in his testament the desire to be buried near the altar of Saint John *in novo edifico*; later this altar is known to have been located in the axial chapel of the Gothic work (Du Ranquet, 1928, p. 12).

1263: Pope Urban IV allows questors to seek money for the work throughout France (*ibid.*, p. 12).

1265: Pope Clement IV allows questors to seek money for the work in the dioceses of Bourges, Narbonne and Bordeaux (*ibid.*, p. 13, erroneously dated 1263; cf. Dufraisse, p. 499).

1273: Bishop Guy de la Tour gives land for the building; the piece in question had been promised by his predecessor (probably Hugh de la Tour, d. 1249) but had not been necessary before this time. The charter contains the phrase, "secundam formam inceptam et nunc apparentem" (Dufraisse, pp. 500–501).

1275: Guillaume de Jeu, canon, chooses the site for a family tomb in the radiating chapel south of the axis (Du Ranquet, 1928, p. 12).

1286: a silver altar-table is made (*ibid.*, pp. 13–14).

It is extremely difficult on archaeological grounds alone to accept a date of 1248 for the oldest parts of the Gothic work, that is, the radiating chapels and the ambulatory. There is no significant difference between the details of the chapels and those of the clerestory, which Du Ranquet assigned to a later period. All the details in the lower parts, as well as the ground plan, must in fact be compared with the cathedrals of Narbonne (begun in 1272); Toulouse (begun in 1272); Limoges (begun in 1273) and Rodez (begun in 1277). This suggests that the date of 1248 for the inauguration of the work should be reviewed. Only two factors support it:

the 1480 reading of the tombstone inscription and the gift of land by Bishop Hugh, who died in 1249. The latter does point to a project, but it does not prove that it was undertaken at once: as with moving the church of St Firmin le Confesseur at Amiens, agreement may have been reached but the step not actually taken until some years later. The 1480 reading of Jean des Champs' inscription at Clermont stands alone, therefore, in so far as the actual date of the commencement of building is concerned, and it cannot be controlled. On the other hand the 1273 document, which mentions that the building was then assuming a visible form, suggests that only at that time were the radiating chapels rising above the ground.

An argument against a date of actual construction in the 1260s can be based on the dean's testament of 1263, for its very existence suggests that he expected the chapel to be ready by the time he died. Such a date would be acceptable for the chapels to be nearing completion if they had been begun in 1248, for a span of about fifteen years also occurred at Troyes, Reims and some other sites (see R. Branner, "Historical Aspects of the Reconstruction of Reims Cathedral, 1210–1241", *Speculum*, XXXVI, 1961, pp. 23–37). But another, equally defensible interpretation can be put on the same document. There are cases where chaplaincies were founded for buildings that could under no circumstances have been ready for services at the time, and they must have been in the nature of signs of confidence in the work. At Reims, such a one was founded in the very year the foundation stone was laid (*loc. cit.* p. 33, n. 6); and at León Cathedral, which was begun in 1255, chaplaincies were founded in 1258 and 1259, long before the radiating chapels could have been ready to hold them and only in expectation of their completion (E. Lambert, *L'art gothique en Espagne*, Paris, 1931, p. 239). While a will is more personal and may have different overtones, I submit that the dean's testament was made in just such a context as existed at Reims and León. We must not forget that the cathedral at Clermont was rebuilt by the chapter, not the bishop (Dufraisse, 1273 document), and the dean may have been using his will in the way others did chaplaincies.

In sum, if the project was formed in 1248, nothing of any importance was done for nearly fifteen years, as was also the case at Cologne and perhaps at Westminster (1220). It was taken up again in 1262, perhaps under the king's stimulation, and obviously, as at Cologne and Westminster, an entirely new, up-to-date project was drawn up. At this time, work was undertaken in earnest, with questors sent out to raise funds, donations solicited, chapels founded and wills made in anticipation of the new work. Appreciable progress was made during the next decade, and in the late 1280s the church was being equipped for services.

J. Dufraisse, *L'origine des églises de France*, Paris, 1688;

H. du Ranquet, "Les architectes de la cathédrale de Clermont", *Bulletin monumental*, LXXVI, 1912, pp. 70–124;

Idem, La cathédrale de Clermont-Ferrand, Paris, 1928;

P. Balme, *La cathédrale Notre-Dame de Clermont*, Clermont, n.d.

APPENDIX C

The St Denis Master and
Pierre de Montreuil

MY view of the relatively slow development of an architect's style in the thirteenth century has led me to re-examine and to reject the time-honoured identification of Pierre de Montreuil with the St Denis Master.[1] If we compare St Denis or St Germain en Laye with the refectory and Virgin chapel at St Germain des Prés, Pierre's only uncontested works from the same time, it is difficult to conclude that both masters were one and the same person (Pls. 73, 77–79, 82, 83 and Pls. 40–47).[2] The scale of the chapel was extremely fine, quite unlike the bold forms of St Germain en Laye or St Denis, and from what we can tell of the refectory, it had similar subtleties. The extant arches of the chapel dado are pointed, with pointed trefoils below and a row of crockets that move against a thin sculpted cornice above. The mouldings are minuscule and the crockets look as if they had been taken from an illuminated manuscript. There is of course something of St Denis in the linkage of windows and dado,[3] but that can be found in several of the nave chapels at Notre Dame precisely at the same time (Pl. 76), and like the refectory windows or for that matter like the rose and gallery in the north transept of Notre Dame, it merely indicates that the St Denis master had a formal influence on Parisian designs in the 1240s, and nothing more. As for the famed portals in the "style of Pierre de Montreuil", they are really in the "style of Paris". The portal of the Virgin chapel, now in the Cluny Museum (Pl. 54), recalls those at the Ste Chapelle (Pl. 52) and the south transept of St Denis, but the same statueless design, with realistic foliage on the jambs, also characterizes the portals of the refectory of St Martin des Champs (Pl. 55), Gonesse (Pl. 53) and St Pierre aux Boeufs (now on St Severin, Pl. 51), among many others.[4] The architecture of the 1230s in

1. See my "A Note on Pierre de Montreuil and St.-Denis", *Art Bulletin*, XLV, 1963, pp. 355–357.

2. See H. Verlet, "Les bâtiments monastiques de l'abbaye de Saint-Germain des Prés", *Paris et l'Ile-de-France*, IX, 1957–1958, pp. 9–68, esp. pp. 20–25.

3. The mullions in Pl. 73 have been incorrectly assembled. They should alternate from weak (1) to strong (3). See ch. 4.

4. There are also examples at Larchant, nave; St Germain en Laye (north, Pl. 56, and south) and St Gervais in Paris (fragments now in the Cluny Museum). Older examples are Rouen Cathedral (St John portal, with statues); Villeneuve sur Verberie and St Frambourg at Senlis. Parallels can be found at Lincoln Cathedral (piers) and Ely (triforium). Perhaps the origin was the upper story of Suger's façade at St Denis. For this reason I cannot agree with Verdier that Pierre de Montreuil "invented a new type of Gothic portal decoration" ("The Window of Saint Vincent . . .", *Journal, Walters Art Gallery*, XXV–XXVI, 1962–1963, p. 90).

Paris was also rather heavily ornamented with vines and leaves, as for example the refectory lecterns at St Martin des Champs and also, according to reports, at St Germain des Prés, as well as the aisle portal at St Denis (Pl. 40), and one finds a foretoken of this on the façade of Amiens and a postlude in the Ste Chapelle (Pl. 48). But a stylistic mode of this sort does not prove that all the buildings were executed by the same master; quite the contrary, it suggests that several architects were at work side by side.

The document relating Pierre de Montreuil to St Denis is far from unequivocal. It is a charter of 1247 mentioning the man as a "mason of (or from) St Denis", but he is not given an official title such as Master of the Works.[5] It is therefore only natural to assume that if he worked at the abbey at all, he was not the chief architect, the *unus magister principalis* who normally was in charge of the design and execution of large works in the mid-thirteenth century.[6] Even if it could be proved that Pierre was the head of the workshop in 1247, the point is a minor one, for little if any major construction was going on at St Denis at that time. Work seems to have been suspended in 1241 and not taken up again until the abbacy of Matthieu de Vendôme (1258–1286). It was in 1241 that Abbot Eudes instituted and regulated feasts in the church, acts which seem to signify the end of construction and the preparation of the building for immediate use.[7] The charters mention the use of three altars, one – the main altar – located in the bay east of the crossing and another – the matutinal altar – probably situated at the western side of the present crossing.[8] The 1240s and '50s were also the time when the refurbished altars in Suger's radiating chapels were rededicated,[9] and the fitting out of monuments generally followed construction or was done between campaigns. Thus glazing the windows and decorating the chapels were probably the chief activities in hand when Pierre de Montreuil is said to have been at the abbey. Work also may have been slow during the Crusade (1248–1254), for perhaps only one altar was dedicated during that period. It would most likely have been considered unseemly to

5. H. Stein, "Pierre de Montereau, architecte de l'église abbatiale de Saint-Denis", *Mémoires, Société des antiquaires de France*, LXI, 1902, pp. 79–104.

6. V. Mortet-P. Deschamps, *Recueil de textes*, Paris, 1929, p. 291.

7. The November 1241 charter is in Félibien, *Histoire de Saint-Denis*, p. cxxii, and *Gallia christiana*, vol. 7, *instrumenta*, c. 102–104; the January 1241 charter, largely concerning Abbot Eude's provisions for the celebration of his own anniversary, is in Paris, Arch. Nat., LL 1157, pp. 85–87. The date of the letter is perhaps incomplete, but it must be 1241 or before Easter 1242 ("Anno Domini M° CC.° XL° primo mense").

8. E. Panofsky (*Abbot Suger*, Princeton, 1946, pp. 186–187) located the matutinal altar there, using seventeenth- and eighteenth-century sources, as well as twelfth-century ones. If the chronology proposed here is correct, the area around the matutinal altar would have been rebuilt after January 1234 but before November 1241 and probably before January 1237.

9. Formigé, *Saint-Denis*, pp. 121–122. Guilhermy (Paris, Bibl. Nat., nouv. acq. fr. 6122, p. 5) gives somewhat different dates (Saint Osmanna, 1245; Saint Cucuphas, 1254; Saint Hilarius, 1240). Guilhermy elsewhere raised some question about the date of the one chapel dedication falling outside this group, namely, that of Saint Pelegrinus in 1230 (*Inscriptions de la France*, vol. 2, pp. 125–128).

push work forward at the very site where the king had received the oriflamme before departing for the Holy Land. The period of the Crusade was undoubtedly also marked by caution in the regular commitment of funds, for unforeseen exigencies were common. Abbot Guillaume de Massouris, for example, sent a shipful of clothes and food to his monarch in 1253.[10] Between 1254 and 1258, under Abbot Henri Mallet, the transept may have been glazed, for it was ready for the transfer of the first tombs in 1259.

A lacuna in the construction of St Denis is most clearly shown by the building itself. There are no parts in the church that can be irrefutably assigned to the 1240s, or even to the early or mid-1250s, for that matter. Although the forms may look the same, various details such as the capital style indicate that the triforium and clerestory of the south wall of the nave and of the last five bays on the north (west of the monks' choir) were not erected until about 1260 or later (Pl. 47). The aediculae on the buttresses also belong to that time, when similar forms were used on the chapel at St Germer (Pl. 99).[11] This corresponds to the abbacy of Matthieu de Vendôme, who is credited in the *Chroniques de St Denis* with having finished "about half the work, the part toward the end" of the nave.[12] In 1259 a scaffolding fell and killed some monks and laymen who were walking around discussing the work, and this seems to confirm my suggestion that the shop had been reactivated.[13] And in 1263–1264 the first royal tombs were placed in the Gothic transept. As a whole, Matthieu's work seems to have been carried out very slowly, in sharp contrast to Eudes', for the completed church was dedicated only in 1281.

The importance of this chronology lies in the state in which the building was left in 1241. Even though at that time use was made of the monks' choir lying in the eastern bays of the new nave, as well as of the matutinal altar at the edge of the crossing, the choir was not yet complete. The text of the Annals of St Denis says as much,[14] and it is confirmed in the monument itself. Three clerestory windows remained to be erected on the south side (corresponding to the three that had been put up on the north by the St Denis Master before February 1237) and the vaults had not yet been raised above them. This suggests that the campaign of construction, which, like most Gothic planning, undoubtedly took both liturgical and structural factors into consideration, was not brought to a normal term but was interrupted. Not much remained to be done to complete the choir, but all the same Abbot Eudes ignored it and turned his attention to fitting out the chevet, thereby leaving us a precious indication that something untoward had happened in the shop. The St Denis Master, in fact, seems to have vanished from the abbey, for nothing short of the total disappearance of the architect-in-chief would have

10. *Recueil des historiens des Gaules*, vol. 20, p. 555.

11. They can also be found on the chevet of Meaux Cathedral and the nave of Châlons sur Marne, both also from the 1250s.

12. *Recueil des historiens des Gaules*, vol. 20, p. 654.

13. *Flores historiarum*, ed. Luard (Chronicles and Memorials, 95.2), London, 1890, p. 430.

14. See ch. 3, note 30.

prevented the completion of the monks' choir, which was a reasonably simple operation. Perhaps he was hurt and retired from work, like William of Sens, or perhaps he suddenly died. Lest the reader feel that I have invented a drama to cover the inadequacies of my argument, I must ask him to note that the drama is implicit in the building itself, in the abrupt and inexplicable cessation of work at a meaningless point in the general programme. The reader should also remember that in 1241 the presence of the designer was very probably necessary to the continuance of the work: instead of putting his ideas down on parchment, it is likely that the architect still followed the old method of carrying them around in his head.[15]

Recent works concerning St Denis:

S. McK. Crosby, *The Abbey of St.-Denis, 475-1122*, vol. 1, New Haven, 1942;

E. Panofsky, *Abbot Suger,* Princeton, 1946;

S. McK. Crosby, *L'abbaye royale de Saint-Denis*, Paris, 1953;

J. Dupont, "Travaux de mise en valeur â l'église abbatiale de Saint-Denis", *Les monuments historiques de la France*, 1955, pp. 106–115;

O. von Simson, *The Gothic Cathedral* (Bollingen Series, 48), New York, 1956; 2nd ed., New York, 1962;

W. Sauerländer, "Die Marienkrönungsportale von Senlis und Mantes", *Wallraf-Richartz-Jahrbuch*, XX, 1958, pp. 115–162;

J. Formigé, *L'abbaye royale de Saint-Denis. Recherches nouvelles*, Paris, 1960;

L. Grodecki, "Les vitraux allégoriques de Saint-Denis", *Art de France*, I, 1961, pp. 19–46;

R. Branner, "Paris and the Origins of Rayonnant Gothic Architecture down to 1240", *Art Bulletin*, XLIV, 1962, pp. 39–51;

R. Branner, "A Note on Pierre de Montreuil and St.-Denis", *Art Bulletin*, XLV, 1963, pp. 355–357;

S. McK. Crosby, "Abbot Suger's St.-Denis. The new Gothic", *Studies in Western Art*, vol. 1, Princeton, 1963, pp. 85–91.

15. See Branner, "Villard de Honnecourt, Reims and the Origin of Gothic Architectural Drawing", *Gazette des Beaux-Arts*, ser. 6, LXI, 1963, pp. 129–146.

BIBLIOGRAPHICAL NOTE

Since the bibliography for this book consists almost entirely of monographs devoted to individual buildings, and since these works can most quickly be found by consulting the pages where the buildings are discussed (via the Index), only books dealing with groups of buildings or with issues are mentioned here.

A. Boinet, *Les églises parisiennes*, vol. 1, *Moyen âge et renaissance*, Paris, 1958, with bibliography;

Y. Christ, *Eglises de Paris actuelles et disparues*, Paris, 1947;

M. Dumolin-G. Outardel, *Paris et la Seine (Les églises de France)*, Paris, 1936;

P. Frankl, *Gothic Architecture (The Pelican History of Art)* Harmondsworth, 1962;

H. Focillon, *Art of the West*, vol. 2, *Gothic Art*, London, 1963;

W. Gross, *Die abendländische Architektur um 1300*, Stuttgart, 1947;

R. Krautheimer, *Die Kirchen der Bettelorden in Deutschland*, Cologne, 1925;

L. Schürenberg, *Die kirchliche Baukunst in Frankreich zwischen 1270 und 1380*, Berlin, 1934.

Note: Relations between Assisi and Reims Cathedral are discussed by E. Hertlein, *Die Basilika San Francesco in Assisi*, Florence, 1964, which was received after note 6, p. 113, was written. I am not certain they were as closely related as Hertlein suggests, nor do I find any influence from royal French milieux at Assisi.

THE PLATES

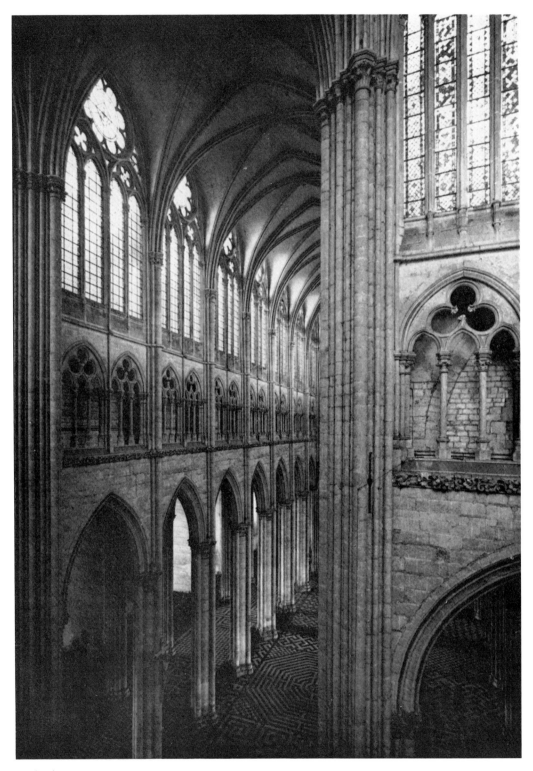

1. Amiens, nave

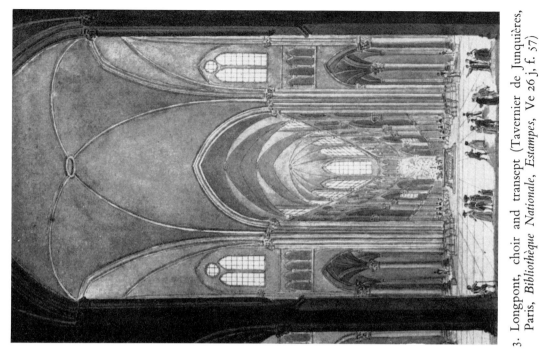

3. Longpont, choir and transept (Tavernier de Junquières, Paris, *Bibliothèque Nationale, Estampes,* Ve 26 j, f. 57)

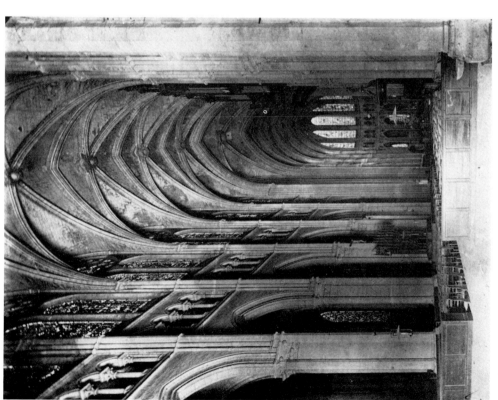

2. Chartres, nave

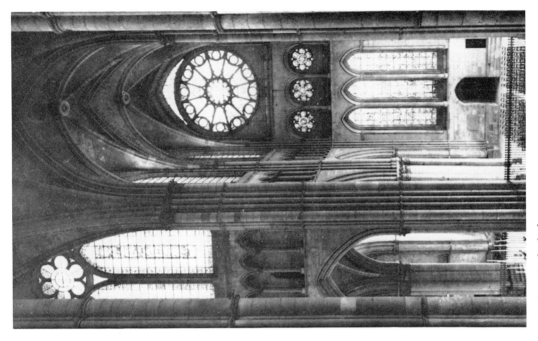

5. Reims Cathedral, transept

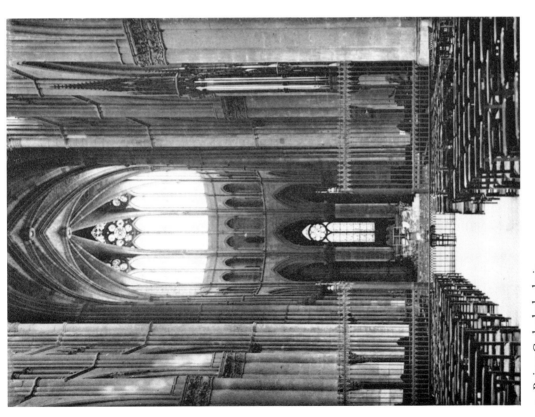

4. Reims Cathedral, choir

7. Amiens, detail from buttress on west front

6. Amiens, north transept, aisle window on west side

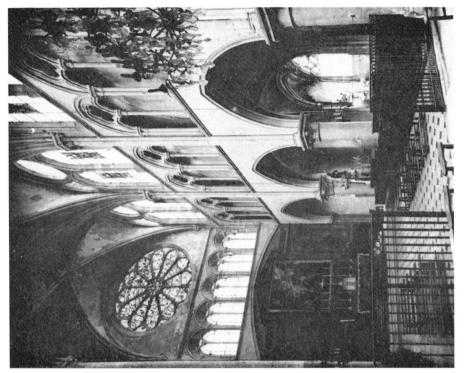

9. Brie-Comte-Robert, choir

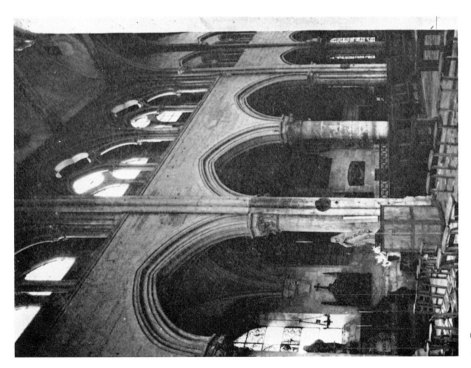

8. Gonesse, nave

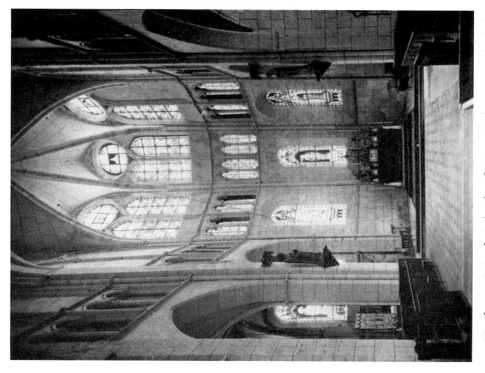

11. Vaudoy en Brie, choir (with triforium windows painted open)

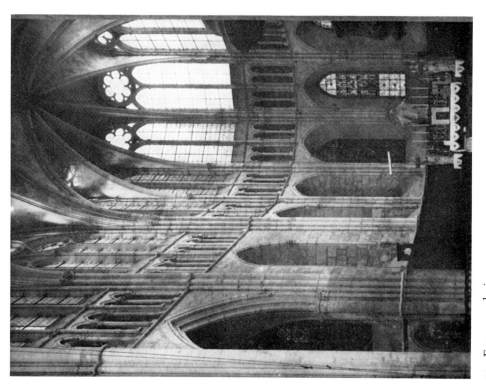

10. Essomes, choir

13. Reims, St Jacques, nave

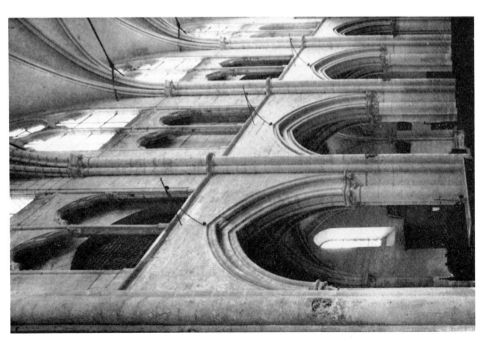

12. Agnetz, nave

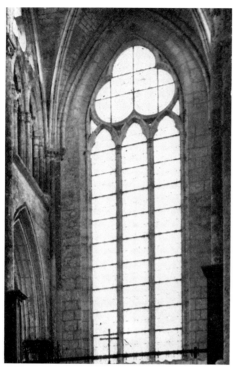

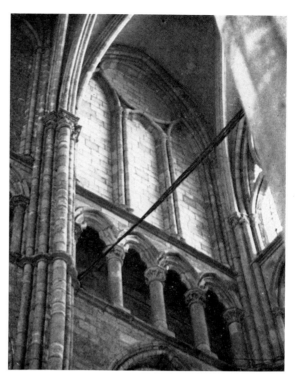

14. Cambronne lès Clermont, east window

15. Châlons sur Marne, Cathedral, south transept, east wall, detail

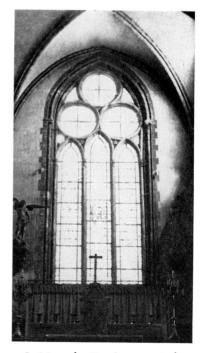

16. Lys, apse window

17. St Maur des Fossés, east window

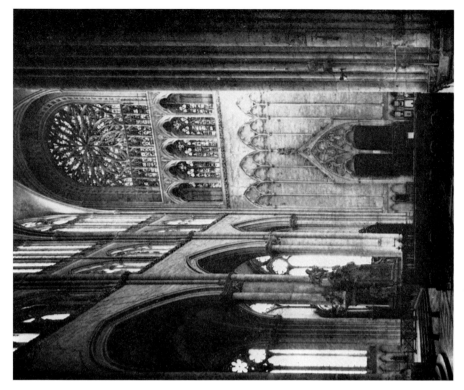

19. Amiens, south transept

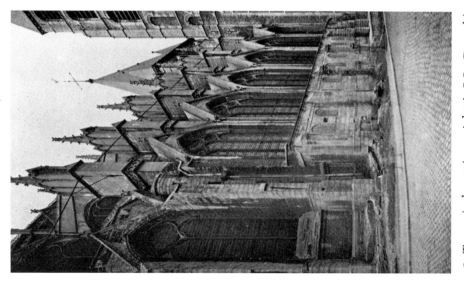

18. Tournai, chevet (copyright A.C.L., Brussels)

20. Cambrai, Cathedral
(van der Meulen)

21. Arras, Cathedral
(Garnerey)

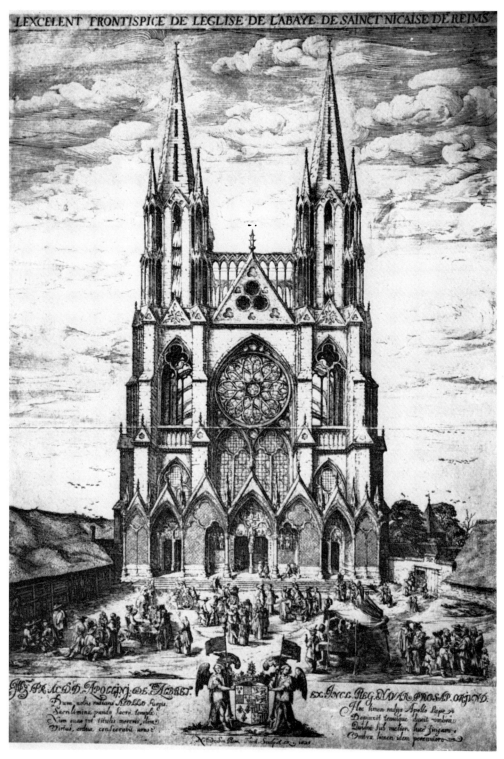

22. Reims, St Nicaise (De Son, 1625)

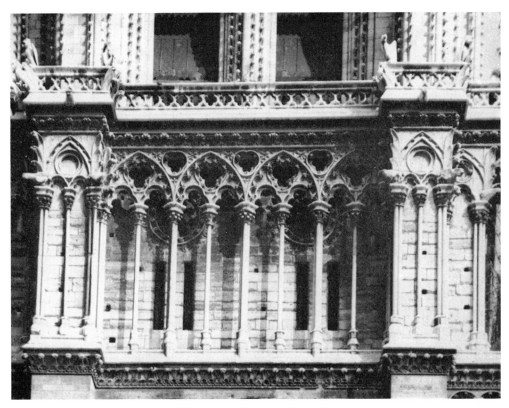

23. Paris, Notre Dame, façade gallery, north tower, west side

24. Paris, Notre Dame, façade gallery, south tower, east side

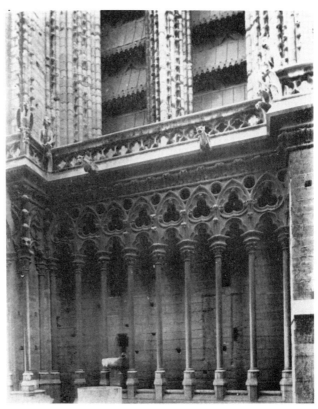

25. Paris, Notre Dame, façade gallery, north tower, south side

26. Royaumont, triforium detail

27. Royaumont, arcade capital

28. Royaumont, triforium capital

29. Royaumont, detail of triforium

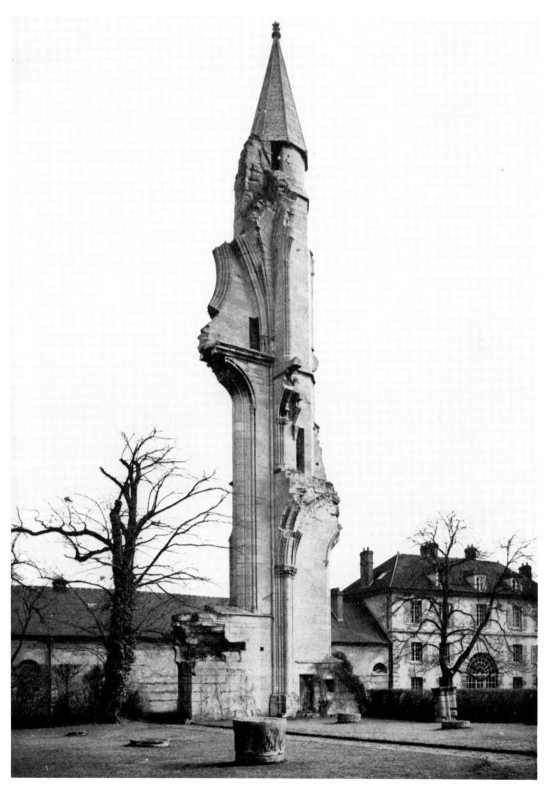

30. Royaumont, north transept

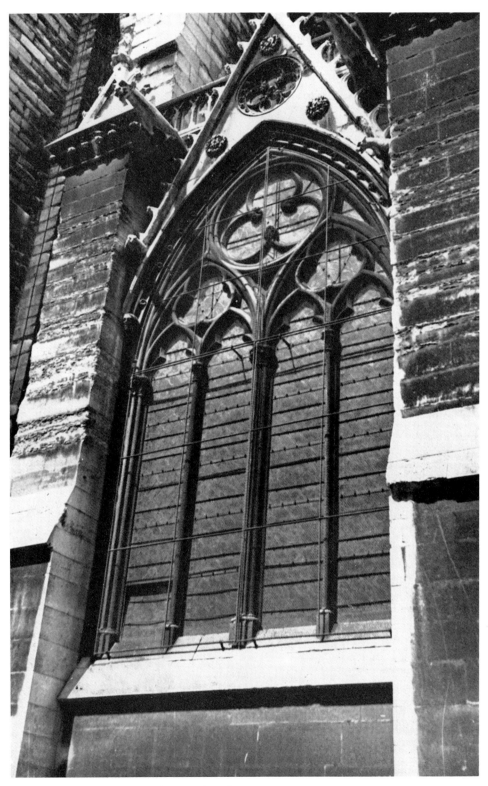

31. Paris, Notre Dame, south nave chapel 1

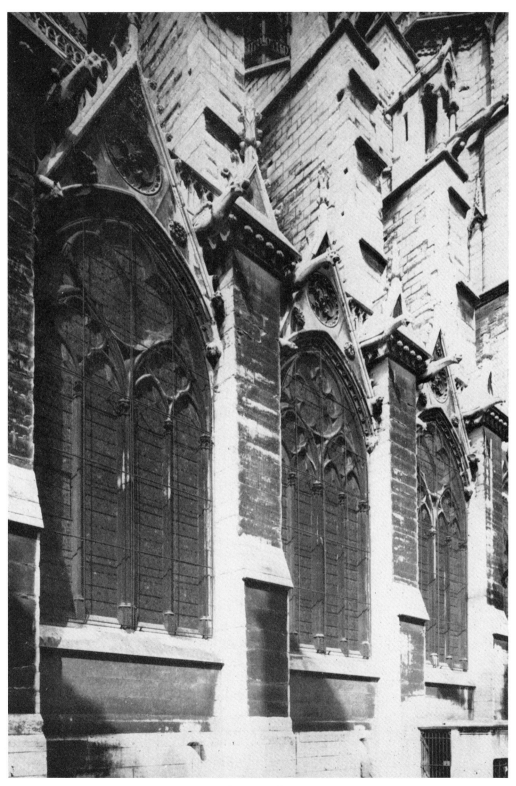

32. Paris, Notre Dame, south nave chapels 5, 6 and 7

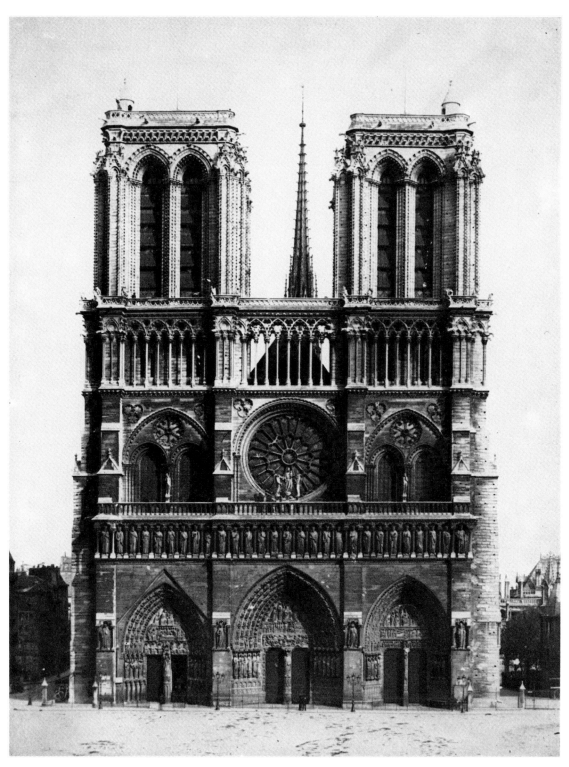

33. Paris, Notre Dame, west front

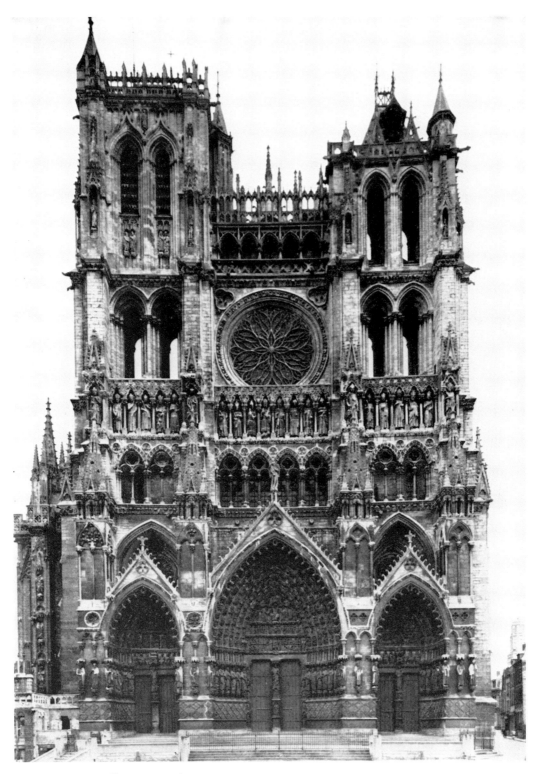

34. Amiens, west front

36. Tours, hemicycle

35. Tours, ambulatory

38. Troyes Cathedral, south aisle

37. Troyes Cathedral, hemicycle

40. St Denis, nave aisle

39. Auxerre, south aisle

42. St Germain en Laye, chapel from west

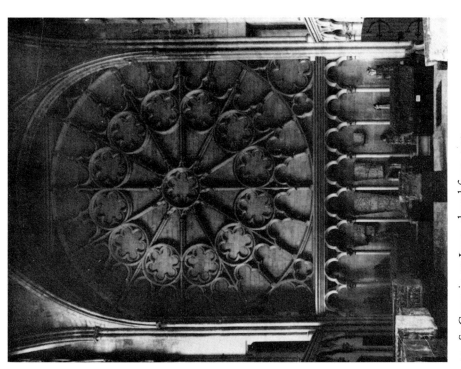

41. St Germain en Laye, chapel from east

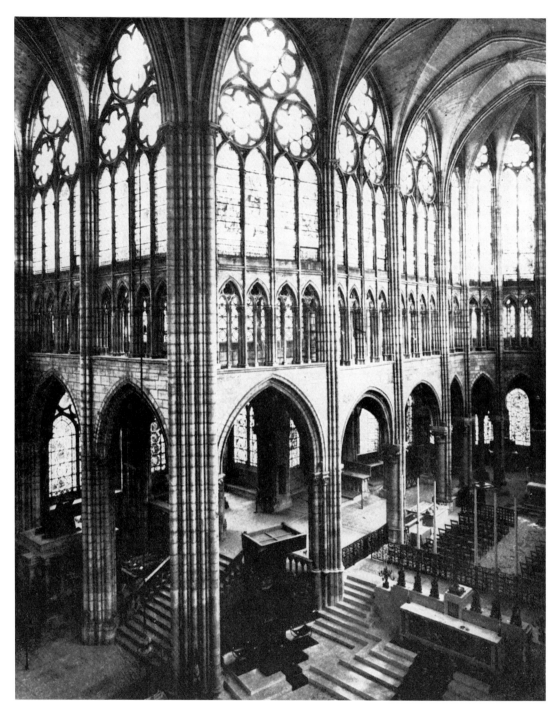

43. St Denis, choir and north transept

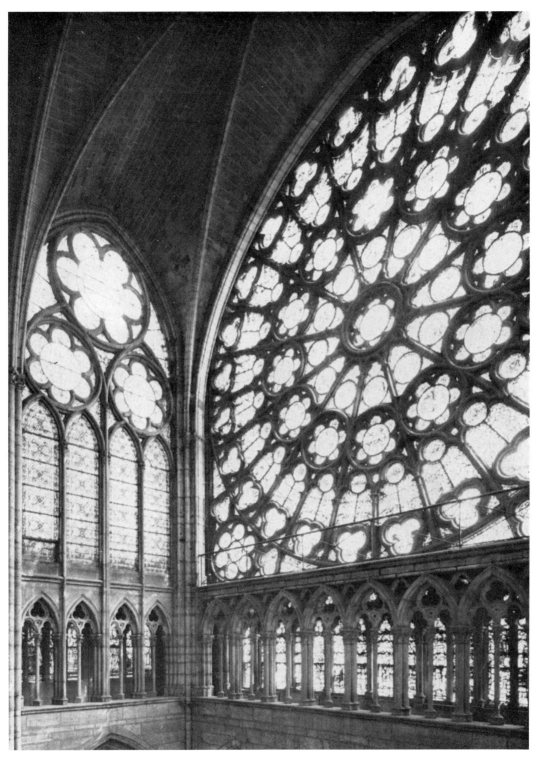

44. St Denis, south transept

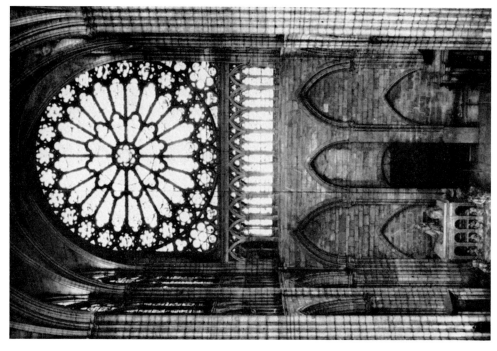

46. St Denis, north transept

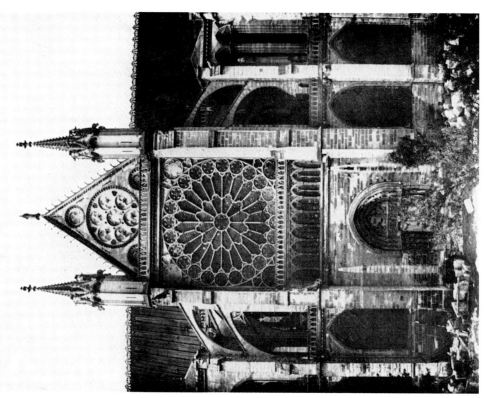

45. St Denis, north transept

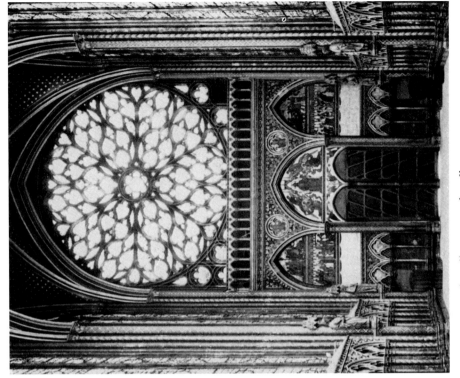

48. Paris, Ste Chapelle, terminal wall

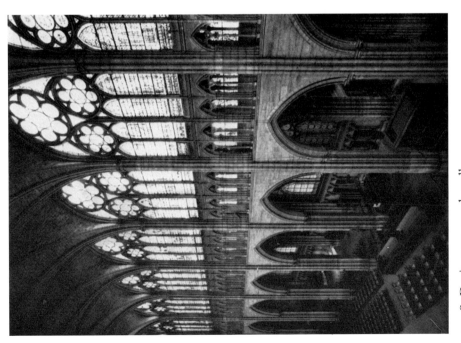

47. St Denis, nave, north wall

50. Chaalis, abbot's chapel (Paris, *Bibliothèque Nationale, Estampes*, Va 145 a)

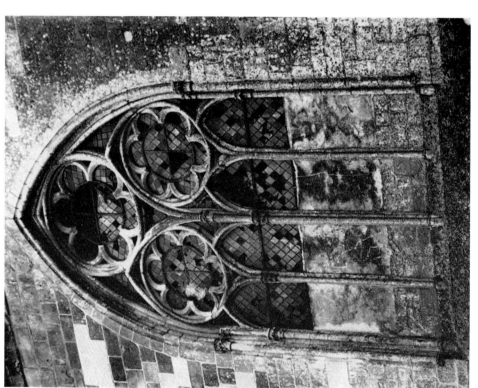

49. Angicourt, chevet window

51. Paris, St Pierre aux Boeufs, portal (now St Severin)

52. Paris, Ste Chapelle, portal

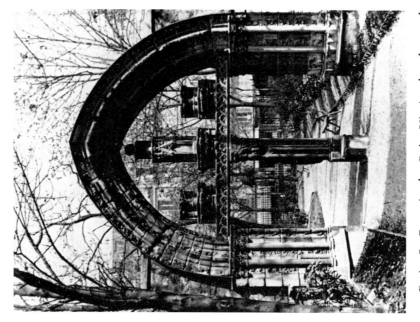

54. Paris, St Germain des Prés, Virgin chapel, portal (Cluny Museum)

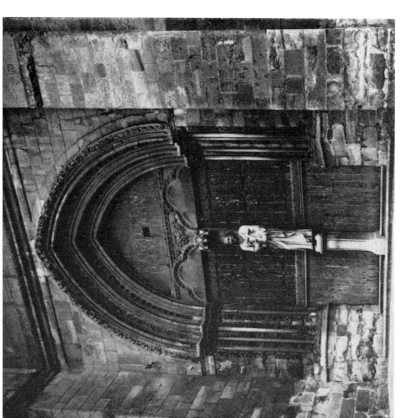

53. Gonesse, portal

56. St Germain en Laye, north portal

55. Paris, St Martin des Champs, refectory, portal

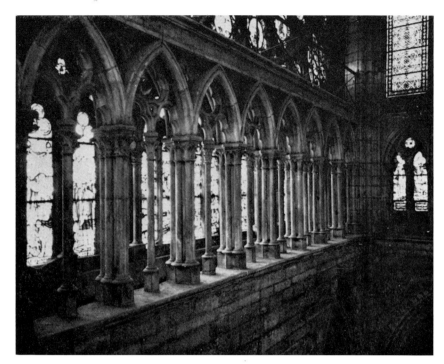

57. St Denis, north transept triforium

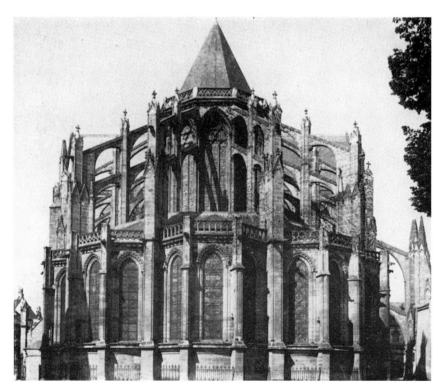

58. Tours, chevet

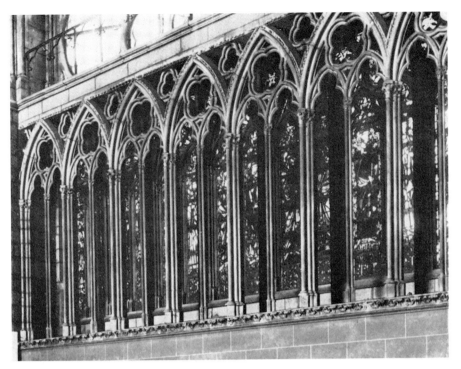

59. Paris, Notre Dame, north transept triforium

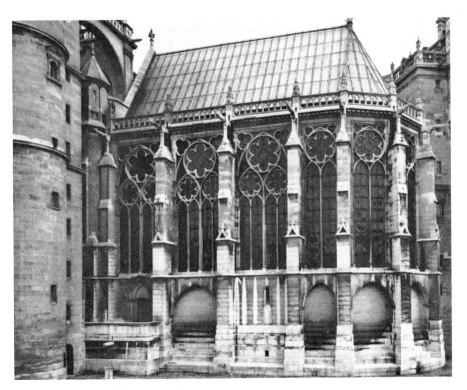

60. St Germain en Laye, chapel

62a. Paris, Ste Chapelle (Decloux and Doury): lower chapel

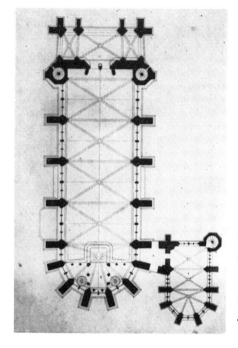

62b. Upper chapel

A Rondpoint ou Chevet
B Chœur
C Nef

1 Autel de St Denys
2 Grand Autel
3 Autel de la Communion
4 Autel Funebre du Roy Louis XIII

5 De St Benoist
6 De St Jean Baptiste
7 De St Lazare aujourd'huy de Sacriste haute)
8 De St Romain Cesf
9 De St Eugene Mart
10 De St Euphore Mart
11 De la Ste Vierge
12 De St Pregrin Ev. et Mart
13 De St Maurice Mart
14 De Ste Romaine Vierge
15 De St Germain Ev. et Mart
16 De St Eustache Mart
17 De Nostre Dame la Blanche
18 De St Hippolyte Mart
19 De St Anne ou des Pelerins
20 De la Ste Trinite
21 De St Marin Evesque
22 De Ste Magdelaine
23 De St Michel aujourd'huy la Sacriste basse)

Tombeaux
24 De Marguerite Comtesse de Flandre)
25 Du Roy Francois I.
26 De Guillaume du Chastel
27 Des Valois
28 Du Roy Louis XII.

Voyez les Tombeaux du Chœur pag 260.
Et les autres Tombeaux pag XXI et bas.

Plan de l'Eglise de Saint-Denys en France.

61. St Denis (Félibien)

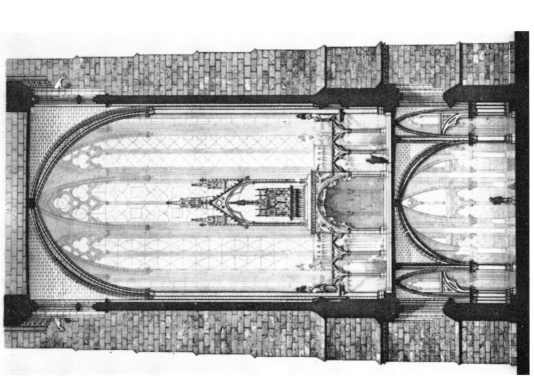

62d. Longitudinal section

62c. Cross section

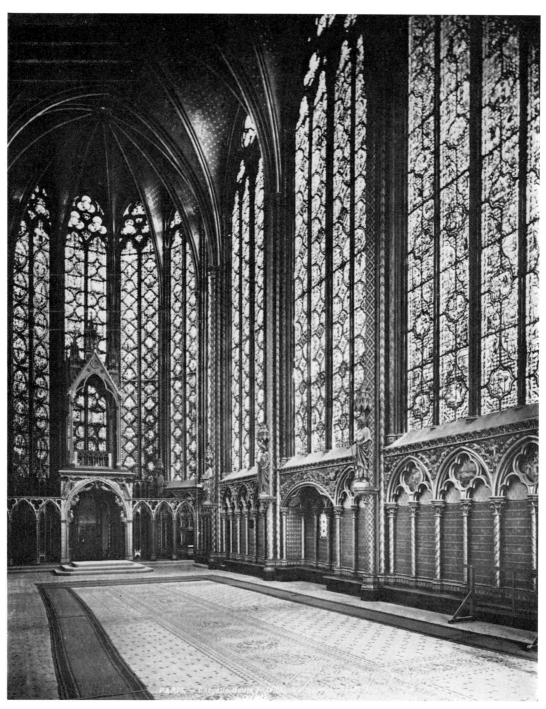

63. Paris, Ste Chapelle, upper chapel

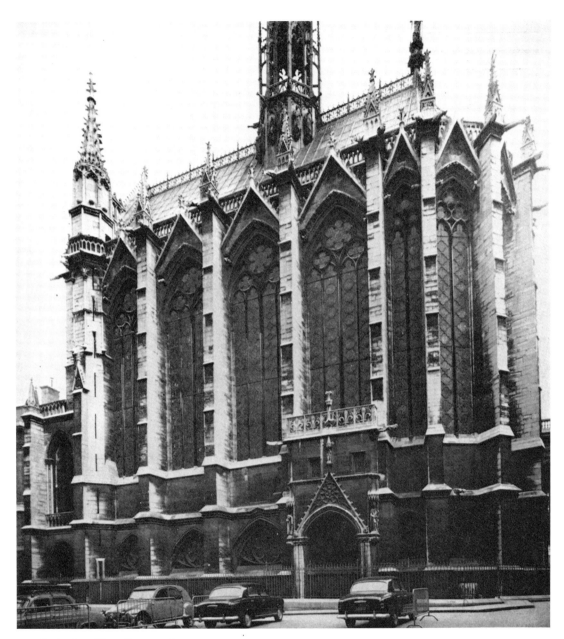

64. Paris, Ste Chapelle, exterior

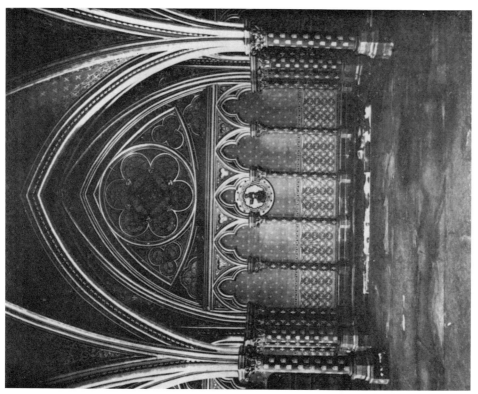

66. Paris, Ste Chapelle, lower chapel, detail

65. Amiens, radiating chapel, dado

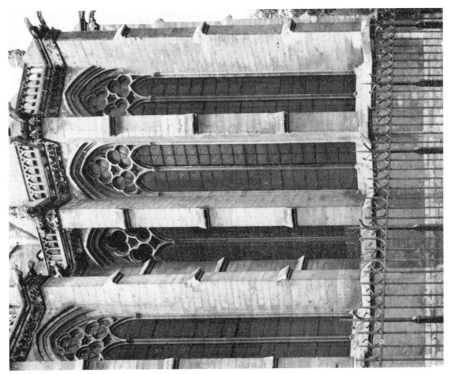

68. Amiens, radiating chapels

67. Amiens, ambulatory

71. Paris, Ste Chapelle, Treasury (T. de Froideau, Paris, *Bibliothèque Nationale, Estampes*, Ve 53 g, p. 126)

70. Amiens, nave aisle

69. Paris, Ste Chapelle, upper chapel, detail

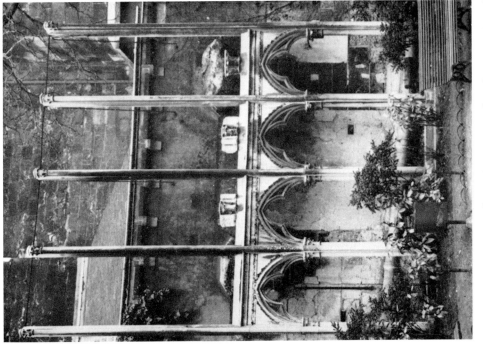

73. Paris, St Germain des Prés, Virgin chapel, reconstituted bay (incorrect)

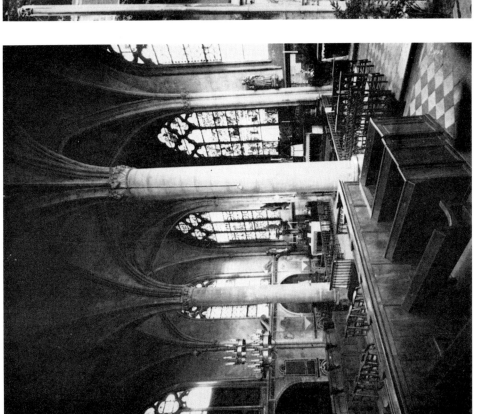

72. Nogent les Vierges, chevet

74. Paris, Ste Chapelle, altar fragment

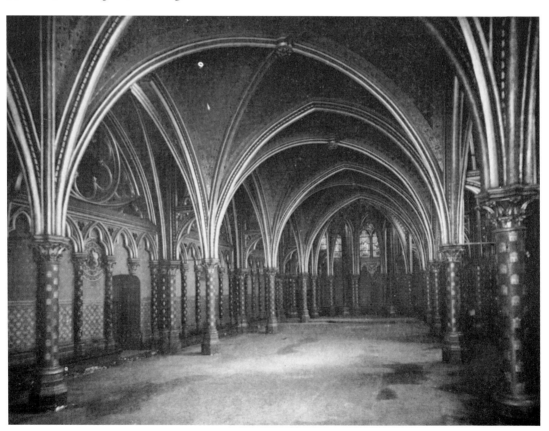

75. Paris, Ste Chapelle, lower chapel

76. Paris, Notre Dame, north nave chapel 5, dado

77. Paris, St Germain des Prés, refectory (Paris, *Bibliothèque Nationale, Estampes*, Ve 53 d, p. 67; Weigert 133)

78. Paris, St Germain des Prés, refectory, longitudinal section (Frère Nicolas, 1713, project for library; Paris, *Archives Nationales*, N III Seine 85/4)

79. Paris, St Germain des Prés, Virgin chapel, details

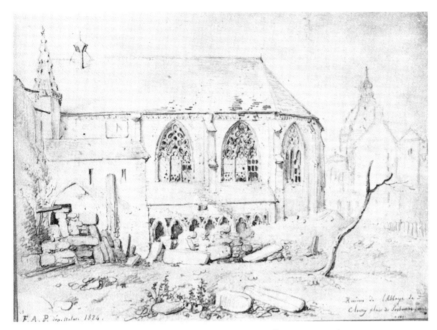

80. Paris, Cluny College (Pernot, 1824; Carnavalet Museum)

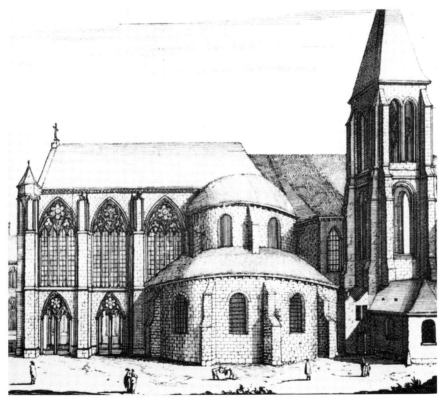

81. Paris, Temple (Israël Silvestre)

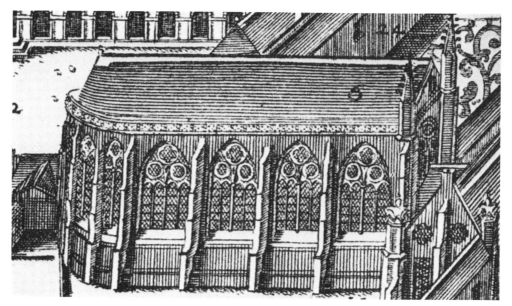

82. Paris, St Germain des Prés, Virgin chapel (1687; *Monasticon Gallicanum*, pl. 75)

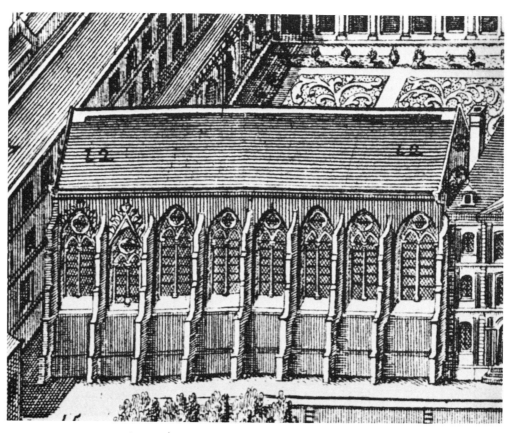

83. Paris, St Germain des Prés, refectory (1687; *Monasticon Gallicanum*, pl. 75)

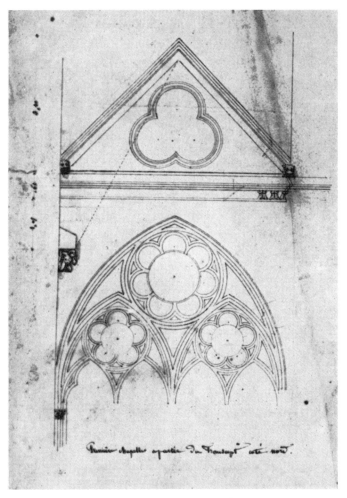

84. Paris, Notre Dame, north nave chapel 7 (Lassus)

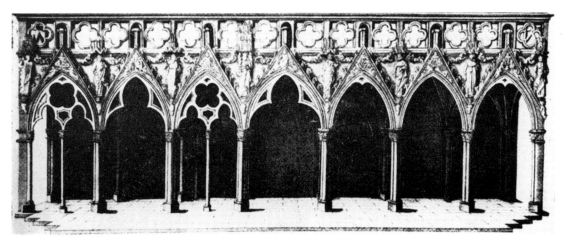

85. Strasbourg Cathedral, choir screen (after Arhardt)

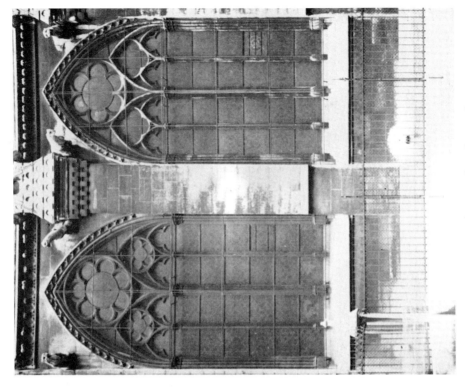

87. Paris, Notre Dame, north nave chapels 6 and 7

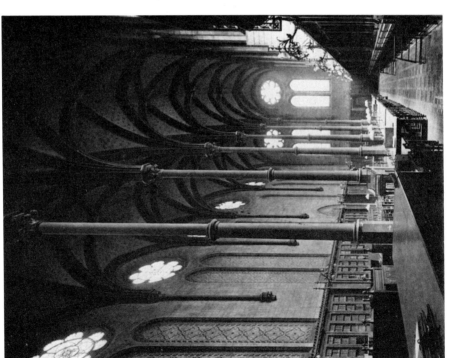

86. Paris, St Martin des Champs, refectory

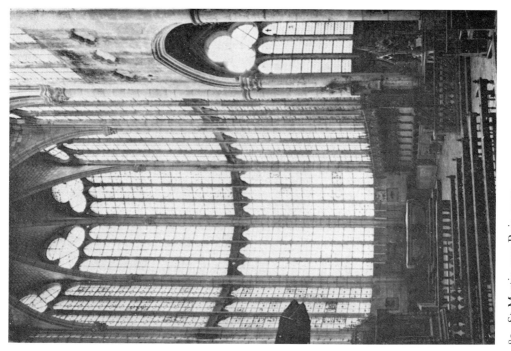

89. St Martin aux Bois, apse

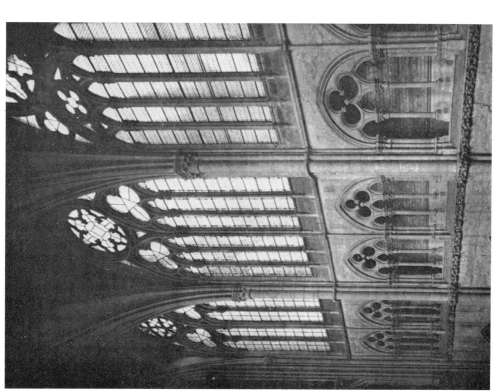

88. Amiens, south transept, west wall

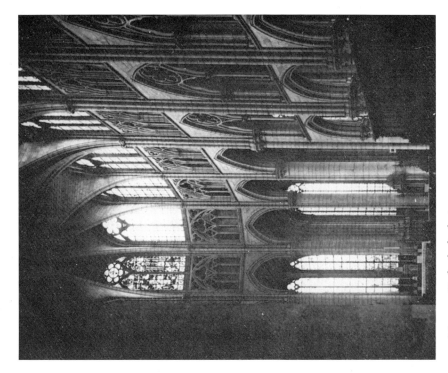

91. Meaux, Cathedral, choir

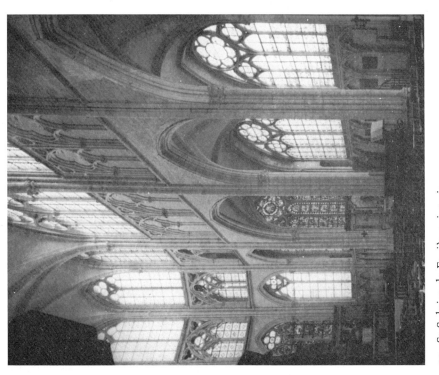

90. St Sulpice de Favières, interior

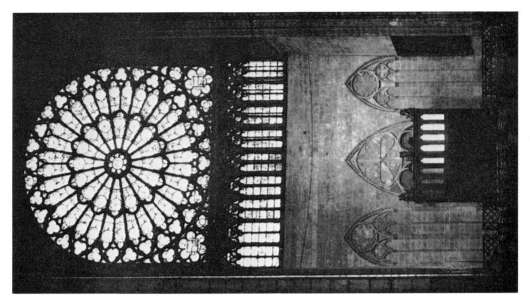

93. Paris, Notre Dame, north transept

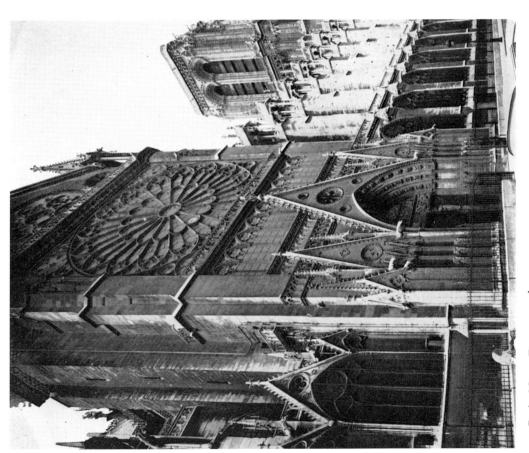

92. Paris, Notre Dame, north transept

94. Paris, Notre Dame, north transept

95. Paris, Notre Dame, north transept

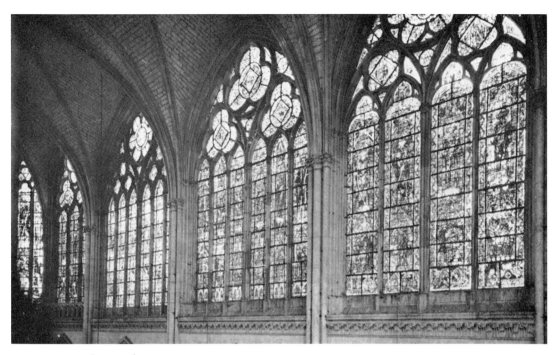

96. Le Mans, chevet, clerestory

97. Le Mans, chevet, clerestory

98. Le Mans, chevet, clerestory

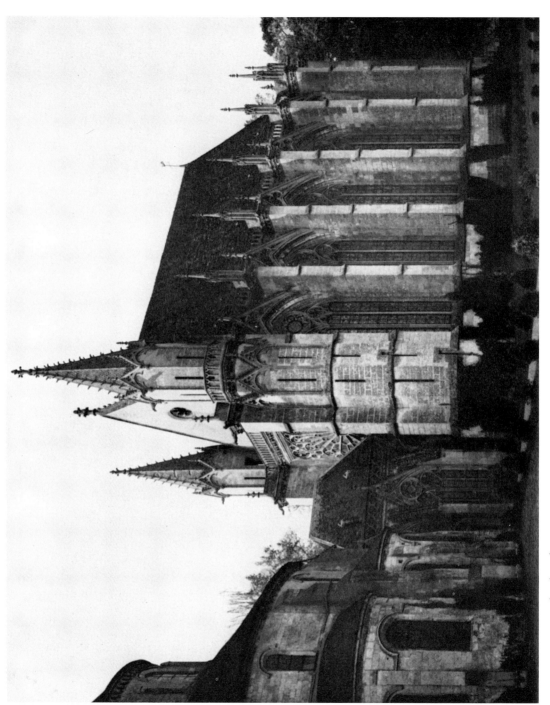

99. St Germer, Lady chapel

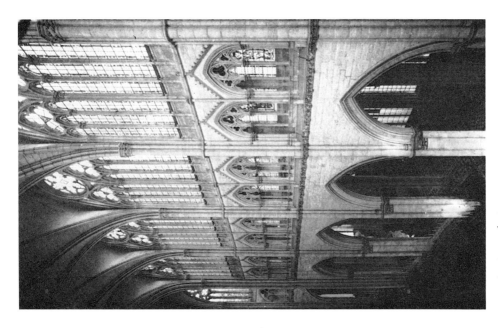

101. Amiens, choir

100. St Denis, detail from *Monasticon Gallicanum*, pl. 66

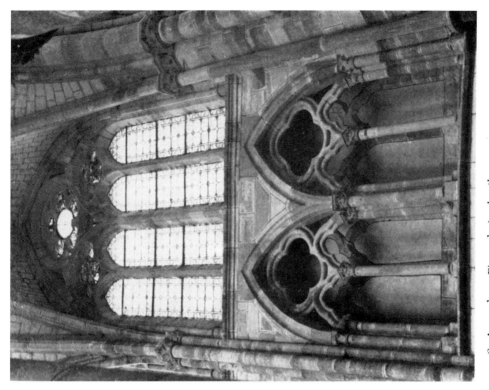

103. St Amand sur Fion, choir, detail

102. St Amand sur Fion, chevet

105. St Germer, Lady chapel, vestibule

104. St Germer, Lady chapel

107. Beauvais, hemicycle bay

106. St Germer, Lady chapel

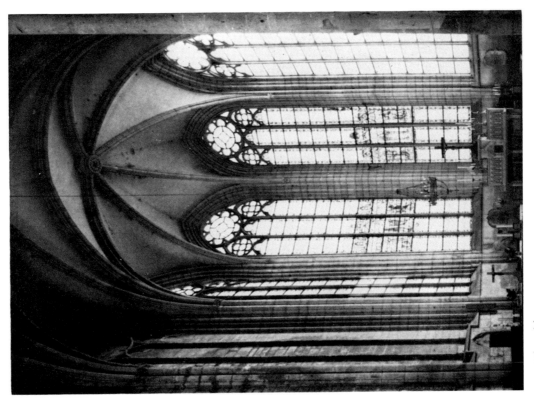

109. Chambly, apse

108. Paris, Jacobins, detail (1878; Carnavalet Museum)

111. Clermont Ferrand, choir

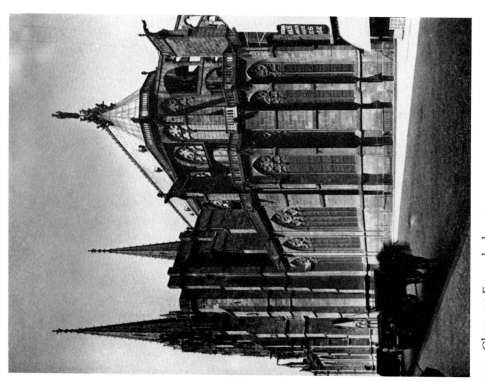

110. Clermont Ferrand, chevet

113. Paris, Notre Dame, south transept

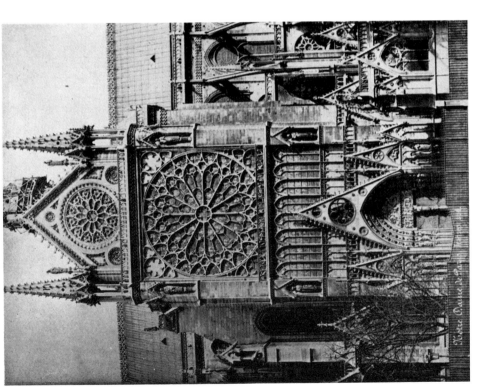

112. Paris, Notre Dame, south transept

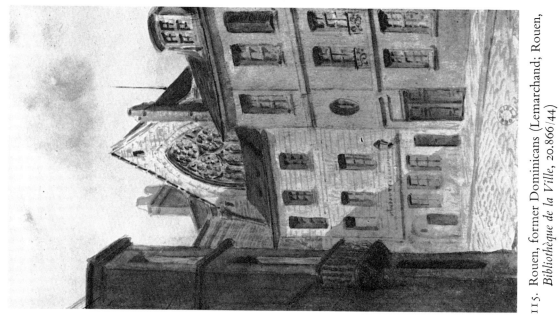

115. Rouen, former Dominicans (Lemarchand; Rouen, *Bibliothèque de la Ville*, 20.866/44)

114. Paris, Notre Dame, south transept, east wall

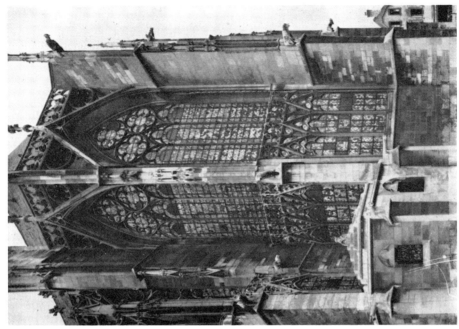

117. Troyes, St Urbain

116. Troyes, St Urbain

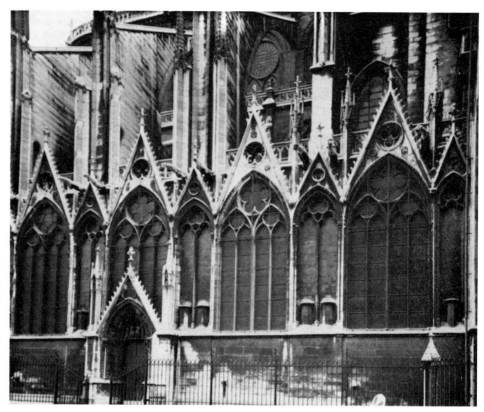

118. Paris, Notre Dame, north choir chapels and Porte Rouge

119. Carcassonne, St Nazaire

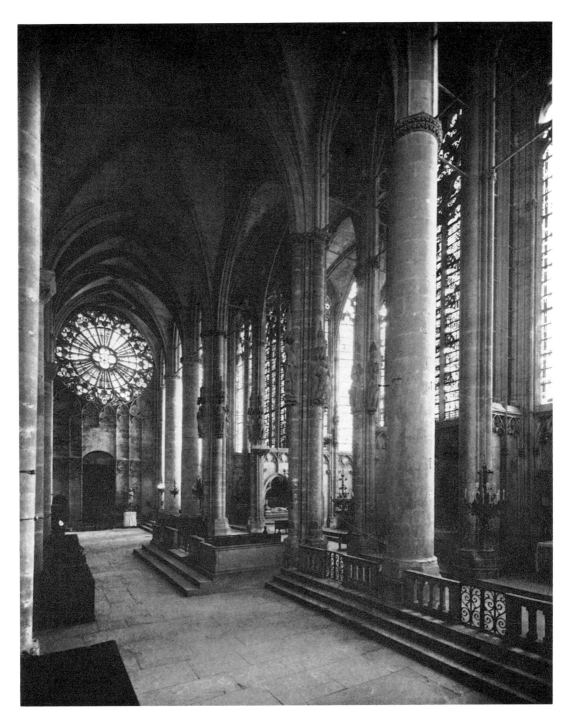

120. Carcassonne, St Nazaire

122. Cologne, Franciscans, apse

121. Vétheuil, apse

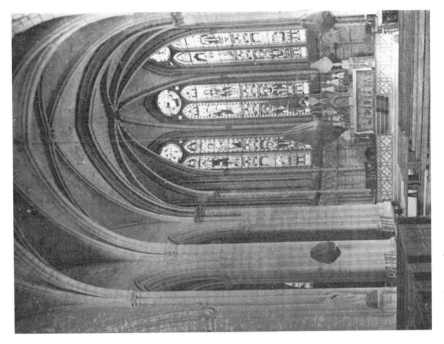

124. Montataire, apse

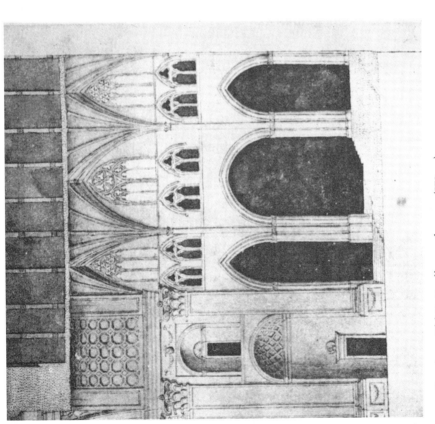

123. London, Old St Paul's, presbytery (Wren)

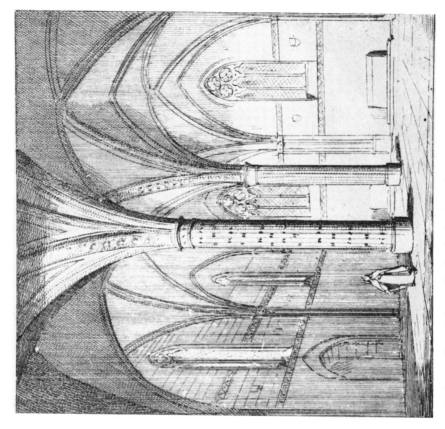

126. Agen, Dominicans (Rohault de Fleury)

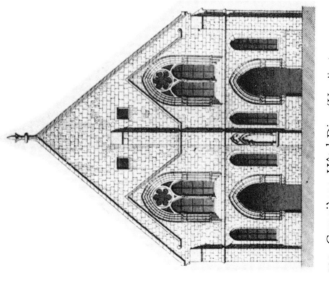

125. Compiègne, Hôtel-Dieu (Verdier)

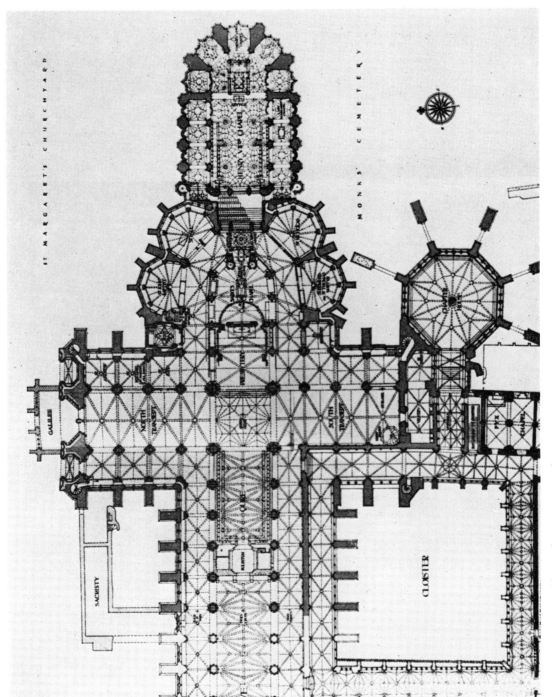

GALILEE

NORTH TRANSEPT

HENRY VII CHAPEL

SOUTH TRANSEPT

CHOIR

SACRISTY

NAVE

PULPIT

PYX CHAPEL

CLOISTER

127. Westminster Abbey, plan (R.C.H.M.)

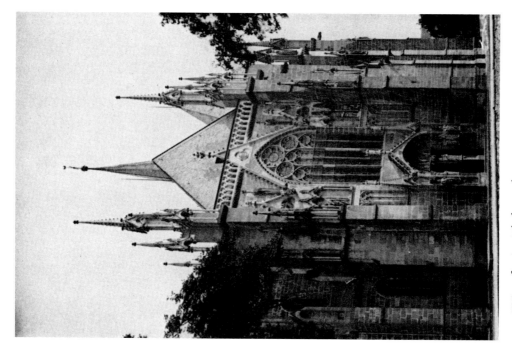

129. Wimpfen im Thal, south transept

128. Strasbourg, Riss 'A' (Musée de l'Oeuvre)

131. London, Old St Paul's, east front (Hollar, 1656)

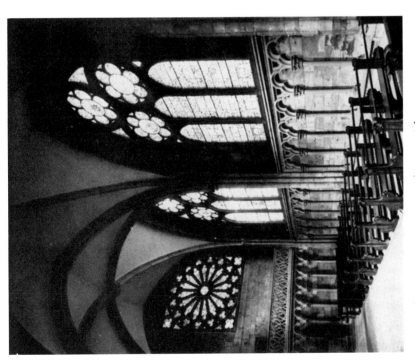

130. Freiburg im Breisgau, north nave aisle

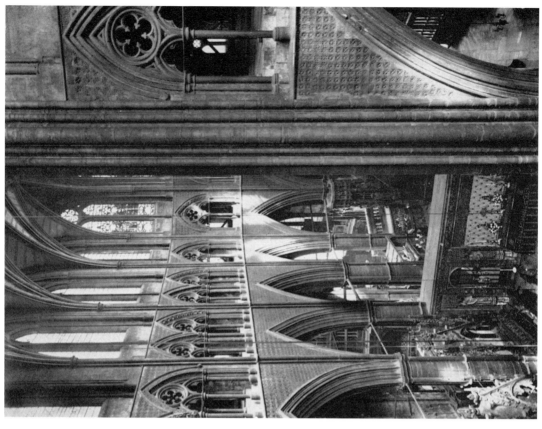

133. Westminster Abbey, choir

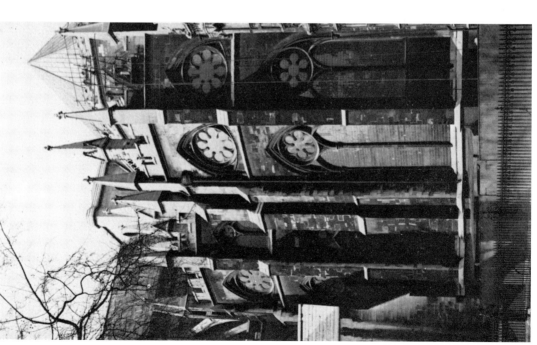

132. Westminster Abbey, chevet

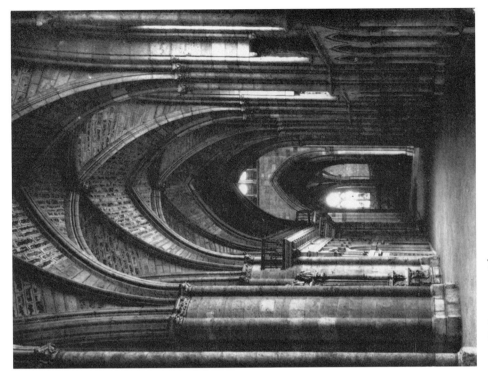

135. León, nave aisle

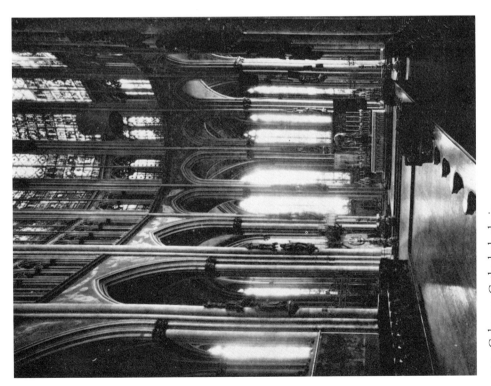

134. Cologne, Cathedral, choir

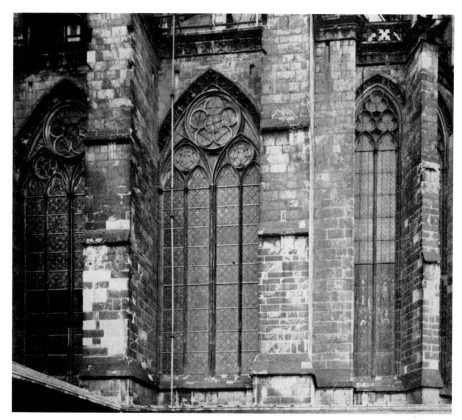

136. Cologne, Cathedral, chevet chapels

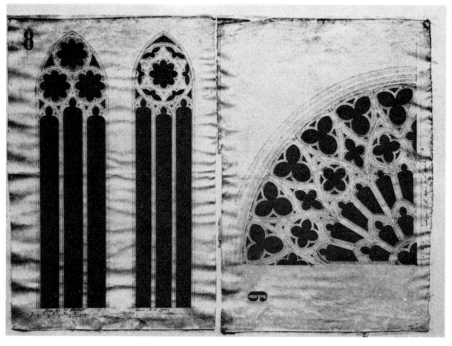

137. Barcelona, Sta Catalina, lower and upper windows of apse, and west rose

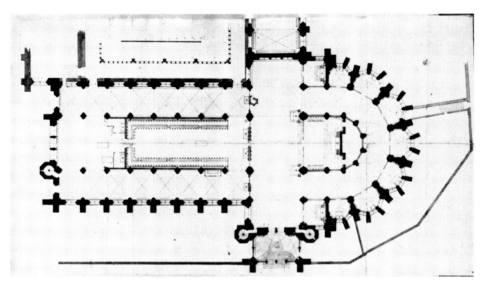

138. Poissy, St Louis, plan (Paris, *Bibliothèque Nationale*, *Estampes*, Va 448d)

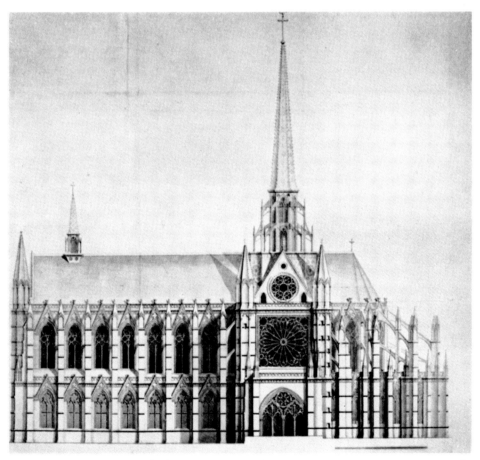

139. Poissy, St Louis, south elevation (Paris, *Bibliothèque Nationale*, *Estampes*, Va 448d)

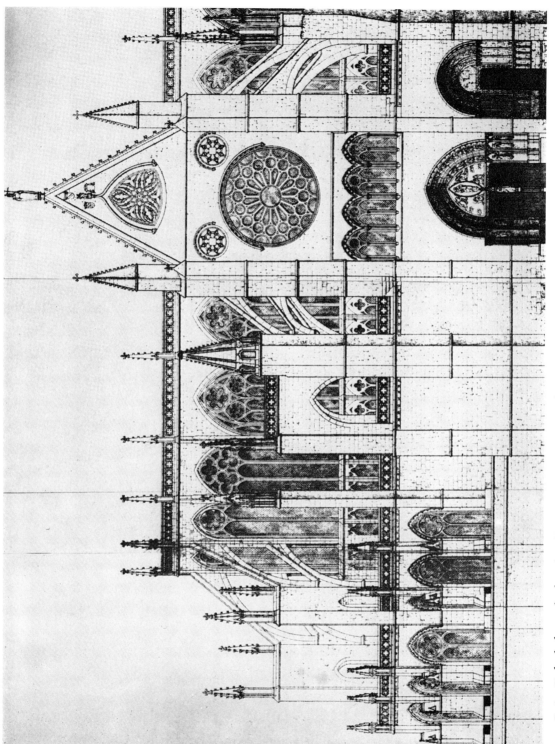

140. León Cathedral, north elevation (*Monumentos arquitectonicos*)

INDEX